Private Vices – Public Virtues

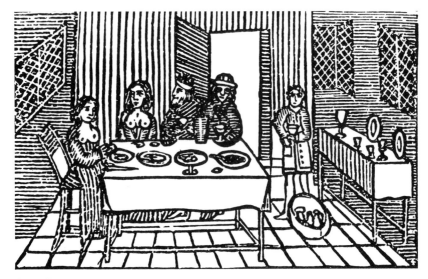

'Their brestes all bare embusk'd and paynted bee on high.' Thomas
Nashe's account of a dinner scene in an English brothel, *c.* 1590

Private Vices –
Public Virtues

*Bawdry in London from
Elizabethan Times to the Regency*

E.J. Burford
and Joy Wotton

ROBERT HALE · LONDON

ISBN 0 7090 5724 5 (*hardback*)
ISBN 0 7090 5822 5 (*paperback*)

Robert Hale Limited
Clerkenwell House
Clerkenwell Green
London EC1R 0HT

2 4 6 8 10 9 7 5 3 1

Photoset in North Wales by
Derek Doyle & Associates, Mold, Clwyd.
Printed in Great Britain by
St Edmundsbury Press Ltd, Bury St Edmunds, Suffolk.
Bound by WBC Book Manufacturers Limited,
Bridgend, Mid-Glamorgan.

Contents

A memorial for all my siblings, Harry, Gerald, Ena and Ernie – an harmonious family.

E.J.B.

To my parents, with love.

J.C.W.

Illustrations

PICTURE CREDITS

Introduction

Adultery, fornication and prostitution are all evocative words guaranteed to provoke instantaneous reaction, either of concern or condemnation. History records these aspects of human behaviour from the most ancient times, all aspects of Nature's plan for the propagation of the human species.

The profession of whore has been graced by innumerable lovely women since history began, acclaimed in song and verse, in painting and sculpture. Yet the profession of bawd, the organizer of these pleasantries, has been vilified, although many of its practitioners were themselves beautiful and intelligent. History records their services to both royalty and the humblest of mankind; the bawd's services acting, like that of the priest, according to the immutable laws of supply and demand.

In Britain organized bawdry is evidenced by the word *hor-hus* (whorehouse), as in Archbishop Aelfric's *Glossorium* (AD 1000) in which *lenocinium* is equated to brothel and the Latin *pronube* is translated as *bawdstrott* – a procuress.

Organized and recognized bawdry entered England in 1066 with William the Conqueror, himself the owner of several well-known brothels in Rouen in Normandy, run by Flemish women; from this time is noted the presence of Froes of Flaundres – Flanders boasting a great many well-known whorehouses patronized by the nobles and gentry. These women were famed for their efficiency and were soon to be found running the stewes on the Bankside in Southwark, which had been licensed by the Bishop of Winchester in Henry II's Ordinance of 1161.

By 1230 the oligarchs of the City of London had their own bordhawes around the Guildhall and in Gropecuntelane, a turning off Cheapside. By 1276, in which year the Mayor and Corporation enacted that all such establishments were relegated to a small alley next to Smithfield, named Cock Alley, or Cokkes-lane, part of the estate of St Paul's cathedral. Incontinent citizens could cross the river to Bankside during the day, but the

wherrymen had to tie up their craft by nightfall so that the citizen had perforce to spend his nocturnal delights until sunrise. (There is, however, some evidence that as early as AD 61 a Roman establishment called the Four Sisters was operating in what is today known as Moorfields.)

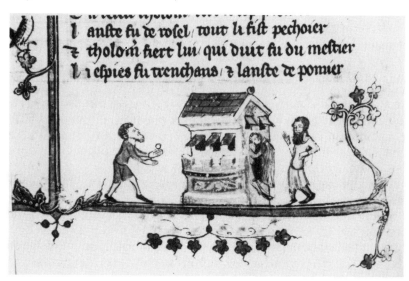

Brothel scene from the margin of a medieval manuscript, *c* 1350. Tossing his coins, a hopeful client approaches a whore-house, while a satisfied client leaves by the back door

Henry VII closed down the Bankside whorehouses in 1505 because of the outbreak of syphilis which had struck the continent. The contemporary poet John Skelton recorded in his *Hickescorner*:

> Some at St Kathereine's strake a-grounde
> and manie in Hole Bourne been founde:
> Some at Saynte Gyles, I trow
> also in Ave Maria Alley ...
> and some in Shore Ditch drew there
> in grate lamentation ...
> and by cause they have lost that fayre Place
> they will buyilde at Colman Hedge a space
> an othere Noble Mansion.

Ave Maria alley is next to St Paul's Cathedral; St Leonard's in Shoreditch had been a whores' nest for generations; St Katherine's by the Tower of London was not inhabited by the

pure in body; but – most surprisingly – Colman Hedge was a far-out suburb where today stands the National Gallery, then a dunghill. The same poem also mentions two small City brothels, the Bell, in Grasschurch Strete, and the Hartshorne, location unspecified but with resident whores, 'Kate, Bess, Sybil and Jane … all fulle praty and wanton [they] will make you weary!'

When they re-opened in 1506 after the scare had subsided, only ten of the original eighteen survived, with their frontages 'paynted white' in accord with a seemingly ancient custom – but those who had moved away never had to return since their new locations flourished during the succeeding centuries.

On 13 April 1546 that paragon of virtue, Henry VIII, shut down the Bankside brothels with 'an harolde and a trumpett' an occasion noted by John Taylor, the Water Poet, succinctly:

The *Stewes* in England bore a beastly sway
til the eighth Henry banished them away:
and since these Common whores were quite put downe
a damn'd crewe of privat whores are growne.

However, ten of them re-opened in the reign of Henry's son, Edward VI, who ordered that 'their frontes shoulde be paynted white' as of olden time, although they seem to have been likened to taverns, since the owners were all hauled before the local magistrates soon after re-opening and fined derisory sums for breaches of the liquor licences. Four were women: Margery Curzon of the Herte (Hart); Margaret Toogood of the Hertyshorn; Anna Ratclyffe of the Crosse Keyes and Joan Freeman of the Fflower Delyce. A little later Eleanor Kent was managing the Beere.

These 'privat whores' flourished in the guise of bath-houses – bagnios – and as ale-houses and taverns in the reign of Queen Elizabeth, although the Queen herself disliked the idea of bawdy-houses. During her reign flourished Elizabeth Holland – better known as *Donna Britannica Hollandia* – who after a long and profitable career in the Liberty of Duke Humphrey and elsewhere finished up in the Liberty of Old Paris Garden, next to the Bankside, in a mansion thenceforth known as Holland's Leaguer – the most luxurious establishment of its time, which for good measure she had leased from the Queen's own cousin, Lord Hunsdon. This set the pattern for a whole generation for elegance, luxury, privacy and service, the excellence of its cuisine and above all, the beauty and expertise of its young ladies. It was also a place for great entertainment – a regular visitor was the

bandy-legg'd Presbyterian himself James I and a great many of his court. This king was no spoilsport.

Bawdry's march was little impeded under the rectitudinous Charles I although forced underground by Cromwell's Puritans, only to rebound to great heights under the lascivious Charles II and his Cavaliers. The other sexual aberration, buggery, likewise flourished.

English sexual behaviour has not changed much since Mother Cresswell's sapient observation that 'everie man hath a Dolour for a Renown'd Brothell', and every subsequent generation has proved this by building ever larger and more luxurious premises, to make sexual congress easier and more pleasant than Pepys's and Boswell's furtive performance in dark alleyways and sleazy tavern-rooms.

Mother Cresswell knew that most men and women would enjoy sexual congress more frequently than the prevailing Protestant ethic then permitted: and that the bawd is the only intermediary to guarantee value for money without any further responsibility falling upon either participant. The profits for efficient bawds were usually great enough to counteract the odium which the profession usually attracted. This attitude is summed up by Ovid's *Amores*:

> Hired intercourse earns no gratitude:
> The client is relieved of all responsibility
> and owes you nothing for your good offices.
> And even the docile whore, earning her pittance
> at every man's demand, curses the greedy Lena
> whom she is bound to obey.

Whether brothelry should be privately or publicly controlled has been the subject of burning contention since Solon's day; and more particularly since the emergence of western Christianity, with its insistence on female chastity on earth – and even in Heaven. In Anne Fielding's immortal phrase 'only the Mohammedans expect fucking in heaven.' The patriarch Judah was not surprised to find a prostitute by the wayside, although he could not have been pleased to find that she was his widowed daughter-in-law trying to make him obey the Torah and marry her, as was his duty.

As early as the reign of Queen Anne, that sagacious anglicized Dutchman Bernard de Mandeville opined that the services of bawds were essential, that 'private vices enable men to perform Virtuous public office' but that the element of private profit 'must be eschewed'. He set out a comprehensive scheme as to how

these disparate objectives might be attained, but he and his ideas were rejected and reviled.

The stark fact is that, in Damaris Page's words, 'Mony and Cunny are Best Commodities', subject however to the basic principle 'No Money! No Cunny!' The last word however lies with that oft-maligned, oft-praised, much quoted and much misunderstood Italian, Pietro Aretino, in his famous *La Puttana Errante*: 'In Bawdy-houses there are sold Blasphemies, Rogueries,

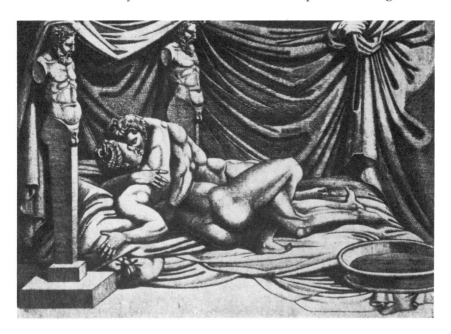

A Temple of Love. One of sixteen engravings made by Marcantonio Raimondi after the *modi* of Giulio Romano. On their publication, political lampoonist and erotic writer Pietro Aretino (1492–1556) wrote the *sonnetti lussuriosi* which describe the *modi* and was promptly forced to flee Rome to escape imprisonment

Quarrels, Scandals, Dishonour, Knavish Tricks, Filth, Hatred, Cruelty, Assassination, French Pox, Treason, Evil renown and Poverty.'

The scope of this book is limited to London because it is the most thoroughly documented area. There were of course excellent brothels and bawds in other centres, notably Edinburgh where, although the women were described as 'drabbes', the activity was very great and well organized long before the advent of James I and VI. This is not to deny the efficient entrepreneurs

in Bath, Bristol, Norwich, Oxford and York – and indeed in Winchester itself, where it is on record that many a church site sheltered loose local ladies.

1 'Elizabeth was King: Now is James Queen'

Prior to the reign of Henry VIII, licensed prostitution had been the monopoly of the Bishops of Winchester, whose 'stewes' on the south bank of the Thames – known popularly as the Bankside – immediately opposite the City of London had existed from the time of the Conqueror's son, William Rufus. They were given official status by an Ordinance of Henry II in 1161 'Touching the Gouerment of the Stewholders in Southwarke under the direccion of the Bishoppe of Winchester'. It consisted of some thirty-two Latin rubrics and fifty-two paragraphs in English.

The main part of these regulations concerned the employment of women 'living by their bodies' in these stewe-houses – the current term for brothels. The Bankside was, in terms of the law of London 'an assigned place' for whoredom, which was rigorously forbidden within the City's walls; the other 'assigned place' was Cock Lane, just outside the City wall in Smithfield. This area, like that of the Bishops of Winchester, fell ultimately to the diocese of St Paul's.

Notwithstanding this precept, there were 'abodes of wantons' in the City in the Cheapside area, the most notorious being Gropecuntelane, adjacent to Old Jewry, and Ladd Lane. Any citizen needing sexual gratification had to take, during daylight hours, a licensed wherry across to Southwark; the boatmen were enjoined to keep their boats tied-up after sundown.

However, apart from these areas there was the Liberty of St Martin's le Grand, which had been established about 700 by King Wihtread of Kent: his charter included the right of sanctuary, and more important, exemption from civil and ecclesiastical jurisdiction. These rights and privileges were endorsed by William the Conqueror's Charter of 1067. In 1503 Henry VII gave the Liberty to Westminster Abbey, which resisted every attempt by Crown and City to interfere with these 'immunities'. Not surprisingly this Liberty also covered houses used for prostitution in an area

including the later redlight district of Pickthatch around Aldersgate Street – notorious in Queen Elizabeth's reign. When the Liberty was finally surrendered in 1548 Edward VI still allowed these ancient privileges to be maintained, and taverns and wine-houses were immediately built and mansions 'letten to Straungeres', amongst whom were a number of bawds.

An Ordinance issued by the Lord Mayor of London in 1483, on behalf of Edward V, 'For to Eschewe the Stynkynge and Orrible Synne of Lecherie the which daily groweth and is used more than it hath been in daies past by the Meanes of Strumpettes'

When King Henry VIII dissolved the monasteries, confiscating their lands and properties – quite a few of the incumbents 'did a deal' with the King to prevent the worst effects, since all he really needed was money. Many of these vast properties were sold to his noblemen and the great City magnates. However, this caused a great increase in the numbers of unemployed men and women: those who could not find work were classed as *vacabondes* and driven from pillar to post – naturally a great number of the females were driven into prostitution. When in 1546 the King closed down the Bishop's licensed brothels on Bankside he created even more unemployment and hardship among females – but he died soon afterwards and his son re-opened the Bankside stews – he stipulated only that they should be 'painted white to

show what they are' – and many private and quasi-clandestine private brothels began to emerge. So much so that one of Edward's mentors, Bishop Latimer drove him to ennui in his constant demands to take action against bawdry. He actually singled-out that ancient stronghold of vice, the Liberty of St Martin's le Grand. (Its right of sanctuary was only abolished in 1815.)

In Elizabeth's court the atmosphere was somewhat formal: the protocol became stricter as the Queen aged. There were numerous balls – she loved dancing – but woe betide the maid of honour who became pregnant in inexplicable circumstances. Outside the Court the populace 'neither observed nor enjoyed any Fast Days or Holy Days ... and murder and rapine and every form of violence' was practised with comparative immunity. Male brothels were also known – one belonged to the Queen's cousin, Lord Hunsdon, who 'kept his house of beasts in Hoggesdon' (Hoxton-next Shoreditch), much esteemed by noble lechers addicted to buggery.

Thomas Nashe (1567–1601), poet and playwright, wrote of a device introduced about 1600 from France – the dildo. In the *Merrie Ballad of Nashe his Dildo* he details his visit to a high-class brothel where he performed so unsuccessfully that his expensive ina-morata scorned him and was compelled to use a dildo. Nashe mentions that there were 'Sixpenny whorehouses nexte dore to the Magistrate' which could not have carried on 'if brybory did nott bestir the magistrates ... Dishonest Strumpettes ... weren clustered Night and Daye at the entrances to brothells as freely as if they were entrances to Tavernes ... and everie one of them claimed to bee a Gentlewoman.'

The price was usually half-a-crown – a very large sum in those days, although Nashe admits that sometimes the price was less after bargaining: he called the suburbs of London 'Licensed stewes'.

The Queen's own lawyers ignored her laws. *The Calendar of the Inner Temple* for February 1601 complained that: 'the Fellows of the Inn repair unto & haunt & frequent unfitt & dangerous places, Yea! oftentimes to their overthrow and undoing ... they wear their haire long ... verie unseemlie for Gentlemen of their Profession.'

The lawyers' sexual needs were catered for by a number of whorehouses just outside the Inn's gates in such as Tooks Court, although their clerks and lesser legal fry had to be content to pick up the 'white Aprons' in Fleet Street and Fetter Lane or slake their lusts in the neighbouring alleys which certainly were 'daungerous and unfitt'.

Towards the end of the Queen's reign, the reign of quite a different Queen was beginning – heralding the era of the brothel de

luxe. This was Elizabeth Holland, born of respectable county parents, a spoilt and over-indulged child of great beauty who grew into a haughty and imperious nymphomaniac. She badgered her parents until they sent her to London into the care of 'a great City Magnate' who launched her into high society. She married very young, but her incontinent behaviour with her husband's rich friends caused a separation and 'shee came under the protection of a rich and handsome young Italian merchant in London' who set her up as a high-class courtesan. She became very wealthy. However sometime about 1590 she decided to be: 'no more a *Lais* but a *Lena*: no more a bewitching Whore but a deceiving Bawd ... the synnes of others shall mayntayne her Synne.'

She opened a very luxurious brothel in the Liberty of Baynards Castle, near Puddle Dock in Blackfriars – and had she stayed there would have saved herself a lot of grief, but she moved over to Pickthatch 'in Finsburie' where in 1597 she ran foul of the law; the unrestrained behaviour of her rich and noble clients, the loud music, the dancing and noisy gambling disturbed the whole neighbourhood. Complaints were made, she was arrested and found herself in Newgate Prison. On 23 November she was charged before the Middlesex Bench: 'THAT for six months previously she had kept a *Lupanar* and practised *lenocineum* ... wherein depravities and Debaucheries were carried out.' To such an extent that the neighbours were reduced to fear and trembling and fearful of their daughters' safety. Such disturbances were considered *subverconem*, in English 'overthrowynges ... a threat to subvert Her Majesty's subjects'. She was sent back to Newgate.

Aided by powerful City friends, who bribed the Keeper of Newgate Gaol, she escaped into the nearby sanctuary of St Martin-le-Grand where she devised a new strategy for her future. This led her after much research to establish her business over the Thames in the Liberty of Old Paris Garden, next to the Bankside, in a great mansion set in extensive grounds set in a moat, accessible only over a drawbridge. In 1603 she signed a lease from the late Queen's own cousin, Lord Hunsdon, allowing the premises to be used as a brothel. Dr Rendell, the historian who last saw the lease, remarked on some curious conditions, one of which was: 'the, lease would be voyde if one Woman was founde bryngyng-in more than two men, or one Man comynge-in with three women in the same Daye.'

Here she launched the Hollands Leaguer, the most exclusive, expensive and luxurious *Howse of Obsenities* ever known in England, with four hand-picked 'Wantons, a Cooke-wenche, a

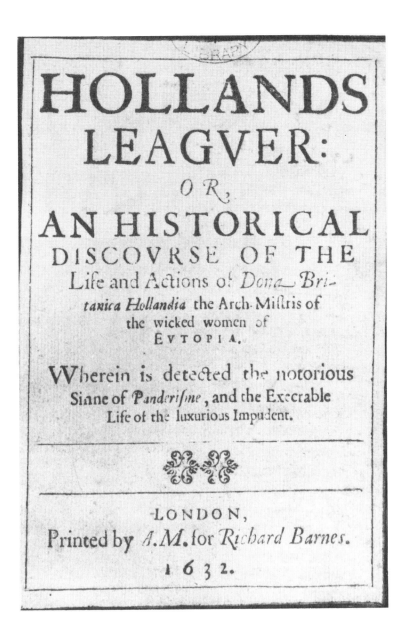

HOLLANDS LEAGVER:

OR,

AN HISTORICAL

DISCOVRSE OF THE

Life and Actions of *Dona Bri-*
tanica Hollandia the Arch-Miſtris of
the wicked women of
EVTOPIA.

Wherein is detected the notorious
Siane of *Panderiſme*, and the Execrable
Life of the luxurious Impudent.

-LONDON,
Printed by *A.M.* for *Richard Barnes.*
1 6 3 2.

'Pecunia non olet' (money has no smell) – the motto of Elizabeth Holland, founder of the infamous Hollands Leagver

laundrie lasse and a girle Scullion' all protected by a giant
Cerberus 'monstrous in Size, shape and Condition' to guard the
drawbridge. Her slogan was 'This Chastitie is clene oute-of-date,
a mere obsolete Thynge', and its acceptance by a distinguished
and aristocratic clientele made her extremely rich and unmolested
for some thirty years. The opening coincided with the advent to
the throne of James I, hitherto a poor uneasy monarch of a 'wild
countrie' whose capital, Edinburgh was, *vide* Sir Anthony Weldon
who accompanied James to England: 'foul howses, foul sheetes,
foule dishes ... Scottish women ... everie whore in Houndsditch
is a *Helena* compared with them ... the greasy whores in Turnbull
streete are as Greek Dames in comparison with them.'

James' easygoing sexually tolerant attitudes swiftly led to moral
and financial corruption. For money you could become a knight;
for more money, a baronet, for even more you could become a
peer. Women could achieve wealth, eminence and influence in a
different way!

The Court was very boring: up at ten, leisurely dressing till
midday. After dining, an afternoon in St James' Park or a visit to
the bull-and bear-baiting rings on Bankside or the cockpit.
Mooching about in Whitehall, intriguing for money or power or
gambling for high stakes – the duns could not enter the royal
premises. After supper at nine o'clock the King would retire and
the courtier would then go home to his wife or mistress or go to a
brothel or even get drunk. At Hollands Leaguer, both King and
courtiers could dine excellently, dance or walk in the secluded
garden, or gamble – although here they had to pay cash for
Elizabeth Holland granted credit to no one. Finally, if he was
broke, he could wander the Bankside, pick up an ambulant whore
or keep an assignment with a Court bawd. In this way the
brothels became more luxurious and their food and entertain-
ment more satisfying than the new balls and masquerades at
Court – clubs began to develop, into which many men would
retire when tired of wives and mistresses.

From the servant class many a Court bawd now sprang, with a
readymade clientele at hand, perhaps a good example is the
astrologer, 'Doctor' Simon Forman, an early Rasputin whose
astral powers were as genuine as his medical degree. He had a
profitable sideline as a pimp, keeping a *Register of the Ladies of Love*
in the Court. He secured royal protection even against the Lord
Chief Justice: after his death his illegitimate daughter Anne,
'Handsome but lewd', married the respectable real doctor William
Turner. She became an abortionist-cum-midwife to many a great
lady. She also had a flair for fashion, her 'creations' becoming

very desirable: one close friend was Lady Frances Howard, daughter of the Duke of Norfolk and 'a nymphomatick adulteress' who conspired with Robert Carr to murder Sir John Overbury. All three were found guilty in the subsequent trial, but only Anne was executed at Tyburn on 15 November 1615, 'wearing a fine silk dress with yellow starched ruffs' – a fashion she had introduced at Court – the fashion died with her.

There was also Lady Mary Grisby (or Griseley) a former whore turned Court bawd who on 10 September 1610 had been found guilty of recusancy and had her property confiscated; in December 1611 she was presented before the magistrates in Stepney 'for not going to church as required by Law'. Meanwhile she shifted her residence to the Liberty of St Martin-in-the-Fields, very convenient for her clients at Court, and a safe place. She was again found guilty of recusancy in October 1617, but no penalty could be exacted against an inhabitant of that Liberty.

Some ladies of the Court did not need a bawd: there was a Lady Elizabeth Broughton 'a most exquisite Beauty with a delicate Wit'. She was a veritable Thais selling herself to the highest bidder. Her sexual exploits became so flagrant that Ben Jonson observes in a *Satyre*:

'From the Watch at Twelve o'clock
And Bess Broughton's button'd Smock
 Libere nos Domine'

He also coined the phrase 'Bess Broughton's Pox on thee!' because of the syphilis from which she died.

There was also Lady Venetia Stanley of the noble house of Derby, perhaps the best known nymphomaniac at Court. 'A most desirable and tractable Creature ... her beauty could not be hidden ... a most lovely sweet-tun'd Face & Cheeks like a Damask Rose' says the ballad *Panders Come Away*. Her lovers included half the aristocracy and it was alleged that over the door of her lodging there was a plate:

PRAY COME NOT NEARE
DAME VENETIA STANLEY LODGETH HERE!

She later married and lived happily for several years with Sir Kenelm Digby, who penned a moving and loving tribute to her early death.

Another Court lady was Jane Selby, an outspoken lesbian – which is probably the reason why her husband, Sir John, was found in bed with Mrs Overall, wife of the Dean of St Paul's: of

her it was said she was 'verie obliging and tender-hearted … her Eyes being Wondrous Wanton'.

To complement these Court exquisites there was the Todd gang who operated from a house in St Martin-in-the-Fields; the principal was the eldest brother William, 'an abortionist who harbour'd lewd Persons'. Then there was Thomas, 'A Gentleman', but nevertheless with several convictions for 'pandering with assault and battery'; and Richard, a bricklayer by craft but an 'unlicenced Vendor of liquor', who with his brother Robert did robbery with violence. All catered in some way or another for 'Persons at Court' – possibly fencing stolen goods.

All this time, however, Hollands Leagver was flourishing under the benevolent eye of the King himself, who availed himself of its services quite frequently. In the City and suburbs, where life did not revolve round the Court, middle-class men and women now had more money to spare for sexual adventures: a number of 'respectable' brothels existed for gentlemen. For the ladies there came into existence 'Houses of Assignation' run by professional bawds who supplied 'Stallions' – the euphemism was 'Gallants' – on condition that the lady did not accept money from the chosen stud.

In his book *A Crew of Kinde Gossips* (1609), Sam Rowland deals with the absent-husband syndrome, where 'two or three kind Gentlemen' look after a neglected wife 'whenas her Husbandes out a-Nights at Dice!' The absent husband posed another problem for stay-at-home wives. The street ballad *A Married Woman's Care* sets out the problem with brutal clarity.

> A Woman that's to a Whoremonger's wed
> Is in a most desperate Case.
> She scarce dares to perform her Duty in Bed
> With one of condition so base:
> For sometimes he's bitten with Turnbull-streete Fleas,
> The Poxe or some other infectious Disease,
> And yett, to her Perill, his Lust shee must please!
> Oh! Thus lives a Woman that's married.

The Registers of the Middlesex Sessions evidence the spread of bawdry; every suburb is mentioned therein. In February 1609 George While was arrested 'in a notorious Bawdy-howse swaggering drunke all nighte'. In February 1613, Ann Wright was found hiding 'in a Chest at Mrs Crabbe's brothel', while in December Mrs Crabbe herself was arrested, whipped and carted for keeping the brothel. Also in that month Joan Cole, then in the Bridewell, was further sentenced 'to be whip'd and carted with

Papers on her Head and with a Bellman ringing his Bell going before her, what time three other Turnbull Street whores must accompany her on this pilgrimage'. Anne Robinson of Aldgate was sentenced 'for that she is a Notorious Common whore and setteth upp at the Doare till eleven or twelve a-clocke in the Nighte to entertaine lewd Persons that resorts unto her'.

More grim is the report in 1610 when John Burgoyne of Cripplegate was charged 'that he nott only received in his brothell people sicke of the Plague (but also) an other sycke of the Frenche Poxe ... who liveth there incontinently with Fayth Langley'. In 1611 Joan Woodshore of Clerckenwell was charged with 'being a Noted Whoare ... but also sells Tobacco' and also charged 'with running at two sea-faring men with a Spitt or Rapier' – probably bilkers.

William and Isabel Sowthe kept a 'House of Misrule in Cow Crosse ... in whiche verie synnfull Lust and Carnall behaviour' occurred – worse still, one Shercoe 'also confessed that he had the use of Isabel's body on the Sabbath Day' – a truly heinous crime. Nearby the barber-surgeon George Maine kept a bawdy-house in Clerkenwell Green, his two colleagues kept houses of ill-fame in St Giles-in-the-Fieldes; and two master butchers in Cow Cross were charged, with Anne Morrow, 'whoe confesseth ... to bringing half-a-dozen Whoares to bed in the house'. Susan Brown 'was taken in Bedd with a Scots Man in the Common Bawdy House kept by Christopher Thwaytes, Gent.' (A 'Gentleman', being a 'Person of Consequence', had no business in a common whorehouse.) In the following year, his landlord Richard Smith was charged with 'oppressynge Thwaytes by putting-in a Bond of the House' – a notorious bawdy-house – 'itt falleth oute that Thwaytes could nott quietly enjoy the same because of the continuall Distturbances of evil-disposed people'. The Bench ordered Smith to accept the rent 'without further Argument ... and nott to vex Thwaytes anie further.'

Time and time again the records return to Turnmill Street – indifferently called Turnbull Street even though it was originally and officially known as Trimill Street because there were three flour mills on the then sloping bank of gardens down to the River Fleet. The mansions of the rich and mighty London oligarchs lined this pleasant scene until the Fleet turned into a sewer! There is a note of despair in the court records of 1 January 1624: 'manie lewd persons in Turnmill street ... keepe comon brothell houses and harbour divers impudent Queanes.' Murders and man-slaughters were rife, as well as abortions.

The best indicator of the rise of bawdry comes in the Middlesex

County Records, under 'True Bills for Keeping brothels'. In the eighteen years from 1603 these had averaged three 'True Bills' per annum: in 1631 it shot up to thirty-three! Hence even the easy-going James was compelled in 1622 to issue an Ordinance:

Touching upon Disorderly Houses in Saffron Hill

> ... to restrain the shamless Weomen ... Bawds who entertained and lured men into divers Howses for base and filthie lucre ... ackrewinge to the private Benefitt of the Landlordes ... by sitting outside their Dores ... and beckoning in the clients.

The Ordinance was also intended to strengthen action against dishonest and corrupt beadles and constables who 'aided and abetted and blackmailed' both whores and bawds. These law-enforcement officers were drawn from the lowest ranks of society, in the main illiterate, prepared to work long unsocial hours for little pay. Many constables could neither read or write and had to resort to a scrivener to know what was in their Warrant!

In 1624 James had to renew the 1622 Ordinance regarding disorderly houses extending its scope – but still omitting such protected enclaves as Old Paris Gardens – and Hollands Leaguer – but in 1625 the 'True Bill for Brothels' had sprung to thirty-two requiring an extra proviso requiring that 'Bawds who had not been detained were nott to be lett oute on Bail unless adequate assurances of Good Behaviour were found beforehand.'

Assuredly the reign of James I had done little to tame the ravenous monster of bawdry; his successor, his second son, Charles I, a rectitudinous man, could not succeed either.

2 A Chaste King
and the Rollicking Roundheads

The reign of Charles I opened inauspiciously with one of the worst outbreaks of bubonic plague ever to strike the kingdom. His accession also boded ill for bawdry because sexually he was a most correct man, which he showed by telling his first Parliament to instruct the Lord Chief Justice: 'TO TAKE some present Order for the reformation of Places of Open Bawdry in Clerckenwell, Pickehatche, Turnmill Street, Golden Lane & Duke Humphreys in Blackfriars'.

Pickehatche – usually spelt Pickthatch – was the area lying between Aldersgate Street and the border of Finsbury – originally part of the ancient Liberty of St Martin's le Grand but never actually defined. (A *pickhatch* was the metal grille set in a front door.) Possibly the whole area was full of hatched doors of whorehouses to obtain this sobriquet.

Turnmill Street was in the Ward of Farringdon Without, so-called from the three windmills which had anciently stood on the site – it still exists next to Farringdon Street underground station. It had been regarded as the very sink of iniquity from medieval days and well deserved its unsavoury reputation. Golden Lane, which also still exists, runs north of Moorfields – it became famous for its Fortune Theatre in later days; it was also a centre of whoredom.

Duke Humphrey's Rents was an alley in the Liberty of the Duke of Gloucester – Humfrey was the 'Good Duke' – a few yards from Puddle dock where the Mermaid Theatre now stands. The Liberty had been a centre of prostitution since medieval days, being part of the estates of old John of Gaunt and his son, Cardinal Beaufort, both of whom derived enormous wealth from the whore-houses which they licensed.

Elizabeth Holland had briefly graced the Liberty with her presence, and other offshoots of the Holland clan who ran successful brothels there for years after her departure – the most

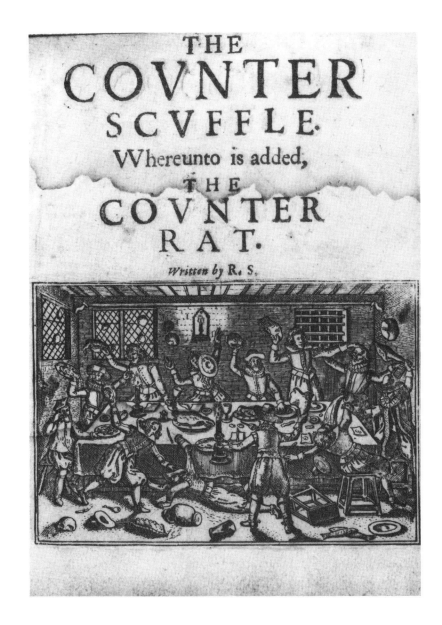

The Counter Scuffle of 1621. Robert Speed's pamphlet explains how the keeper and several of his minions joined imprisoned rakehells and bawds in a revel that 'turn'd Nighte into day by Drinking, Whoreing, Swearing, Roaring, Cursing, Blasphemy and Debauchery'

notorious being Richard and Amy Holland who were later to be involved in much more serious troubles. These Hollands are the first known indication of a family of professional brotheleers. With the death of King James, the fortunes of Hollands Leaguer began to decline.

Fashionable bawdry had moved to the up-and-coming area of Covent Garden, and progress was catching-up with the Leaguer; the constant disturbances disturbed the neighbours, by now including very many highly respectable Huguenot families and Puritan tradesmen, who demanded that action should be done. In December 1631 the Lord Mayor's constables and beadles having dismally failed to eject Mrs Holland, the troops were called in; they met with such determined resistance from the female defenders that they were shamefully discomfited. Fresh troops were called in but not until the mansion had been beleagured for several weeks did the bastion fall – however Elizabeth and her *mignons* had vanished through some secret exit – long prepared for such an eventuality. From this moment Elizabeth Holland disappears from history, but the fame of Hollands Leaguer was known for more than a century afterwards as the prototype and epitome of luxurious brothelry; as late as 1639 one Ursula Bapthorpe was indicted as 'a whore from Hollands Leaguer' in a curious court case; although a whore named Susan Holland was charged soon after the fall of the Leaguer – from her stated age she may have been a daughter or even a granddaughter of the founder.

King Charles' ordinances were just as ineffectual as all previous ordinances of the previous 500 years – when he was executed in 1649 the whole area in an arc round the northern suburbs of London was one vast brothel.

John Taylor, the Water Poet, wrote a book called *The Vertuous Bawd* in 1630. A licensed ferryman who lived till 1653 when he was more than eighty, he was a most colourful, intelligent and percipient observer of his long life and times. He must have ferried many an incontinent 'City Gent' over to the Leaguer in contravention of the ancient City Ordinance *De Batellariis* (of Boatmen). It is very likely that his *Vertuous Bawd* was Elizabeth Holland – he may even have known Elizabeth Cresswell, who was known in her youth to have had some connection with the Bankside. He would certainly have known Damaris Page and her famous establishment at Ratcliff.

Taylor extolled bawds as virtuous in comparison with similar 'virtues' professed by tradesmen – giving an excellent insight into manners and morals of three reigns and a part of the

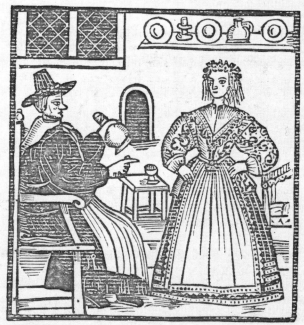

The Vertuous Bawd (1635). An account of
Elizabeth Holland and her ways by John Taylor,
the Water Poet of Elizabethan London

Commonwealth. He starts by saying that a bawd's knowledge is not easily acquired.

First, she has to start as a pretty young girl, not spending her time idly, but learning; by the time she is about thirty she has had experience of the 'rigours of the laws, the penances and whippings and all the hazards of the profession, including the handling of the Justices' Clerks – even when necessary the Justices themselves' – and when her beauty begins to fade she becomes a bawd 'as the proper Right for her long services to Society'. She will recruit and in this way manage to sell a maidenhead 'three or four hundred times'; she 'will not be averse' to recruiting local wives and daughters 'to help out'.

Her great knowledge of grammar enables her to speak and write 'amorously, merrily and craftily': she is an expert in astronomy because having lain so long 'on her back performing all sorts of planetary movements' she has well observed the stars. She had however, little need for arithmetic because all her business was done for cash. In geometry she knows all the angles ' … even triangles and quadrangles'. In musick she was master of the 'Pricksong' and also played the 'Sackbut' – selling butts of Sack at highest prices. And she could demonstrate her skill in painting by choosing erotic pictures to bedeck the walls of her house.

All 'Seven Sinnes and Vices' were welcomed by the bawd: primarily 'Letcherie', 'Gluttony' and 'Drunkenness', as also 'Sloth' and 'Idleness' in gentlemen because they ensured 'Carelessness' and 'Generosity'. 'All Vices' says Taylor 'are greatly respected by bawds, particularly *Hypocrasie* since many men have an itching *Desire* in private for that which they will condemn in Publick!'

All bawds have the great virtue of Civility; they will never ask awkward questions; they will only ask if the customer has enough money, 'like Landlords, Surgeons and honest Lawyers, she will require her Fee in advance' and the impeccable Principle that men will pay quickly and generously for hope and desire, 'but onlie grudgingly, or even not at all when they have had their Fill!'

Taylor then contrasts the treatment of bawds with that meted out to the poor whores, who were 'carted'; their heads were shaven, they were stripped naked to the waist and their heads adorned with 'a paper' – a paper cap – inscribed with their name and offence. Sometimes they had to carry a peeled white rod as an extra indication of shame. Then they were tied by a rope to the cart-arse and whipped like cattle until the blood flowed.

Generally the bawd was well-known and accounted a person of some wealth and consequence, and a valued customer to all local tradesmen – even though the latter might revile them in public. If carted, she would be clad in a 'Blew Mantle', a sitting target for the mob, who would throw every kind of filth from the dunghills as she passed by. Drums were hired from local barbers, and after being paraded round the district she would be expelled through the nearest City gate and warned to stay away, under threat of imprisonment at Newgate or Bridewell where she could be tied to the stocks and whipped – indeed she might even have her nose slit – the ancient permanent mark of a sexual sinner. Alleviation was almost always possible if enough *aurum argentum* was paid into avid palms – most often the Justices' clerks or even the keeper of the gaol.

Finally, Taylor reminds his readers that 'Bawdry is nott some upstarte new-fangled *Bauble or Toye* ... but a real solid lasting Thinge', pointing out that when business was bad everywhere else, 'A Bawd can sett up with little or no Capital ... if her Luck holds she will extract from Sin and Wickedness, Good Money, Good Cloathes and almost anything Good, except Good Conscience – and that is but a Poore Beggarlie Vertue!! ... But let itt be blowing High or Low the Englishman is neare uppon all Occasions!'

If by any mischance a bawd ran foul of the law by keeping some young woman 'or undeclared foreign women' who had been seized and sent to prison, 'shee can compound this Business by offering a small Toy (bribe) to redeem her *commoditie* back into the fold' – the girl was just a commodity to be bought and sold or hired – and the bribe would be taken from the girl's own earnings, so that the bawd was in no way financially incommoded. He summed-up by saying 'A Bawd is onlie considered a Loathsome Figure to the satiated Lover!'

One of the innumerable polemics 'agin sin' was Thomas Cranley's ballad about a very superior whore, entitled *Amanda, or the Reform'd Whore*, written while he was in the King's Bench prison for debt in 1630. He describes how prostitution was now organized to provide greater luxury and comfort. Amanda's back-up organization had to include first a pimp and a pander and also a host of servants to run a high-class establishment. Four verses refer to help given by professionals, such as doctors, surgeons and apothecaries. (This section was omitted in the 1869 edition of the *Roxburgh Ballads* presumably because it was thought unsuitable to include such worthies in the cast.) The surgeon was all important, 'since without his needfull Helpe Thou cans't nott

live!' Others needed were 'some well-approv'd Phisitian' and 'a skill'd Apothecary to make up his Prescriptions' to ensure not only Amanda's health but that of her clients' too. A resident Surgeon had been employed in Elizabeth Holland's establishment some thirty years earlier.

The latter years of this King's reign engendered the Civil War and popular unrest; from 1640 onwards there was a great expansion of sexual confusion, helped somewhat by the Parliament in 1640 reducing prostitution from a felony 'to a Nuisance if committed in Public' the penalty being the lash and a short spell in a house of correction. The penalty for 'simple fornication' was reduced to three months' imprisonment. In 1641 the Parliament enforced the Common Law, thereby abolishing torture in England – the punishment of 'carting' is less evident from this time. Only the Puritans strongly opposed sexual sinning – the Long Parliament contained many disparate elements from big landowners to the proto-socialist Diggers united only in one thing, they were against the King and his policies.

The great virtue of the Commonwealth Parliaments was its vigorous protest against cruelty in punishment – the house of correction was for rehabilitation. The Bill for the *Generall Releif of Debtors* would have helped many a bawd and prostitute held in prison for debt by unscrupulous madams or spiteful customers. There were enactments against cruelty to animals but legislation fell short of abolishing some of the greater disabilities of women – this was mainly because of the biblical injunctions against women and harlotry.

The Cavaliers composed many tuneful satirical songs against their straight-lac'd adversaries – one of the best is the ballad *The Puritannickal Ladde*, whose half-willing paramour was more concerned that 'her peticotes were all myred' than with the sexual cavortions. The Roundheads also had bawdy songs, one of which advised lasses to go to bawds to get advice and experience to ensure that 'they did not give away their Love for nothing!' Thomas Prestwick's ballad *My Mistris is a Ladye* (1649) contrives to be pornographic by the repetition of the word 'cunt', not as a word of abuse, but as a word in common parlance.

The Four-legg'd Elder was a most popular anti-Puritan ballad, well worth the re-telling; each verse ends with the refrain:

Help! House of Commons, House of Peers
Oh! Now or never help!
Th' Assembly having sat four Years
Hath now brought forth a Whelp.

It is very long and funny but the two final verses will give the reader a good idea:

Then was shee brought to Newgate Jail
And there was nak'd stripp'd
They whipped her till the Cords did fall
As Dogges used to be whipt
Poor City Maids, shed many a tear
When shee was lash'd and bang'd
But had shee been a *Cavalier*
Surely shee had been hang'd!

Her's was but Fornicacian found
For whiche shee felt the lash:
But his was buggery presum'd
Therefore they hanged SWASH.
What will become of Bishops then?
Or Independency?
For now we have both Dogges and Men
Stand for the Presbytery.

Although derided, proscribed and periodically flushed-out by zealous Puritans, brothels continued to flourish all through the Commonwealth period. A few examples must suffice; the indictments had to be carefully vetted because it was not unknown for spiteful persons to allege that someone was keeping a bawdy-house. In July 1646 William Leader, Judith Faulkner and Virgen Turner were sentenced to prison for maliciously alleging that the Hon. Mr Digby had kept a bawdy-house and had ravished his maid – in another time they might well have been hanged. The next case is unusual; in June 1652, Mary Neale, commonly called the *Queen of Morocco* was taken in a bawdy-house – 'shee is a suspected Whoare and wears riche Cloathes & cannot give good accompte how shee cometh by them or how shee gets her Livings ... shee says her Mother's name was Stuart and shee lives in Moorefeildes'. The sobriquet Queen of Morocco was usually given to a dark-skinned woman – all coloured people were then called Moors – but Stuart was clearly untrue; it was not then a popular surname! Another unusual case was that of Mary Reason on 9 June: she was a servant in Mrs Susan King's house 'had men drawn into her mistress' house, being a Bawdy-house ... sent away because shee hath the Poxe.' It was ORDERED shee be sent to Bridewell'. This is curious because there were no facilities for curing venereal diseases in Bridewell,

The Poultry Compter in Cheapside, with Love Lane, near the Guildhall,
this stood in a brothel area from 'tyme out of mynde'

unless the frequent lashing of her back was thought to drive away the disease?

On 12 June 1652 the Headborough at Ratcliffe charged John Greene with keeping 'a notorious Disorderly House ... by keeping Wenches to stand at his Dore to beckon in Flemminges and other lewd Persons ... where Bawdery is suspected.' This brings to mind the references in the City of London's courts in the Middle Ages stigmatizing 'ffrensshman, fflemmings and Piccardes' as a generic term for all randy foreigners lusting to corrupt innocent true-blue blonde English maidens. Nevertheless in Commonwealth days there were many foreign bawds managing London's brothels and enjoying high esteem for their expertise.

In August 1652 occurs the only recorded case where a woman was executed for a sexual offence: this was Ursula Powell, 'wife' to Robert Powell, sentenced to be hanged for whoredom with a man unknown. She pleaded clemency as she was pregnant, and was examined by a Jury of Matrons. After the baby was born, she was 'Hung for Adultery'; the case caused a furore, but the woman was dead.

About this time a new name for Bawds was coined – 'Nappers'. In summer 1653 'A Napper named James Stuart employed lewd women to take gentlemen to Adam Wallis his house to be nappt'. One Richard Sawson of St Martin le Grand also kept a napping-house.

Some of the offences uncovered by vigilant Puritans were really heinous. Many men and women living in Cripplegate Ward 'lived incontinently'; and Christopher Waters, a 'Musitioner' in Rosemary Lane 'weav'd drunkenly and loosely from alehouse to alehouse ... leading the Watch to Jane Foxe's house wherein 'menie men and women were discovered in lewd postures!' When Mrs Elizabeth Dunbar's two pimps were arrested she was found later that night in the cellar 'in a verie uncivil posture'; what time Marie Miller of St Katherine's Dock 'a lewd woman living by her own hand ... was found dancing at Midnight with a Gentleman'. What a gentleman was doing in a rough dockside area is remarkable, since he could have got these pleasures much nearer home – however '*De gustibus ...*'

In January 1653 Christina Adams was indicted 'ffor knowing Men carnally' but was granted a conditional pardon by the Lord Protector, Oliver Cromwell himself. Two pimps, described uniquely as 'Seductioners', John Singleton and Mary Meggs were still operating in 1662 when their names are noted in *The Wand'ring Whore*.

Nevertheless, when Cromwell died, bawdy-houses were still

flourishing: in 1658 Henry Marsh published a chapbook, *The Craftie Whore: or, The Mistery & Iniquitie of Bawdy-houses Laid Open*:

> They were houses full of Rogues, Plumers, Filers & Cloaktwitchers, and Warehouses for all Thefts and Fellons … designed to … save the Whores the labour of caterwauling at Midnight under the Bulks or at the Corners of streetes, with a large *White Apron* … and often to bee found … in an old poor tottering House in the Suburbes … in which she practises … as an *Astrologer* or *Cunny-woman*.

The White Apron had been the sign of an ambulant prostitute for centuries and was to remain so until the end of the eighteenth century.

After Cromwell's death in September 1658 the floodgates of whoredom opened wide – about this time the saying was coined 'Its a Poor Kin that has neither Whore nor Thief in it!'

But despite all its shortcomings the Commonwealth inculcated greater humanity when dealing with female 'crimes' and misdemeanours; juries became reluctant to impose death sentences – indeed as early as the reign of James I juries had granted females the right to plead 'benefit of Clergy' in cases of simple larceny of goods under ten shillings in value – many juries reduced charges of grand larceny to simple larceny just to avoid death or harsh penalties. This trend had accelerated when the *Jurors for the King* were replaced by *Jurors of the Keepers of the Liberties under the Authority of Parliament* in 1640, and later when Oliver Cromwell's name was inserted as Lord Protector. This trend became more pronounced when juries consistently refused to pass verdicts of guilty in cases of fornication, which meant hanging. (Ursula Powell was in fact hanged for Adultery – not Fornication.) Many women were saved by jurors' common sense – one such lucky one was to be Damaris Page.

There were some anomalies. Murder of a wife was only a hanging offence: to murder one's husband meant burning at the stake. The Puritans equated adultery with theft, since a wife was her husband's property! For divorce a simple declaration before the congregation was all that was necessary; marriage was still a matter of 'common law'. The issue of marriage licences had been a growth industry from 1636 – it was a status symbol, which only the wealthy could afford. The cost of the licence varied from ten shillings in York to 3/6d in Norwich.

The Puritans enunciated the doctrine of a wife's rights as a helpmeet, although of course subordinate to her husband – they favoured marriage for love, with freedom of choice: there were of course dissenters. The Quakers advocated complete liberty in

marriage – to whom they Love, neither Birth nor Portion should hinder the Match! – small wonder Quakers were not popular. Wife-beating now became an offence and it was actionable to call a woman a whore or denigrate her with some adverse sexual phrase. For lesser offences there were many pillories and stocks and at strategic places there were Cages. (A stocks is still to be seen in St Leonard's churchyard in Shoreditch.)

3 The Haunts of Proletarian Bawdry

The population of London at the time of the first two Stuarts was estimated at about 400,000; by then the extra-mural suburbs had been incorporated under easily recognized names; for example Farringdon Without (outside the old walls), Cripplegate Without and Bishopsgate Without. There were still some Liberties wherein bawds and prostitutes retained some protection against the law of London – sometimes it was to nobody's interest to disturb them because a City oligarch – an Alderman or even a Sheriff (and upon one occasion a Lord Mayor!) or a Guild – owned or had a share in a brothel.

Dozens of sleazy alleys existed – choking with dust when dry and impassable when wet. Sanitation was almost non-existent and the sanitary habits of the inhabitants likewise primitive – as late as 1647 in the parish of Cow Cross in Farringdon: 'divers Persons dwellynge in severall allies do dayly brynge their Nyght-soyle and other unfitt Excrements and lay theym in the open streetes to the grete comon Annoyaunce of the Dwellers and Passers-by.' Family chamber-pots and *schyttynge-pans* were emptied into the *kennel* (channel) in the middle of the street – a hazard to passers-by – and none of these alleys were paved.

An excellent guide to the locations of the numerous whorehouses is in the ballad *The Merrie-Mans Resolution* (1640), wherein a young countryman reluctantly leaving London's fleshpots samples every red-light district. He starts by bidding 'Farewell to St Giles that standeth in the feildes' – the Liberty of St Giles (now Tottenham Court Road and Oxford Street) then at the very furthest perimeter, well away from the City of London's interference.

'And farewell to Turnbul-street, for that no Comfort yeildes' – this ancient centre of prostitution runs parallel to Farringdon Street into Clerkenwell Green. It was then a tree-lined avenue with fine mansions and gardens running down to the River Fleet. When, after about 1690, the river had degenerated into a foul

Cheapside before the Great Fire. Here, on the right, stood the
graphically named Bordhawelane and Gropecuntlane, and also the
Poultry Compter

sewer, the grandees departed and the houses became low-class brothels – to be described as a 'Turnbull Whore' was a terrible insult – even actionable.

Our ballad hero, *The Merrie-Man*, bids farewell in sequence to Long Acre, Drury Lane and Common Garden (Covent Garden) and to nearby *Sodom* 'with all her paynted Drabbes', the site of today's Kingsway. Sodom was aptly named – it was a self-generating colony of every kind of law-breaking, rough and tough. A century later when it was known as Seven Dials, troops had to be sent in to break-up resistance of brutal denizens. Dog and Bitch Lane ran off Drury Lane and as late as 1722 was called 'A Nest of Strumpetts'. Sam Pepys diarized 'an abundance of loose women at the doors' but eschewed them because he did not want to risk a dose of the pox.

In nearby Thieving Lane, Mrs Ross, Nell Gwyn's 'tutoress', had her brothel and taught that lovely little girl 'to serve strong drink' to the gentlemen. Then, pausing only for a couple of drinks, our *Merrie-Man* bids farewell to 'Shore Ditch and Moorfeildes eke also', introducing thereby the most ancient and venerable centres of whoredom in the land's history. In 1281 part of 'the more' included 'le Grube' – the ditch, later famous as Grub Street. The City's own red-light district was Gropecuntelane, from 1200 to 1400, off Cheapside.

There had been red-light districts in Aldersgate, Crepelgate (Cripplegate) St Martin's and Cokkeslane almost ever since the Romans had their garrisons thereabouts: indeed when in 1837 Moorgate Street was being driven through, a large stone *phallus* was discovered, which *vide Archaeologia* 25, p. 23, almost certainly marked the site of a Roman brothel.

Our hero now staggers to the working-class stewes in Ratcliffe Highway (originally Redcleeve, later Redcliff), passing Rosemary Lane where the Royal Mint now stands – it was called Hogg Lane in Queen Elizabeth's time; hard by East Smithfield, home of the infamous Mr Hammond's prick-office. He passes over London Bridge to the Bankside Stewes, noting the whores standing at many doors in Blackman Street – they chased him away – and then re-crossing London Bridge he ends:

Farewell! Luthner Ladies, for they have got the Poxe
Farewell the Cherry Garden – for evermore, Adue!

Lewkners Lane, named after Sir Lewis Lewknor, Master of Ceremonies to James the First was usually known as Dirty Lane; the fine houses being taken over by better-class bawds: Sir Roger

L'Estrange called it 'a Rendezvous and Nursery of Lewd Women' back to Cromwell's Roundheads. It is now Macklin Street.

At the other end of Lincoln's Inn lay Whetstone Park, described in 1722 as a 'receptacle for wanton Does' – the famous Mrs Creswell operated here at an early stage in her career. As late as Victorian times Lord Macaulay wrote: 'of Country Squires coming up to London and resorting to painted Women, the refuse of Lewknor's Lane and Whetstone Park [who] pass themselves off as Countesses!'

The Cherry Garden in St Martin's-in-the-Fields hard by Trafalgar Square, was run by the notorious Mother Cunny – there was a Mother Cunny in every generation, but this one secured maidens for the *crème de la crème* of the Court. She also owned the Black Swan of St Martins-le-Grand, but her principal 'house' was in Whetstone Park – a very discreet maison d'assignation.

A vivid description of Mother Cunny is given in Richard Head's account of a visit after a roistering evening in 1655, with his friend, Frank Kirkman, when they had exceptionally some money in their pockets. On arrival they were conducted and 'civilly welcomed by *Mother* Cunny'. After carefully assessing their clothes and personalities she led them upstairs to a 'large fair Dining Room hung with rich tapestries and adorned with excellent pictures of naked beauties'. A servant then brought in a bottle of wine and they picked out a girl from the pictures: a few minutes later a very beautiful person entered and after an exchange of compliments was told that if he wished to stay the night he must deposit ten gold pieces – ten guineas – and for every occasion of 'intimate congress' he could take back one piece: if he drew back all his money in one night he could 'be dismissed with applause'. Next morning he still had eight guineas and when he departed realized that he had met not 'the usual countrey Dirt' but a lady out for sport. In fact the ladies sized-up their clients through a peephole, and if she did not fancy the stud 'absented herself', leaving Mother Cunny to give one of her regular girls.

Mother Cunny explained that each house was furnished for a different type of client and 'the stock' carefully 'chosen properly for their accommodation', although the 'Lower Orders' – servants and pages also had to be served.

> as my House is well enough furnish'd to accommodate my ordinary Guests so I have severall [women] kept abroad who serve my Best Sort of Guests ... [especially] those who are so squeamish ... they will not see the one Face more than two or three times ...

with these a *Maidenhead* is a Great Dainty for which they will lay
out a great Expence for a quarter or a half-year in advance.

The prospective employee would be told she must not have any
dealings with more than three or four men in a twelvemonth and
only those 'who can maintain you in a brave Garb and Equipage
and you shall gain manie *Jewells* and good round sums of *Money*.'
Her expertise was noted in a broadsheet *The Lovinge Chambermaid*:

> The famous Patronesse of Whetstone will tell
> that shee can a *Maydenhead* thirty times sell!

She was still operating her string of whorehouses in 1661, earning
a mention in *The Wand'ring Whores*, but died soon thereafter
leaving an evil reputation as a slavedriver and a rapacious old
woman.

The *Merrie-Man* finishes his tour with rhapsody of Finsburie's
delights:

> In Cow Cross and at Smithfeile I have much Pleasure founde
> and Wenches, like to *fayeries* did often trace the Ground.

although what fairies one could find in the dreadful sleaze of
Turdshead Alley – Cowcross was the very pit of prostitution – the
last resort of the poorest and most indigent. (*Turdshead* was a
corruption of 'Turks Head' a name much favoured by pubs in
those days.)

The *Merrie-Man* seems to omit some extra 'delights'. There was
Saffron Hill, next to Hatton Garden, and Hockley i'the Hole
nearby, famed for its naked women wrestlers and bare-fist fights
at the cockpits and bearpits there. There was the Glasshouse,
actually the charterhouse, a Liberty from ancient times of the
Carthusian monks – it was a safe enclave for whores and
whoredom.

Most of these 'houses' were mere shacks – it would be a gross
exaggeration to think of them as real brothels – but in Turnmill
Street there were many alleys with tenements up to four stories
high, each room with its own occupant. Hence carnality was not a
comfortable enjoyment, although that was no bar to its expansion
and profitability – all that was needed was a free-spending public
and an understanding monarch. In 1660 both wishes were to be
fulfilled.

4 A Merrie Monarch,
Scandalous and Poor

Before 1660 there are few records of professional bawds by name or personal description, with the exception of Elizabeth Holland and Mother Cunny. With the advent of Charles II many more are noted, both those who served the Court and those who dealt with the public. The Court bawds were in the main aristocratic ladies who by choice or financial stress had become procuresses to serve their own kind.

The operations of Court bawds have been overshadowed in history books by the glamour of the royal whores – in this respect Charles II only followed a long line of royal lechers from Henry I. It was the lecherous Henry VIII who closed down the licensed brothels on Bankside, thereby giving a tremendous fillip to the establishment of private enterprises, which were still thriving in the time of the Lord Protector Cromwell.

Charles II is hailed as the 'liberator' of the English people, but in fact all those he liberated were those elements which found the restraints of Puritanism financially and morally irksome – the aristocracy, the City financiers and merchants and tradesmen and the aspiring middle class: it was also convenient that Protestantism encouraged mercantile expansion rather than religious conversion – Charles, a secret Catholic, found it convenient to be a Protestant. There was no liberation for the great mass of the common people – the very poor remained very poor and discriminated against as before. Their indigent women swarmed into the urban areas to earn money as servants to the new expanding middle class and also to engage in prostitution with the *nouveau riche* hangers-on; there was an expanding class of customers – the middle class.

This middle class had been enabled to build better houses with greater comforts: carpets replaced rushes on the floors, walls were covered with material or tapestry or adorned with pictures. Beds with mattresses had replaced straw, making connubial bliss

to be enjoyed in privacy and comfort – and for that matter extra marital copulation likewise.

The new class of housewives required maids and a cook and general servants, although the women and girls thus employed were often reduced to concubinage by randy masters and sons of the household. Pepys describes beating his servants when he was not trying to seduce them. These new houses were still surrounded by slums where could be found the mass of casual workers – sedan-chairmen or link-men or porters and messengers – and a great mass of beggars and criminals. Many substantial houses were rented out to bawds and prostitutes to command higher rentals – a situation attacked by writers like Thomas Dekker – such brothels could not but succeed.

The King's character was aptly summed up by the equally lecherous Earl of Rochester, a Court favourite who was very outspoken; he had the temerity to read his ballad to the King (and suffered temporary exile as a result). This poetry is not for the squeamish but its truth is unvarnished.

> I'n th' Isle of Britain, long since famous grown
> For breeding the best *Cunts* in Christendome
> There reigns, and Oh! long may he reign and thrive
> The easiest King and best-bred Man alive.
>
> Him no *Ambition* moves to get renown,
> Like the French Fool that wanders up and down
> Starving his People, hazarding his Crown.
> PEACE is his aim: his gentleness is such
> And LOVE he loves, for he loves fucking much.
>
> Nor are his high desires above his strength,
> His *Sceptre* and his *Prick* are of a length,
> And she may sway the one who plays with t'other
> And make him little wiser than his Brother.
> Poor *Prince*, thy Prick, like thy Buffoon at Court
> Will govern thee because it makes thee Sport.
>
> 'Tis sure the sauciest Prick that e'er did Swive
> The proudest peremptoriest Prick alive.
> Tho' Safety, Law, Religion, Life lay on't
> 'twould break through all to make way to *Cunt*.
>
> Restless he rolls about from Whore to Whore
> A Merry Monarch, scandalous and poor!

Charles was not particularly nice in his choice of paramours,

wandering from the most exquisite Court lady to the commonest street-walker; he would drop into a brothel occasionally or pick up one of the orange-girls at the theatre. With him it was fucking for fucking's sake – the reaction of a man suffering from satyriasis he had contempt for all those whom he had seduced. The roll-call is like Leporello's in *Don Giovanni*.

One of the first mentioned is Lady Crofts, foster-mother to Charles' bastard son by Lucy Walter, later James, Duke of Monmouth. She was mistress to the Duke of St Albans: of her John Dryden wrote:

> the ugliest whore makes the most able BAWD
> from Bawd to Stateswoman advanced.

although Lucy Walters was very badly treated even though her son was potential heir to the throne. Lady Mary Tudor was his daughter by Moll Davis, and she seems to have been a nymphomaniac, frequenting a high-class brothel near Berkeley Square.

More successful was the actress Elizabeth Jennings, who had three beautiful daughters but had to earn money by procuring. Of her Dryden had some lewd references in his *Satyre*, but she had the last laugh on her traducer. Her eldest daughter Frances eventually became wife to the Earl of Tyrconnel; the second married Viscount Rosse, becoming an ancestress of Lord Snowden, and the third, Sarah, married John Churchill who became Duke of Marlborough, and she became Queen Anne's bosom friend.

Another was Anne Temple, daughter to Sir John Temple – a Puritan. In 1674 Elkanah Settle, in his play *The Empress of Morocco*, makes a witch to sing:

> A Helthe! a Helthe! to Sister Temple
> Her Trade's chief Beauty and Exemple;
> She'll serve the *Gallant* or the Pimp, well!

But far and away the most versatile was Lady Jane Bennett whose outrageous actions created embarrassment to the Court even in that farouche age. Her title was genuine since she was the widow of Sir Richard Leeke, Bt., and a lady of considerable means. Indeed her conduct was so flagitious that when Sir Henry Bennett was offered the title of Lord Bennett he told the King: 'he could not have his own name to any title ... because he could not have to avoid opprobrium in his future lady's name ... Lady Bennett being too infamous.' (The King obliged him by making him Lord Arlington.)

Lady Bennett and the infamous noble gang known as the Ballers were involved in a bizarre incident when the gang were trying to import a rather precious item without paying customs duty.

> The Customs *Farmers* had seized a Box containing a Dozen Phallick Leather Instruments call'd *Dildos* ... Sir Charles Sedley and Lord Henry Saville [the King's boon companions] went down to the City to save the *dildoes* being destroyed only to be told that ... those filthy Things had been burnt without Mercy!

Samuel Butler immortalised this incident in his *Dildoides*:

> Twelve Dildoes – means for the support
> of aged Lechers of the Court –
> Were lately burnt by impious hands
> of Tradeing Rascals of the land –
> Who, envying their curious Frames
> expos'd those PRIAPUSES to the Flame!

With Lady Bennett we finish with Court Bawds and turn our attention to the well-known professionals who supplied nubile young ladies to the general public and to the nobility and gentry alike.

5 Panders to the Public

The list of non-Whitehall bawds is too vast to deal with in full – suffice it to say that, although many were quite well-known in their day, there is surprisingly little information about them: and the records of the various Courts become rather tedious in repetition.

Almost all of them had raised themselves from poor backgrounds, often as seduced maidens, then as ambulant whores or in a brothel, turning to procuring when their beauty had faded. The Earl of Rochester's letters and poems are very useful in sexual matters of his period.

> T'ENQUIRE for whores, the more the better
> Hunger makes anie Man a *Glutton*.
> If Roberts, Thomas, Mrs Dutton
> or anie other Baud of Note
> informs of a fresh petycote –
> Inquire I pray, with friendly care
> Where their respective Lodgings are!

Jane Roberts, a lovely good-natured young woman, was one of the King's short-term mistresses, quickly taken over by Rochester who seems to have had a real soft spot for her. With his help and that of his coterie she established a nice clientele, but unluckily caught syphilis from one of them and had to spend an agonizing time in the Leather Lane Mercury Baths – she died before she was thirty in the summer of 1679.

Nothing is known of Mrs Thomas, but she must have been of some consequence to have been singled-out by Rochester.

Mrs Dutton, however is better known. She was the daughter of Lord John Scudamore, who had first married one Russell, and, when he died, she married on 25 January 1662 William Dutton. Her father's status guaranteed her entry into Court circles, but there is otherwise no record of her bawdy services.

Patience Russell is quite something else; she is immortalized by

'A courtesan paramount', according to Lord Rochester. Patience Russell, regarded as one of the most beautiful women of her day, became the paramour of the notorious rake Rochester. Pictured here by Marcel Laroun

her portrait by Marcel Laroun when she was one of Mrs Cresswell's girls in 1670. She was not long a procuress – when Rochester died he left her £150 – a considerable sum in those days – without giving any reason for so doing.

Elizabeth – Betty, Morris is better known, being admired by some and reviled by many. In Rochester's a *Letter from Artemis to Chloe* (1674) he wrote

> Betty Morris had her City *Cokes* (dupes or simpletons)
> As woman, ne'er so minded, but she can
> Be still revenged on her un-doer – Man!
> How lost so'eer, shee finds some Lover more
> A lewd abandon'd Fool than she's a Whore.

Dryden calls her Bonny Bess in his *Tenth Satyre* (1675) and she is noted as a bawd in *The Wand'ring Whore*. She was a mistress to Sir Henry Bulkeley, Master of the King's Household and then became mistress to Lord Buckhurst who was Lord Chamberlain in 1678. She was a forceful young woman and once when in Court an envious rival called her Lord Buckley's Whore she riposted that 'she was only one man's whore and not promiscuous like her traducer!

The most notorious Procuress of all was *Mother* Moseley who had started her career in the reign of James I, when her husband was a footman to Lord Henry Holland and later became his coachman. In his satire *Timon* Lord Rochester compares him with the food served at Locket's eating house, in which he had been served with a portion of beef 'Hard as the Arse of Moseley, under which the coachman sweats'. Notwithstanding her husband's hard arse she had the *entrée* to the Court circles and was held in high esteem wherever it mattered. In *The Empress of Morocco*, the Witches Chorus after extolling the virtues of *Mothers* Temple, Temple, Cresswell, Bewley and Graydon, sing with gusto

> But of all the brisk Bawds 'tis *Moseley* for me:
> 'tis *Moseley* the Best in her Degree:
> She can serve from the Lord to the Squire and the Clown
> From a *Guinny* she'll fitt ye, to Half-a-Crown!

She is alleged to have carried out flagellations in her mansion. Sarah Moseley is thought to have died about 1675 'at a great age' but before she died she had launched another star into the bawdy firmament, Sue Willis.

In the satire *Against Mankind* is the panegyric:

SUE WILLIS has this Darling's Heart secured
He too, has her's – the Damsel is Insur'd
Two only by themselves to be indur'd.
This WHORE at first her life with MOSELEY led
The Bawd's least profit, not her Bully's bread.

Sue was a young and pretty actress in one of the playhouses, where she attracted the attention of Lord Thomas Culpeper – and became known as 'Culpeper's Whore'. She operated on the fringes of the Court and Rochester immortalized her in a ballad in 1660:

Against her Charms our Ballocks have
How weak all human skill is;
Since they can make a man a Slave
To such a Bitch as WILLIS.

Her LOOKS, damn'd impudent,
Ungainly, Beautiful:
Her MODESTY is Insolent
Her WIT both pert and dull.

Bawdy in thought, precise in Words
Ill-natur'd, tho' a WHORE
Her BELLY is a bag of Turds
And her Cunt a Common Shore.

This is manifestly a case of sour grapes, but nevertheless Lord Culpeper took her everywhere with him and they lived happily together for many years: she seems not to have been one of his majesty's 'ladies'. She is not heard of after 1690.

There were houses of assignment for thwarted ladies of the quality – one such was Potter's. In 1681 a satire *Utile Dulce* mentions:

I hear how Ladyes bred in Godly way
have oft of late be known to go astray
to POTTER'S.

John Evelyn remarked disgustedly that 'Ladies of Rank now frequent Taverns in which no courtezan would even set foot!', and the ex-Puritan, Sir Henry Blount, when young 'much addicted to wenches' noted an 'abominable pamphlet *The Parliament of Ladies* … with a dangerous doctrine that it was far safer and cheaper to lie with Comon Wenches than with Ladies of the Quality!'

Especial mention must be made of Elizabeth Bewley – Betty Bewley in common parlance – also Mother Buly or Beaulie, depending on the circumstances. She operated from dignified elegant premises in Durham Yard in the Strand. Her commodities were highly esteemed by visiting noblemen from the Continent: and it was noted that 'Men of God to Betty Bewley go!' There was a particular incident involving Charles Maurice Tellier, Archbishop of Rheims who had come to try out a marriage between the Dauphin of France and Lady Mary, daughter of the Duke of York. Archbishop Tellier had placed orders with Betty Bewley for a number of young ladies for his entourage, but had not paid for them: in consequence Betty 'sued the Right Reverend and Gracious Gentleman' for breach of contract, and this was when she was described as 'an olde Bawd'. The outcome is not known but assuredly no British bawd would ever trust a French priest again: perhaps more importantly, Betty had damaged the reputation of all those other men of God who usually repaired to brothels to taste forbidden fruits. The pinnacle of fame came with Elkanah Settle's eulogy in 1674 in *The Empress of Morocco*, when in plangent terms, the First Witch intones:

> A Helthe! a Helthe! to Bettie Bewley
> Tho' she began the Trade but newlie;
> Of Countrie Squires there's not a few lie.

The encomium is a little inaccurate, since she had been in the trade from about 1650 and she is listed in *The Wand'ring Whore'* in 1661 – although not in the Top Ten. She died on 20 January 1677, leaving an instruction that 'all her Plate, Jewells, Goodes & Chattles' should be sold and, after payment of all debts, held in trust for her young son George.

Another splendid rendezvous was run by Lady Elizabeth Southcott – sister to Sir John Buckling and widow of that Sir John Southcott who had invented the game of Cribbage and then hanged himself. After his death she moved from Bishopsgate to St Martin-in-the-Fields, and married the man who later became Bishop of Oxford, but when he died in 1635 she moved and kept a 'house' in Old Dunkirk Square (near Albemarle Street in Piccadilly) more convenient to the Court. She attracted a number of clergymen 'of High Estate' to her 'House of Ease'. In the year that she died, 1686, the lewd ballad *The Last Night's Ramble* warbled that 'only the lewd Quality fuck there!' In passing, the ballad detailed an argument between a rampant peer haggling with one of the girls, who, when offered a guinea, remarked that Sir William Rose always gave her five.

The same ballad mentions Graydons in St James Street, run by Robert Graydon, Gent., which competed with the same clientele. It was much used by Lady Mary Tudor, then Lady Ratcliff, as a place of assignation. This royal sprig was now married to Francis, Earl of Derwentwater, to whom she was constantly unfaithful. She was much in demand by those who fancied a 'royal fuck'. On this occasion other rakes such as the 'old griping' Richard Jones, Earl of Ranelagh, 'sweated and stank for one poor single bout!': and the next client, William Cavendish, Earl of Devonshire, was rebuked by the madam because he had bilked the 'maid' he had asked for – 'You never pay!' she complained, at which he stalked out in high dudgeon. Next to be announced was the 28-year-old Charles Montague, Duke of Manchester, when the madam accused him of 'stealing her best whore away!' which was bad form when not reimbursing the establishment. When he demurred she shouted:

Henceforth I'll watch your Lordship's waters
and bring you City Wives – but no more daughters.

While this argument was taking place, the Earl of Newburgh was asking for 'some fine thing; I am tired of fucking Quality!', so he was pacified with the wife of Judge Sir Francis Wythers. (There was a tenuous link with Sue Willis, because the widowed Lady Wythers married Sir Thomas Culpeper in 1704.) Her virginity had, seemingly, been restored sometime in between.

Another contemporary was the well-known Cuffley – Christian name or address never mentioned – one of Mrs Temple's girls who was taken up by Rochester. Rochester and some friends, when teenagers, had taken young Cuffley and another girl out, and in skylarking about 'had used them roughly' causing some injury. To make up for this, Rochester helped her build up a clientele and wrote a rave notice beginning, 'Cuffley, that whore paramount – her sex's Pride and Shame!' later describing 'her Powerful Cunt, whose very name kindles an amorous Flame!' By 1688 she was a well-established madam.

There was no shortage of fashionable bawds. 'Old Bess' Blundell owned three whorehouses in Dog and Bitch Yard off the Strand, as well as the Jacob's Well off Jewin Street in the City; on 25 July 1664 Pepys found the yard 'full of loathsome people and houses … and so went home!' On 4 July 1667 Pepys refers to 'a group of young lads plotting arson … in a Bawdy-house in Moor-fieldes called the Russia House … the mistress always seen in her shift.'

Mrs Frances Sands ran the Ragg'd Staff in Chiswell Street and

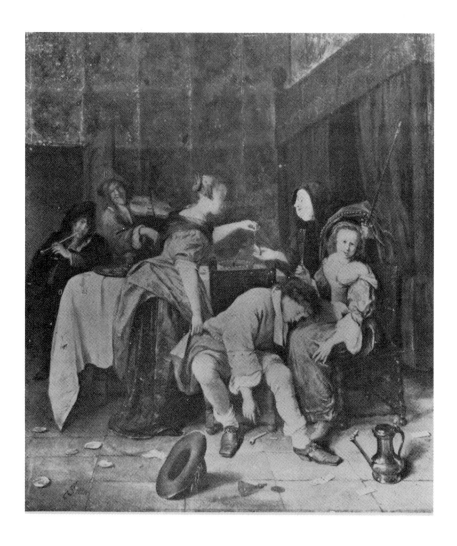

A robustly good-humoured scene of life in a mid-seventeenth-century brothel, depicted by Jan Steen (1626–79). Note the pipes and also the oyster shells – a traditional aphrodisiac

Mrs Habbiger the Turks Head in an alley off Grub Street, nearby. Westward Mrs Jones ran the Cock in Long Acre off Covent Garden, and eastwards Baud Paskins managed the Armitage (Hermitage) in Wapping High Street. There were, however, no hermits thereabouts at that period. Not too far away a Mrs Jones managed an outrageous brothel the Last and Lyon in the Liberty of East Smithfield. This was owned by a man named Hammond, and was better known as Hammond's Prick Office, for the disgusting and degrading behaviour therein. Nearby, Damaris Page was running her famous whorehouse for seamen, on the Ratcliff Highway.

In 1661, according to that useful vade-mecum, *The Wand'ring Whore*, there were a host of others, all well-known to John Garfield, the editor. There was Mrs Pope who kept a house in Petty France – in Moorfields: and not far away from Bedlam lunatic asylum, Mother Daniel kept the Gridiron as well as the Horseshoe in Beech Lane, in the Barbican. Mrs Tresley had a House in 'blomesburie' and kept two whores, Miss Jane and Mrs Louse (probably a misprint for Louise). Mrs Kirby kept the Red Robin and the Little John in Holborn.

Susan Lemmon, then an ambulant whore, was soon to graduate to ownership of the Castle in Moorfields and, together with Mrs Orange who lived in Bum Hill, Bunhill Fields – known to Rochester as *Oranges and Lemons*, were to reach a degree of fame for their extra-curricular activities. The ambulant whores were often described as 'poor lazy whores who fuck for necessity and not for pleasure'; there could not be much pleasure in serving the proletarians; the customers would wait in a queue outside or sit on benches inside and be called in turn by the madam or each girl as she finished her chore.

There was also the annual Cloth Fair, better known as Bartholomew Fair, which attracted people from far and wide: the broadsheet ballad *Room for Company at Bartholomew Fair* succinctly describes it:

Cutpurses and Cheaters and Bawdy-house Keepers
Punks, aye! and Panders and casheered Commanders
Alcumists and Peddlers, Whores, Bawds and Beggers
 In Bartholomew Fair.

In nearby Smithfield were many brothels in Duck [Duke] Street and the ancient 'assigned place' of Cock Lane as well as a multitude of tents set up as whorehouses. In his guise as Old Rowley, Charles II himself would copy Haroun al Rashid and ramble incognito. On one occasion Rochester and the Duchess of

Cleveland cozened him into a whorehouse in Hosier Lane, arranging to have his pocket picked while he was there. When the King finished his sport he found that he had no money – Rochester had departed! He asked the bawd to give him credit till next morning, but she naturally refused. The King pulled his ring off his finger and told her to take it to a jeweller – this she did with reluctance. When the jeweller arrived and examined the ring he gasped, 'There is only one man in the Kingdom who can afford this ring and that is the King himself!' He fell on his knees trembling with fear – and the bawd got worried too – she could be hanged for *lèse-majesté*. The King retained his bonhomie and all was well – but history does not tell us what he later said to his favourites. It was not his first or last visit to a brothel – he is known to have been a visitor to Mrs Cresswell's. The ambulant whores there were known as Bartholomew Babies – the ancient originals were gingerbread dollies – the poorest sort of whores whom only the guileless country bumpkins would copulate with. In 1707 Thomas D'Orfey's *Ancient Ballad of Bartholomew Fair* comments: 'at ev'ry Dore lies a Hagg or a Whore', making it clear that nothing had changed over several centuries.

6 Of Manners and Morals

Although there was a tremendous gulf between the Court and the commonalty, the flagrant examples of sexual and financial corruption set by the highest in the land could not be hidden from the lower orders.

Not only was the Court of Charles II vulgar in its behaviour, it was also vulgar in its speech. Even the 'well bred' King used many vulgar words and Lord Rochester's works mirrored the language and behaviour of his fellow courtiers.

This knowledge was now being spread by the numerous broadsheets, the first gossip publications, which by their nature reflected the common man's views, albeit that meant the views of the emergent Protestant middle class – there was no working-class press.

In such circumstances pornographic literature became popular. Most purported to be translations of foreign works such as Pietro Aretino's *Puttana Errante*, first published in 1534; the French equivalent reached England about 1600 in *L'Escholle des Filles*. These two publications appear frequently in contemporary writings, what time public imagination was stirred by the so-called *Postures* of Aretino – based on the erotic murals in the House of the Vetii in Pompeii. Albums of erotic pictures were exported from China to Europe as early as 1570. *La Puttana Errante* was published in English 'adapted for a colder climate' in 1661 by John Garfield under the title of *The Wand'ring Whore*. This was in fact a list of well-known whores, with a list of brothels and their madams thrown in and a few pimps included. *L'Escholle des Filles* was quite different. It was first published in Paris in 1655 by Michel Millet and Jean Ange as a dialogue between a sexually experienced young lady and her innocent teenage friend. It has some pretensions to elegance in speech – unlike the first English translation in 1658 entitled *The School of Venus* wherein the language is crude to the point of pornography.

The English booksellers quickly ran into trouble and were

harassed by the messengers sent out by the Official Licenser, then Roger L'Estrange: but what really estranged the Establishment were the opening words uttered by the knowledgeable young Fanny when asked by the innocent Katy, 'whether this Pleasure could be partaken of by others than Maids and Young Men?'

> All people of all Ranks and Degree participate therein even from the King to the cobbler, from the Queen to the kitchen-wench. In short, one half the world fucks the other.

The only words to survive the intervening centuries are the well-known prick and cunt – both stemming from Anglo-Saxon times and still in common usage. Both dropped out of ordinary speech when the middle-class began to gentrify the language in Victorian times.

Normal middle-class behaviour before the nineteenth century is exemplified by Samuel Pepys, who can be taken as the prototype of middle-class behaviour and language. He frequented whore-houses and ale-houses and sang the bawdy songs of his peers – a particular favourite was a ballad which contained the stanza 'Shitten-come-Shite the Way to Love is!' His sense of humour was lavatorial and his attitude towards the women who 'obliged' him was cavalier – he haggled over payment of the smallest sums.

The wonder is that with such off-hand promiscuity they were not all 'poxed up'; although the cundum had been invented, it was not generally used until the next century. Rochester himself wrote a panegyric and perhaps invented the name, as his mind was besotted with 'cunt' so that 'cun-dom' was something which dominated it.

One consequence of this frenzied licentiousness at Court and among the commonalty was an immense spread of venereal disease. Dryden affirms that the King got it from Lady Shrewsbury, and Louise de Querouaille constantly railed at Charles that he had given her syphilis.

Gonorrhoea was regarded as an acceptable hazard: Frazer, Pepys' doctor, 'was helping the Ladies at Court to slip their Calves and Great Men of their Claps!' Dr Florence Fourcade, a French chirurgeon skilled in venereal diseases, had been appointed by His Majesty 'to go post-haste to Newmarket to help out' in June 1675. More interesting is this doctor's connection with the mercury sweat baths in Leather Lane, in Holborn, run by Madame Fourcade for the cure of syphilis. Rochester's friend, Henry Saville, writing on 2 July 1678 'from a place from which one cannot expect much news' describes: 'the last act of a teddious

Course of Physicke against Syphilis ... had he known what tortures he would have been undergoing he would rather have turn'd Turk'. Whatever he had suffered was as nought to that endured by Jane Roberts – 'So farr beyond beleef ... it will make your Hayre stande on ende.' She died the following year, her charm and beauty utterly destroyed. Rochester himself spent some time there later for trouble with 'his Whore-pipe': the treatment was by mercury.

In the third issue of Garfield's *Wand'ring Whore* is a long list of bawds and about two hundred names of 'Common Whores' operating in the Clerkenwell, Finsbury, Moorfields and Shoreditch areas – comprising of course only those who had paid to have their names included. There was a third list of 'pickpockets & nightwalkers, Decoys, Hectors & Trapanners': all had been in business since his first issue in 1660. Garfield soon landed in Newgate for trying to dodge the fourpence licensing fee – someone had grassed on him to Mr Forrest the intelligencer, who thereupon raided and arrested a number of those who had advertised. While still in prison he published several booklets, one of which was *Strange & True Nevves from Jack-a-Newberries Six Windmills*, brazenly ascribing it to Peter Aretino, Cardinal at Rome – a gross libel on that Italian atheist. His main complaint was that 'the privat Whores have got the knack of itt'. Dozens of single-sheet lists were now circulating, although it is very doubtful if any ever paid the fourpence fee. In 1663, still in Newgate, he published *The Sixth Part of the Wand'ring Whore Reviv'd*, once more attributing it to Aretino but his imagination was now flagging. There is a mystery about No.5 of *The Wand'ring Whore*, which Garfield, still in Newgate, denied. Another was *The Wand'ring Whore's a Dice Rogue* of which no copy survives.

Another Queen of Morocco, a Mrs Honor, is mentioned and an ambulant whore Fair Rosamund Sugarcunt – who was still operating around the Law Courts some twenty years later! A bandstring-seller sold maidenheads – demonstrating that the legal fraternity preferred maidens – what Ivan Bloch later described as 'the defloration mania – an English Vice!' Maidenheads were frequently restored – astringents were known from earliest times.

7 Concerning Pimps and Ruffians

Pimping is as old as civilization: all over the east – even in modern China and 'third world' countries parents pimp for their daughters when indeed they have not sold them to prostitution beforehand – but in the Western world it has been officially frowned upon and, in Christian lands, regarded as a crime. None the less thousands of men have pimped for their wives and daughters just for food and drink – Cervantes and Francois Villon to name only two – under the stress of dire poverty. After the words procuress and bawd, the words pimp and pander are most evocative of an evil lifestyle.

The other sobriquet is ponce – which probably comes into English from the Portuguese *puncar* – to pounce upon or beat up: about 1690 there is an English pounce-shicer – a blackguard who preyed on actresses.

In Archbishop Aelfric's *Glossarium* (AD 1000), a pimp was just a 'cock-bawd' the female equivalent being a 'bawds-trott', which had the additional meaning of a procuress instead of the Roman 'lena' – a leftover from the Roman occupation. The word pimp occurs from Tudor times, probably from the French *pimper* – to seduce or procure. In old Rome the pandarus was the go-between in illicit amours and a recognized profession; in English this became panders and panderesses, this latter word dropping out of circulation quite early on.

In Tudor times the old Archdeacon John Louth of Nottingham, in one of his interminable sermons to the young Edward VI, referred to Archbishop Gardiner's appointment of Henry Frances as making him: 'Capteyn of the [Bankside] Stewes and alle the Whores there to belongyng ... indeed he prooved to bee an excellent *Cutter* and *Ruffyne*.' – the latter word meaning a pimp. It stems from the Italian and first appears in a poem of 1535 by Lorenzo Veniero *La Tariffa delle Puttane* (The Whores' Price List): 'but if you do not pay her, her Ruffian will cut your throat, or at least make sure that you'll be shoved in the clink until you've

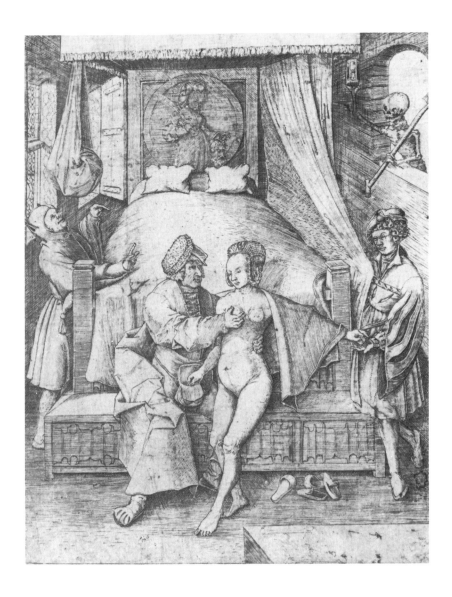

Testing the goods. As the whore filches money from her client's purse, and passes it to the brothel master, the figure of Death on the right looks on. An engraving by Lucas van Leyden

paid her.' The word in Italian being *ruffiano* – a pimp or bully-boy, as also *ruffiana* the female of the species, a procuress.

The hector appears about 1650 as a chucker-out in a brothel although at times the same ruffian is called a guzman – Spaniards then were regarded as being capable of any lowly post, even lookouts for highwaymen.

In the reign of Charles II noblemen pimped for the King when angling for position or favours, or pimped for lovely women who wished to enter the royal bed. Pepys mentions on 15 December 1662 that Sir Charles Berkeley pimped for Barbara Palmer (later Lady Castlemaine). In January 1668 he records that Thomas Howard, Earl of Berkshire, 'hath got Moll Davis for the King' – she was reputed to be Howard's illegitimate daughter. Elsewhere Pepys alleges that his boss, Lord Brounker, 'was pimping for the King'. In all these cases they were currying favour for their own fortunes and influence at Court.

During the whole of the seventeenth century women were their father's chattels, until they married when they became their husband's chattel. Wealthy little girls were 'sold' into marriage by the age of nine. The daughters of poor peasantry were often sold to travelling bawds: bawds met the wagons coming in from the country and enticed the young maidens into the whorehouses or street prostitution.

The number of 'natural' prostitutes in every generation is very small, likewise the number of real nymphomaniacs. In the main, prostitution is based on economic pressure – for every harlot sitting in comparative safety in a brothel, there were a thousand females whose only 'commodity' was their vagina, which they had often to surrender for a few pence for a meal. Starvation is worse than death, Christian injunction to the contrary. Hence many a woman was compelled to accept the smallest return from a 'customer' equally as indigent if 'he had the brimstone in his Britches'. If she went into a brothel she had a roof over her head and food in her belly – the cost was loss of freedom.

If a woman decided 'to go it alone' money had at once to be found for room rent and incidental expenses including bribes to constables – and later to magistrates; she would be overcharged on her rent and on everything she bought from unscrupulous shop-keepers, and she would face bitter competition from the other women 'on the beat'. Sooner or later she would be compelled to have an agent to protect her and also to drum up business – the pimp was the commercial middleman, the fixer, the guard against troublesome customers and bilkers. His role was that of husband or lover, even, on occasion, avuncular or

paternal. He had also to 'square' the constables and the justices' clerks.

In 1671 the Middlesex Bench heard that constables and headboroughs not only failed to seek-out and apprehend bawdy-house keepers, but in Whetstone Park 'gave Countenance unto them and received Moneys from theym … at Dinner in the Bear Tavern many unseemly actions and passages passed between them the said Officers and the said lewd People.' Bribery was the normal insurance risk – the greater the status of whore or madam the higher the category to be squared. *Golden Ointment* had nothing to do with ophthalmology – it was palm-grease, to which jail-keepers were very partial.

Even so it was a risky business for the premises could be closed down at the whim of some jack-in-office from landlord to the sanitary officials. Moreover, there was the certainty of trouble on Shrove Tuesday when the annual apprentices' rampage allowed them to set fire to or pull down whore-houses: and towards the end of the seventeenth century there was the added hazard of the Society for the Reformation of Manners, a middle-class vigilante organization with snoopers proclaiming pure Christian morality – excluding Charity – but very hot against carnal copulation.

The pimp had to foresee all these hazards and see that his women were employed profitably with the least obstruction: since loose women do not keep office hours they had to be ready for business at all times to serve exigent gentlemen – a sick or drunken whore was a dead loss. He also had to protect her from priests and other nuisances who wanted to 'save her soul' – and during the Commonwealth to protect her against fervent Puritan fanatics intent upon physical injury. Because, in the main, these women were emotionally unstable, they tended to heavy drinking, wittingly or unwittingly encouraged by their customers as well as the pimp who got his rake-off from the innkeepers, but his duty was often overtaken by his cupidity. The strain on these women was terrible – they ran the risk of being robbed and beaten-up and even of being murdered; and there was the constant risk of venereal disease.

The glamorous consumptive harlot of grand opera bears no relation to the grim hopelessness of the Elizabethen or Jacobean whore, stricken with this fell disease, compounded by filthy and insanitary living conditions in slum alleys. The average life was only thirty years, most dying in abject poverty. One of the pimp's duties was to have a *phisitian* or *chirurgeon* handy for a speedy abortion, although this was usually done casually by some friendly midwives or, more often, a quack – of whom there were

hundreds preying on these poor souls.

Finally, the pimp would have to teach her how to get information for blackmail or tipping-off highway robbers. The famous Claude Duval, the king of gentlemen-highwaymen had as informant the well-known Mrs Maberley who kept a brothel the Hole-in-the-Wall in Chandos Street off the Strand, in which he was finally arrested. There was a riot when after his hanging at Tyburn his body was brought back there for burial in St Paul's Church in the Covent Garden Piazza.

The wonder is that, although these women knew that their pimps were mercenary parasites who could ditch them at any time, hundreds of women in every generation came to have affection for their pimps, supporting them in times of difficult circumstances – a number of such cases may be found in the *Newgate Calendar*. It is almost impossible to imagine how a woman, tired after coping with the vagaries of strange men, could find love and energy to copulate with their parasite.

However, most pimps throughout history were evil, heartless, vile creatures without any redeeming features – wretched men living off wretched women – many ended swinging from the hangman's rope at Tyburn, or dying early of disease or through murder. The most that can be said of them is that they were witnesses of the harsh struggle for bare existence – which renders futile all facile moral judgements from those sitting comfortably on the sidelines, and the host of futile laws and rules made by often rascally legislators or prurient priests.

Generally speaking the madams of the higher class brothels did not employ pimps – but they needed Hectors who doubled-up as wine-waiters and chuckers-out. Cases are known where madams married their Hectors or made them partners – sometimes voluntarily but more often to avoid blackmail or physical assault, as was the case of one of the most famous whoremistresses in King Charles' reign, Priss Fotheringham, whose contribution to London's bawdy history now demands attention.

8 Priscilla Fotheringham's Chuck Office

Priss Fotheringham's saga is one of the lowest depths of prostitution in its time. She was born about 1615, probably in Scotland, but first appears in the Middlesex Sessions Register on 8 July 1658 when, as Priscilla Carsewell 'late of St Martin's-in-the-Fields, Spinster', she was charged with the theft of some goods belonging to the widow Ellen Cragg on 2 June 1658, found guilty and sentenced to be hanged. Like her cell-mate Damaris Drye, she was lucky to escape hanging being granted a conditional pardon by the new Lord Protector, Oliver Cromwell's son Richard, in January 1659.

When and how she became involved with the Fotheringhams is unknown but many Scots had settled in London after the union of the two kingdoms, and one James Fotheringham, Gent., is mentioned in *The Index of London Inhabitants* for 1638 as living in Emperours Head Lane in the Ward of Cripplegate Without; he was a person of some consequence, being assessed at the considerable sum of four pounds – it would seem that his affluence derived from a dubious source.

According to the local registers a son, James, was born on 13 August 1650 and baptized at the church of St Martin-in-the-Fields. It then transpired that Anne ran a brothel in Cow Lane, off Cow Cross Street in nearby Finsbury, being known before her death *ante* 1661 as 'Old Bawd Fotheringham'. The son, Edmund, served his apprenticeship under his mother's excellent tutelage, but when and how he 'married' Priscilla cannot now be ascertained. He was not her first husband for, when she was released from Newgate Gaol in January 1659, she was in poor health from injuries inflicted on her by 'her rotten husband'. Edmund Fotheringham was probably her pimp to whom she was regarded as 'married' although her first 'husband' was still alive in 1663. Clearly it seems that Fotheringham was younger than she, so it was most likely a *mariage de convenance*.

As a young girl Priss was known as 'a Cat-eyed Gypsy …

pleasing to the Eye in her trick'd up Finery', but early on she had become scarred by smallpox which was endemic between 1640 and 1660, the effects of which were worsened by the efforts of Hercules Pawlett – a watchmaker of dubious repute who practised as a medical quack. (He also practised mayhem, for in 1670 he was charged with robbery and luckily found not guilty, thus escaping hanging.)

As if this were not enough her husband had 'befrench'd her and pockified her Bones soundly!' – given her a dose of gonorrhoea in addition to beating her. Wearying of this treatment she had run away with a halberdier from nearby Artillery Fields in Bunhill Row. 'Shee tooke with her as muche money and goods as she could conveniently lay her hands on', but after she had spent every penny on her paramour he deserted her, leaving her penniless, so she had perforce to return 'to her rotten husband, Rotten in Soul and Rotten with Syphilis.'

On her release from Newgate Priss is next heard of as the madam of the Six Windmills, 'an ale-howse of ill-repute next to the windmill formerly known as the Jack a Newbury in the Upper Fields'. Then, *vide* Garfield, 'The Sign staid up ... until the Fruits of some abhominal Practices compelled them to take it down for fear of the multitude of the Apprentices, as if the alteration of the Signe of the Six Windmills had changed the Nature of these Vultures ... This House hath undone more Yongsters than half the Houses in the Citie'. It was quite common to have brothels and taverns with the same name in the same neighbourhood: in Moorfields alone there were four Chequers in their alleys, three Turks' Heads also in their alleys and even another Jack a Newberry at the corner with Chiswell Street.

The danger from the Shrovetide ravages of the Apprentices was very real. In 1617 Shrovetide, 'the 'Prentices ... or the unruly people of the *Sub-urbes* had caused greate Disorders ... pulling down *Bawdy-Houses* ... in ffinsburie ffieldes they brake open the Prison and lett oute all the prisoners.'

Priss Fotheringham's 'abhominable Practice' was an arcane survival of an ancient Roman form of fornication whereby the whore stood upside down with her legs spread wide apart, allowing customers to throw coins into her vagina – this was known in English as 'chucking' and as a money-spinner it had no equal. It was, however, an accomplishment which required considerable gymnastic agility – although the customers usually obliged by holding her legs: such practitioners were always in great demand, especially at 'stag' parties.

Chucking was thought to be rather un-British by most British

bawds – an Aretinian perversion – although this may have just been professional jealousy. It was bruited about that Priss, when she played the whore, could perform this entertainment many times a day: 'in her early days Priss stood upon her head with naked breech and belly while four cully-rumpers chuck'd in sixteen half-Crowns into her Commoditie.'

Small wonder that the Six Windmills attracted a clientele from far and wide and was immensely profitable. The chuck-office must have been operating from Jack a'Newburies from about 1650, because by 1655 the 'much-pockified' Priss had ceased to be an active whore because of her many disabilities – she probably trained fresh talent. In John Garfield's chapbook *Strange and True Newes from Jack-a-Newberries Six Windmills* the sub-title was: 'the unparrallelled Practices of Priss FOTHERINGHAM her Whores, Hectors & Cully-Rumpers, in their Manner of LIVINGE and erecting a Half-Crown CHUCK-OFFICE.' A half-Crown in those days was about a week's wages for a skilled artisan, which ruled-out the *hoi polloi*.

In the first three issues of *The Wand'ring Whore* in 1660, Priss is ranked with Damarose Page in the list of bawds: Garfield also mentions a well-known whore named Mrs Cupid – the Dutchwoman who performed this ceremony one evening:

> When French Dollars, Spanish Pistoles and English Half-Crowns were chucked [in] as plentifully as Rhenish Wine into the Dutch Wenches two holes [but] ... the Half-Crowns chuck'd into her Commoditie did lesser harm than the Rhenish wine ... differing from the Sack pour'd in by such Cullies as at Priss Fotheringham.'

Mr Cupid, who had condoned his wife's peccadilloes, was an honest working man; but Mrs Cupid shared Fair Rosamund's pimp: Fair Rosamund Sugarcunt was in great demand in legal circles.

The above incident prompted Garfield to exclaim that 'A Cunny is the Deerest piece of Flesh in the World!' He also states that Priss met Damarose Page and Elizabeth Cresswell when all were in Newgate, and there the three ladies discussed a sort of bawds' union on the lines of the famous Venetian courtesans' guild. Undoubtedly in those days there was some sort of liaison between the various bawds in London – Garfield indeed sets out a set of rules, which although a 'cod' undoubtedly bore a substratum of truth.

All the subscribers were to pay 'Twelve Pence apiece for maintaining and reserving a skillfull & peculiar Chirurgeon always in residence for Patching and Clarifying our Wenches'.

Elegantly attired Venetian courtesans await
customers on their balcony. Sixteenth-century
painting by Vittore Carpaccio

This was already the case in the higher class brothels. There were a large number of French and Dutch Quacks who preyed on whores in particular, extolling their nostrums for contraception, abortions, restoring virginities and curing venereal diseases – Priss had already suffered at Pawlett's hands! Many of these scoundrels disappeared as soon as they had amassed a modest fortune.

At that time there was also a very well-known Frenchwoman, Madame Agnodice, who kept the Hand and Urinall in Moorfields – there was another called the Ape and Urinall – the urinal in those days being a hand-held receptacle used in hospitals – and since the streets had no numbers a sign always gave an indication of what was being offered there – in this case more or less a chemists' shop. (The original Greek Agnodike had been compelled to cut off her hair and dress like a man, the Athenian magistrates allowing her to practise because she was a great beauty.)

Mme Agnodice was a beautician offering: 'Exotic Italian washes … to remove Blemishes … a speciality the *Spanish Roll* to conceal pock-marks and a specific against Venereal disease based on Herbs when Venus was bitten by a Scorpion.' Garfield then narrates the sufferings of a 'pittifull whore … Crooked Cunt, the Cheesemonger's Daughter who went to a Hannum for a Cure!' (Fifty years later there were hannums in Covent Garden which were little better than whorehouses.) There is also a reference to a 'Pegoes Nightcap made of Leather' as well as a 'Venus' Pocket Pistol', from the context referring to early cundums – but they were not efficacious because 'they could not check still corrupt and incurable diseases'.

The proposed organization should also have a *Scrivener* to read, write and compose whores' letters – most were illiterate: many used a scrivener's house under cover of making a bond – bawds often lent money to their girls against a bond guaranteeing repayment – it was also a device to blackmail or ruin a 'deserter' because it was enforceable, and non-payment meant jail. Sue Lemmon was to be the secretary.

One important matter alleged to have been discussed was that the chuck-office speciality should be linked with another bizarre outfit at the Last & Lyon, in East Smithfield run by one Hammond, whose speciality was fellatio – it was also known as the Prick Office. Hammond employed a number of women whose introductory qualification was that 'everie one of them must buss the end of his Trapstick … as he lies naked uppon his bed with his *Tarse* standing upwards'. This same sexual therapy was available to all his customers – this too was felt to be somewhat un-English.

It is the only mention of fellatio to be found in contemporary ballads and chapbooks.

There was to be a barber whose job was depilation 'according to the Spanish mode of shaving-off the Haires of the Wenches commodities'. In 1653 those in Drewery [Drury] Lane had a

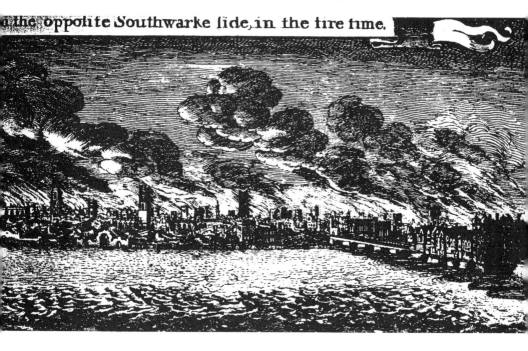

An engraving of the Great Fire of London in 1666 by Wenzel Hollar (1607). The plague and fire forced many a respectable bawd to change her business address

particular moral code – if a married woman gave a dose of the clap to a neighbour's husband they would whip her and shave off her pubic hair in public, to demonstrate that she was a whore. An official limner (painter) was to be appointed – their function was that 'the principal Beauties should have their pictures taken, as well as their Faces!' He was also to paint Aretinian Scenes such as 'Prick in Cunt' to adorn the walls of the Six Windmills as an aid to the customers' endeavours.

In 1663 Garfield remarks that Priss was now 'overgrown with Age and Overworn with her former all-too-frequent Embraces'; her husband on the point of death 'rotten with syphilis' – he died later in that year. Business was badly affected by the onset of the bubonic plague in 1665 when St Giles: 'was full of noisome alleys

& the stinke of stifled buyldynges whose unsavourie Breath with sultrie Venom cloyes the verie Jaws of Death.' This was further adulterated by the immense dunghill in Finsbury Fields, which fouled all the waterways, runnels and ditches. In St Giles' Ward alone in three months, 'Six thousand six hundred and forty men women and children perished … the wealthy inhabitants, including the Vicar Dr Giles Prilcott all fled.' However it was said that the common prostitutes in the back streets were scarcely even struck; three hundred years earlier, the Black Death was prevented by congress with a whore.

Priss survived all this, as well as the dreadful student ravage in 1668 at Shrovetide, dying soon afterwards. Her encomium was that: 'in the Practice & Proficiency of her Profession shee hath outdone & outstript the oldest Beldam in Mens' memory … her epitaph stating "A Cunny is the deerest Peice of Flesh in the World!" '

9 Damaris Page:
'The Great Bawd of the Seamen'

Priss Fotheringham's former cell-mate is one of the most interesting characters in the history of British bawdry. Damaris – sometimes Damarose – Page, whose exertions earned the support of James, Duke of York – later James II – obtained the sobriquet 'The Great Bawd of the Seamen'. She was very lucky to have had any history at all.

Damaris Addersell was born in Stepney about 1620. The details of her early life as a prostitute in Clerkenwell are unknown, but by 1658 she had graduated to being a bawd-cum-midwife-cum-abortionist. She allegedly married on 1 October 1640 a man named William Baker – of whom nothing is known: but on 18 April 1653, describing herself as a spinster, she married James Drye at St Mary Magdalen church, Bermondsey.

She enters history on 7 October 1655, when she was indicted at the Clerkenwell Sessions 'for bigamously & feloniously marrying James Drye', but her plea of not guilty was sustained by the magistrate because her 'marriage' to Baker had not been sanctified: in this indictment she was described as 'Damaris Addersell *otherwise* Baker *otherwise* Drye'. It then transpired that bigamy was the lesser misdemeanour for on the same day she was charged: 'Damaris Baker, spinster, wife of William Baker also known as Damaris Drye wife of James Drye, did on February 25 1655 in Stepney assault Eleanor Pooley wife to Stephen Pooley, shee being with child, with an instrument from whiche the said Eleanor died on March 31st 1655.' The instrument was described as 'a Forke or Prong with two tines' which shee had thrust into Eleanor's belley about four and a half inches'. This being an unsuccessful abortion, the charge was reduced to manslaughter, for which she was found guilty and sentenced to be hanged.

She pleaded clemency on the grounds that she was pregnant and, after being examined by a panel of matrons, she was found to be with child – a stillborn child was born in Newgate. She was

A Strange and True

CONFERENCE

Between two Notorious Bawds,

DAMAROSE PAGE

AND

PRIS. FOTHERINGHAM,

During their Imprifonment and lying
together in *Newgate*:

With the

Neweft ORDER and CUSTOMS of
the *Half-crown Chuck-Office,*
And the OFFICERS thereunto belonging.

VVith the practice of the *Prick-office.*

By *Megg. Spenser*, Over-feer of the
VVhores and Hectors on the
BANK-SIDE.

Printed in the Year 1660.

Contemporary pamphlet, supposedly recording the conversation of those notorious bawds Damaris Page and Priss Fotheringham concerning the 'half-crown chuck-office' and 'the practice of the prick-office'

still in Newgate when on 12 January 1659 her plea for a conditional pardon was granted by the Lord Protector, then Richard Cromwell. She was released from jail soon afterwards.

In the records of the Middlesex Sessions of 10 October 1655 she is charged as 'Damaris Page *alias* etc., etc.,'. There was an Oliver John Page of Ratcliffe who, in December 1654, had been indicted 'for keepynge an alehouse of incontinency'; he had been sentenced *in absentia* for robbery and mayhem with a reward of £10 for his apprehension. He was probably a partner or perhaps her pimp – he does not appear again.

Damaris appears in a contemporary tract of about 1650, *The Man in the Moon* which was 'agin sin' and states:

> How the Cobler, a Brownist who formerly prattled oute of the Nags Heade taverne in Coleman Street and was buried in the Highway neare the Aniseed Cleare was seen at Damaris Pages house in the Ratcliffe Highway the last week: where he is turn'd Tapster & fills her Black-pots of Bawdy-ale for the Mobbs and Gullies that are the Comon Ingineers for the maintenance of her Fortifications: since whiche time the Coblers of the Great Bedlam frequent her House often, and have an intent to erect a weekly Clubb.

It seems peculiar that any Brownist – the Puritans of Puritanism – could contemplate a whore-house as a place for a club, unless it was to have been undercover in a time of persecution. The Great Bedlam is clearly the City of London, and the Brownists were being persecuted for their beliefs and as plotters against the State.

From about 1650 Damaris operated from premises on the Ratcliffe Highway, then described as being 'broad and lined with trees on both sides with a number of houses fronting upon the Thames'. (There had undoubtedly been brothels along this stretch of the river since the first Roman galleys landed their legions at Londinium).

As early as 1617 the Apprentices in a Shrovetide rampage had: 'pull'd down seven or eight houses & defac'd five times as manie … attacking and maiming the prostitutes … one of theym was that of Joan Wilson, [who had already been indicted in 1614] for kepynge an alehowse of incontinence … kepynge wenches to stande at her Door to beckon in Flemyngs and other lewd Persons.' Most of the inhabitants of that area were drawn from the poorest elements of society, often unmarried because church weddings were beyond their means, so that men and women shared bed and a roof without any religious qualms.

Pepys often visited Ratcliff on his way to the dockyards and

records on one visit how he 'was struck with a looseness of the bowels … dashed into a tavern and did give a groat [four pence] for a pot of ale and there I did shit!' (He did it in the fireplace.)

Most of these women were not professional harpies, but the wives of men who had been pressganged: at first they would meet ships in the hope of seeing their men again, but as time went by they lost hope, and needing money to live had no other recourse but prostitution.

Ratcliffe was also strategically placed for the importation of women for prostitution, including Flemish bawds, who were known over the centuries for their expertise; in King Charles' day Venetian women were imported for their skills for the upper classes. Contrariwise there was an excellent export market for blonde blue-eyed English maidens, much esteemed in the Mediterranean area.

In the course of these attempts to establish the Common Market, Mistress Page – she was never called Mother Page – came to amass considerable property and wealth. During her absences in Newgate the estimable Mr Drye carried on; but her predominance in the bawdy field earned her a fine mention in *The Wand'ring Whore* heading the list of prominent bawds. The fact that the inhabitants of Ratcliffe were staunch supporters of the Commonwealth, for political as well as commercial freedom, did not affect her business, perhaps because too many of their own women perforce plied the trade. However, for sailors of rank she had another premises in Rosemary Lane, much nearer the City and of easy access to the Court: hence her sobriquet 'The Great Bawd of the Seamen'.

She was also involved in the importation of exotic Venetian courtesans whom she hired or 'sold' to other bawds. There was much talk of the guild of Venetian whores but in fact there was no such organization – the Venetian Republic licensed all bawds and whores, regulating their behaviour and taxing their incomes at rates varying between eight and ten per cent: pimps and bribes took away another ten per cent of their earnings – but the most glamorous had their protectors, giving them wealth, prestige and security. They did have some sort of sorority to alleviate hardship.

The imported Venetian women were very expensive, so that only the most wealthy and very influential bawds could afford to launch them into Society – the rich and jaded and exigent courtiers. They were advertised as being fully accomplished in all Aretinian practices. A sample (spoof) tariff is given in Garfield, but there is a solid stratum of truth.

Summa Totalis & Bill of Charges

FOR	Broaching a Belly unwemmed and unbored	£1.0.0
ITEM	For the Magdalena's Fee	10.0
ITEM	For the Hectors Fee	2.6
ITEM	For providing a fine Hollands Smock	10.0
ITEM	For Dressing, Perfuming & Painting	5.0
ITEM	For occupying the most convenient Room	5.0
ITEM	For Bottles of Wine	£1.0.0
ITEM	For Pickled Oysters, Anchoves, Olives	10.0
ITEM	For Sweet Meats, Sugar-cakes, Peaches, Walnuts	10.0
ITEM	For Musicke	£1.0.0

Summa Totalis £5.12.6d

Note that the courtesan's own fee is not included: it would certainly have been at least £5 if not more – the Hollands Smock, much prized, was a present. This was of course the top end of the market: at the Ratcliffe Highway end it was quite different.

Three or four girls would be on duty, taking each man as he came in, giving the shortest time for his small fee; this is epitomized by the bawd's remark at the end of the Venetian session: 'This is none of your pittifull Sneak-byes and Raskals that will offer a sturdy Cunt but eighteen Pence or Two Shillings, and repent them of the Business afterwards!'

There was a contemporary remark that 'The French-pox is nothing amongst friends', but it led to the corollary 'No Mony? No cure!' At Ratcliffe, VD was an inconvenience to the client and an acceptable risk to the bawd – the girl could be thrown out or limited to the next few customers. Fresh girls were obtainable without difficulty.

The chuck-office technique would have been useless in the Ratcliffe Highway – the seamen and dockers and the like were prone to pop in and enjoy their copulations quickly and cheaply. (Today the crowns and florins are chucked into the maw of one-armed bandits – although not so pleasurable nor diverting.)

In the midst of all this jollity and prosperity the Shrovetide rampage on 24 March 1668 was more of a revolt than a demonstration, compounded by the extremely bad economic plight of the poor contrasted with the extravaganzas at the Court – all the King's whores were papists and all troubles could be laid at their door. Pepys said that at Whitehall: 'there was much talk about the apprentices taking the liberty of the Holy Days to pull down brothels … one of the greatest grievances of the times.'

The troops were mustered, while the rampages went on all night; the rioters shouting slogans like 'Reformation and

Reducement ... which made the courtiers apprehensive because among the Rioters were manie Men of Understanding that have been of Cromwell's Army!' (Ten years after his death, Cromwell's name still provoked fear in aristocratic breasts.) By daylight, says Pepys, 'a great manie brothels had been destroyed or damaged, and amongst others, 'that belonging to Daman Page, the Great Bawd of the Seamen: and the Duke of York complained merrily that he had lost two tenants by their houses being pulled down, who paid for their Wine Licences fifteen pound the Year!' The Duke of York at that time had a 'Perk' in these licences; but there was no need for him to worry because the bawdy houses would very quickly be back in business. (It would be interesting to know how many other bawdy-houses were holders of His Highness' licences.)

A week after this disaster Mrs Page was involved in the famous *Petition of the Poor Prostitutes about the Town whose Houses had been pull'd down the other Day*, which was addressed to Barbara, Lady Castlemaine, who was then the King's favourite concubine. Pepys reported that 'she was horribly vex'd at the Libell ... because the Petition was not verie Witty ... was Devilishly severe against her and the King!'

There were in fact clashes between the rioting students and the troops, but it was quickly over and the Court and its whores could breathe again. However, the rampage had affected Damaris Page's health; just before she had been released from Newgate in 1659 she had shown signs of ill-health and of turning to religion, making a prophetic remark that: 'she would not go on building new Houses with what she earned by being a common *Hackney Jade* and now the Oldest Bawd, lest they be burned down.' Her qualms stopped short of closing her house, so she would keep it 'as long as it would last because *Money and Cunny are the Best Commodities!*'

Despite her pessimisms about being ruined she left a very handsome estate, dying peacefully in her own bed in her own house in Ratcliffe on 8 September 1669 leaving a will in her name as Damarose Drye, *widdow*. After commending her Soul 'to God who hath in His Great Mercy blest & endow'd me ... with a considerable Temporall Estate withal', she asked to be 'decently interred in the new Parrish Church at Ratcliff' (This church has long disappeared under the combined operations of a great fire in the eighteenth century and the Great Blitz by Hitler on docklands in World War II so that even its exact location is not now known, much less Damaris's grave.)

She made no mention of children in her will, but gave an

annuity of ten pounds to her sister Margaret Poole 'while shee stayed a Widdowe ... the Money to be paid out of the rents', and on her death to Christopher Lowman and Elizabeth Wingfield, whose relationship is unknown. Because she was illiterate she signed 'with her mark' and probate was granted on 1 November 1669. She mentions, *inter alia*, 'my well beloved Friend, John Lowman, Gent., of St Georges, Southwark', who was also sole executor. (This man was a brothel-owner in Southwark.)

Clearly she saw, even on her death-bed, no ethical conflict between her Christian belief and the pursuit of flesh-peddling.

10 Elizabeth Cresswell's Saga

She is Born Well

England's history is studded with the names of beautiful and illustrious harlots who influenced her rulers directly or indirectly in the conduct of the affairs of the nation, but very rare are the instances where a professional bawd has been involved in the national politics as a politician. It is a profession which requires a real knowledge of mens' weaknesses and hence a well-concealed contempt for them, in particular aristocrats and politicians. In Elizabeth Cresswell's own words: 'If Privy Councillors, Judges, Aldermen, Doctors, Dukes, Lords Colonels Knights and Squires may be made into Beasts by stupid Jades, how thinkest thou such Cullies can be handled by Women of Sense and understanding!'

Such bawds had shed any illusions they may ever have had because they knew, to quote Mrs Cresswell again: 'A man will pay as for a Dutchess, yett all the while he embraces in reality a common Strumpette!'

Many such bawds survived into old age, retiring with considerable wealth, then craving respectability. To this end they professed religion and, where possible, the lawful wedded state, so that their children could be brought up unaware of the source of their wealth and education: and where possible with neighbours who were unaware of their past: hence they eschewed politics and its consequent publicity – they wanted no spotlight on their past.

Elizabeth Cresswell's professional life took her from small-time prostitution to become an internationally known procuress, making her very rich. It brought her renown in the political sphere and a certain interest by Royalty, putting her in the public eye as much for her profession as for her politicking. In all this she was guided by another axiom, 'With all Men without distinction you must dissemble and cheat.' When she departed from these fundamental principles, she came near total ruin.

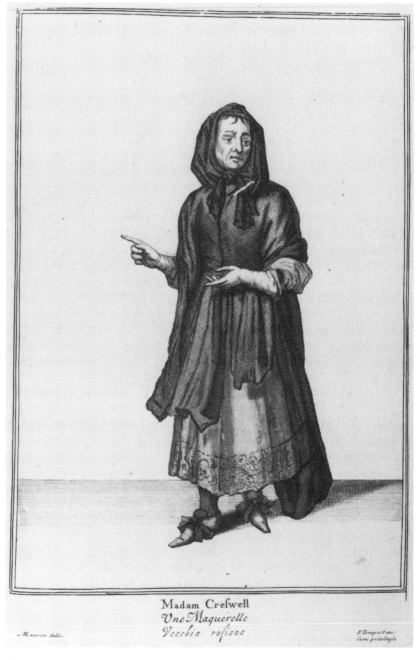

Madam Creſwell
Vne Maquerelle
Vecchia ruſiana

M. auron delin: *P Tempeſt ex:
cum privilegio*

'She Lived well, she died well, in Bridewell.' Mother Cresswell, most
famous of the Jacobean bawds, painted by Marcel Laroun

Elizabeth came from a respectable Protestant family. So far as can be ascertained she was born in the village of Knockholt, near Tonbridge in Kent, in about 1625. Shortly afterwards her parents moved to Camberwell, then a salubrious country place with a few fine houses, on the main road to London and only about two miles from that lively exciting place, the Bankside pleasure haunts. It would seem that Robert Cresswell, Gent., of Grays Inn, a property-owner in Leigh, just outside Tonbridge married the maiden Anne Gourlay at St James', Clerkenwell, on 14 June 1607. Their son Robert, 'Citizen and Merchant Taylor' residing in the parish of St Botolphs, Aldgate, married one Isabella Oram in October 1625, and they had a little daughter, Elizabeth. She was reported to have been a lovely little girl with great charm and attraction who – for some unexplained reason – very early on became a prostitute operating in the districts of Aldersgate, Clerkenwell and Shoreditch. When she was first indicted in July 1658 she was already a bawd. She was then described as a spinster, but when the case came up again in the following February she is described as 'a Widdow'; since there is no record of a marriage or death – he was probably a common-law 'husband'. A grandfather who was a gentleman of Grays Inn and a father who was a liveryman of a famous City of London guild, provided an excellent background for a procuress seeking a high-class clientele.

At this time the centre of bawdry had moved from Bankside to the Liberties of Clerkenwell and Cripplegate Without, stretching as far as St Leonard's in Shoreditch. Then, 'when her beauty was beginning to fade', she so used her fascination to corrupt the innocence of others as to be considered 'a Bawd without rival in her Wickedness!' and also 'an adept in all the diabolical Arts of seduction.'

Success made her a little careless, and in July 1658 she came up before the magistrates in Hicks Hall, where the Constable, one John Marshall, testified: 'Elizabeth Cresswell living in Bartholomew Close was found with divers Gentlemen and women in her House at divers times. Some of the Women were sent to Bridewell'.

Elizabeth made the cardinal error of trying to bribe this constable 'with four pieces of Gold … to forbeare to disgrace her or her House'. He proved to be that rare creature, an incorruptible, Puritan constable. It is to be noted that the gentlemen found on the premises were not punished; perhaps the size of the bribe influenced the justices' clerk, since no more is heard of this matter.

She heeded this warning and moved her headquarters a couple of miles away to St Leonard's, Shoreditch, but here too the goings-on disturbed the neighbours. The following October she came up before the Westminster Bench where there were a large number of 'hostile informants ... all on Oath' testifying:

> THAT Elizabeth Cresswell *alias* Cresworth, late of St Bartholomew the Great and now of the parish of St Leonard's Shoreditch ... did entertain in her House divers loose persons, Men and Women, suspected to have committed bawdry ... AND THAT the said Elizabeth having lately taken the Lease of a House ... in Shoreditch for which shee paid One Hundred Pounds for the Fine and at a rent of Forty Pounds per annum whereunto many Persons well-habited have resorted by Nyght as by Daye and have continued there Drinking, Ranting, Dancing, Revelling, Swearing and much demeaning Themselves as well upon the Lord's Day and Fast Fays ... and the said Elizabeth refused to give admittance to the Constables and Headboroughs ... into her House.

She must have relied upon the presence of the 'Well-habited Persons' to have refused admittance to the constables, who later testified:

> Couples have severall times been seen ... a Man and Woman onlie at a time, the Woman being strip't to her Bodeys & Petycote going into a Room ... where they have shutt the Casement & lockt the Dore ... THAT upon the Lord's Day at noon some Company drunke about a Dozen bottles of Wine AND FURTHER that divers women suspected of Lightnesse have been observed to declyne the Way to the House at the fore-gate when some Neighbours lookt on.

Indecent behaviour was also noted when: 'at the same tyme and in that Places, in the Habitt of a Gentlewoman [one of the whores] began to propose a Helthe to the Privy Member of a Gentleman and in their Presence afterwards dranke the like Toast to her own Private Parts'. As a result many persons of good repute were ready to remove their 'habitations and their Daughters & Maid Servants ... they being often taken for Whoares by the men who frequent the House'.

'All thinges considered', the magistrates sent Elizabeth to the house of correction 'sett to hard Labour until next Sessions ... provided shee was well enough to undergo itt.' Several securities for good behaviour were also required. (In later years her 'hacking cough' was constantly referred to in contemporary news.) In any case 'Golden Ointment' ensured favourable

treatment in emergencies. When brought before the magistrates in February 1659 she was again sent to prison and quickly released – she was then described as 'a widdow'. That the inhabitants of Shoreditch should raise such a hullabaloo is remarkable, since it was not a genteel neighbourhood by any means; as early as 1613 a mob of throwsters had pulled down a brothel there belonging to Mother Leake, next to Shoreditch Church.

Meanwhile, in the great world outside these events, there had been tremendous changes. Oliver Cromwell died in September 1658; his son Richard briefly succeeded him as Lord Protector to make way in April 1660 to Charles II: the times were now most propitious for bawdry. At this time, Mrs Cresswell was operating from a house in Whetstone Park (Lincoln's Inn Fields) whence 'shee sold strong waters and fresh-fac'd wenches to all who had Guineas to buy them with'; but her principal residence was in Back Alley in Moorfields – off Grub Street, in which there were then several very fine mansions.

A first-hand description of Mrs Cresswell is given in 1665 by Richard Head – rakehell son of a London chaplain; a part-time confidence trickster and general ne'er do well who was sent down from Oxford in 1663. He was an incorrigible wencher. One day he and another friend found themselves with some gold in their pockets and decided to celebrate their narrow escape from jail; thereupon they went to Mother Cresswell's 'formerly famous for the good Citizens' wives who frequented her house'. She still 'rode Admiral over all other bawds about the Town', with 'working utensils of refined metal always neatly kept.'

They were conducted into a large handsome room, and a manservant brought them some bottles of French wine and 'salt meats' as appetisers. Then Mrs Cresswell came in and greeted them – even chucking Richard under the chin and calling him 'smock-face' because his complexion was so smooth. He described her as 'an old Matron' – she was only about forty-five. When she had seen the colour of their money she sent in a 'very nice young girl who engaged in a little badinage, "touching his needle", but she was too expensive. The next girl was one of 'Venus' chief Darlings', so he did not bargain but went into the bedroom where she explained that 'she was a girl of superior education accustomed to serving only Persons of Quality'; her price was a guinea but they closed the deal at half-a-guinea. This was a house catering for middle-class lechers: it was 'the thing' to go, after a meal in a tavern, to a brothel, apeing the aristocracy. Small wonder then that middle-class wives feared catching

venereal disease from their husbands, and small wonder that bawds like Cresswell made fortunes from this new class of client.

Under the tolerant eye of the Merry Monarch the gulf between rich and poor began to widen giving rise to the quip that 'poor whores are whipt while rich ones ride in Coaches.'

By 1668 Mrs Cresswell was riding very high. She was also emotionally involved with the City Chamberlain, Sir Thomas Player, MP, and, through him, deeply involved in politics. She and her establishments had survived both the Great Plague and the Great Fire of 1665 and 1666 – but it was the latter which affected her most because of the huge number of citizens who fled into the Moor Fields. A contemporary description refers to: 'the Citizens who from delicateness & easy accommodations in stately and well-furnish'd homes are now reduc'd to extremest poverty & miseries.'

The next record of Mrs Cresswell is as the principal protagonist of the rights of all bawds and whores after the Shrovetide ravages of the 'prentices in 1668. This near rebellion had inflicted great physical and psychological injury on the host of poor prostitutes: it also unsettled the great mass of proletarian elements aggravated by reckless profligate spending in the Court and the immense waste of public monies through embezzlement and graft. Such minimum services as existed were deprived of funds – even the soldiers and the sailors were often unpaid. A particular target for public resentment was Barbara Palmer, Viscountess Castlemaine, whose senseless extravagances shocked even Pepys – the resentment fuelled by the fact that she was also a Catholic.

It is useful to follow the balladry of that period. First there was *The Poor Whores' Complaint to the Apprentices of London*, in which they complain in grief-stricken terms that their present distress is so great that they can find no rest anywhere. Their rents are great, their clients have deserted them and they are all forsaken: but nobody pities them and 'ev'ry *Shag-rag*' casts stones at them. They are hungry, their clothes are in rags – and, on top of all this misery, they are pox'd-up with syphilitic sores. The Dutch and French Quacks 'have now run away at the first sign of trouble.'

Then follows *The Poor Whores' Petition to the Apprentices*, referring to the bloody events of Shrove Tuesday 'when hooligans and trouble-makers got together … when little boys would prove the first to vent their fury on poor frail sinners, and Apprentices made themselves Plaintiffs, Judges and Juries'. In conclusion, they ask the apprentices – themselves oppressed – why they did such things to these poor downtrodden women.

The poor whores receive an apology in *The Prentices's Answer*.

They were not the hooligans, it was 'the scum of a rude multitude who had done damage in the apprentices' name … and would as lief pull down their houses'; the apprentices 'scorn to plunder robb or steal.'

The unexpected result of this uproar was the catapulting of Mrs Cresswell into the limelight, giving her and her profession a boost into the national sphere. The immediate cause was the widespread distribution of 'a seditious pamphlett' – *The Poor Whores' Petition to Lady Castlemaine* – a cry from the poor London whores to the great royal whore. The author is thought to have been John Evelyn, who detested the beautiful Barbara, but it was issued in the joint names of Elizabeth Cresswell and Damaris Page, the recognized leaders of bawdry. It is certain that neither woman had any hand in the authorship, but equally certain that the speedy and widespread distribution was done by their handmaidens. This petition was headed:

THE POOR-WHORES PETITION to the Most Splendid Illustrious Serene & Eminent Lady of Pleasure, the Countess of CASTLEMAINE etc., the HUMBLE PETITION of the Undone Company of poore distress'd Whores, Bawds, Pimps & Panders etc

It asked for help since Lady Castlemaine had had great experience in the practice of whoring and had arrived thereby to 'Great Estate and Position'. It was signed, 'In the behalf of our Sisters & Fellow-sufferers in this Day of our Calamity' and there follows the list of every principal centre of whoredom in London: 'Dog & Bitch Yard, Lukenors' Lane, Saffron Hill, Moorfields, Chiswell Street, Rosemary Lane, Nightingale Lane, Ratcliffe Highway, Well-Close Church Lane, East Smithfield &c. 25th Day of March 1668.'

Angry at this high-flown parody, Barbara importuned the King to discover and deal with the perpetrators – the author was never found, but it was clearly someone close to the Court.

Mrs Cresswell's own post-Shrovetide adversity did not last very long. She was particularly good at spotting 'rising beauties' and decoying many an innocent – and not so innocent – village maiden to London. Indeed that great connoisseur of sex, Lord Rochester, paid tribute to her in this sphere. Her spies and emissaries not only went throughout the kingdom but also into France and the Netherlands in search of suitable goods – and information. The Chevalier Phileas de Chasles records:

His Majesty Charles II personally honoured her with his Presence and deigned to inspect the House which she managed … he saw

that she had established a sound organization which administered a network of Emissaries and Spies in England ... as well as France.

Elizabeth had a *pied-à-terre* in Whitehall, employing a couple of nubile young 'secretaries' to advise and arrange despatch of suitable ladies to exigent sexual experts there, safe from interruption by constables and bailiffs or unpleasant importuning by creditors. She maintained separate establishments for different clienteles. One such was a house of assignation for lustful wives and daughters of City bigwigs to meet equally lustful gentlemen – her friendship with the City Chamberlain stood her in good stead. Another residence served the pseudo-ladies known as 'ape-gentlewomen' who sought amorous dalliance for money but wished to be classed as amateurs – many operated at the Royal Exchange in the City – the milieu of rich brokers and merchants. They were on Mrs Creswell's private register, particularly when some exigent customer demanded a virgin. A fresh young woman who did not look like a professional could pass at least as little used.

The *modus operandi* was a private circular that 'she had a fresh face a-coming' – indeed such was the demand that the apprentice maidenhead would be auctioned, 'by Inch of Candle, he always carrying it that most bids for it, be he Turk or Jew'. This would have been good news for Turks and Jews since the penalty for miscegenation with Christian whores had been death in a variety of dreadful ways since Edward I's Ordinance of 1290. On the other hand, few Turkish Mohammedans were then in England; there may have been a few *marranos* – Spanish or Portuguese Jews who had adopted the cloak of Christianity (there were a few in England in Henry VIII's time) – but in 1653 Oliver Cromwell had revoked all such ordinances and even 'endenizon'd' a handful.

Mrs Cresswell also had an agency for supplying concubines, usually from the ranks of 'ape-gentlewomen' or 'town misses' or 'countesses of the Exchange', the latter operating from Gresham's Royal Exchange – vulgarly known as 'side-pillows' serving as surrogate wives. Of these it was sung: 'They master your Britches and take all your Ritches!', but these dealt only with two or three men 'desirous of buying her Commodity'. Such women were also known variously as 'A Gallant's Business', 'A Citizen's Recreation', 'A Doctor's Necessary Experiment', 'A Parson's Comfortable Importance', or 'A Lawyer's Estate-in-fee-Entail'.

Many of these girls could in truth assert that they were of good family, ruined in the Civil War – these would tend to go only with men of quality. Mrs Cresswell's ploy was that part of their

earnings would be sent to their fathers 'so he could spend his days quietly hunting.'

She Lives Well

Between 1670 and 1680 Mrs Cresswell's wealth and influence grew apace, and her intimacy with Sir Thomas Player became so close that he was nicknamed Sir Thomas Cresswell. He had inherited the office of chamberlain from his father in November 1672, the family being rich property owners in Hackney. His infatuation is noted in a contemporary Roxburgh ballad: 'Old Player's grown rampant! pick'd up with a Woman!' He was popularly known as the 'Railing Rabshakeh' for his constant roaring in argument. He frequently visited Mrs Cresswell in her country mansion in Camberwell, from time to time giving stupendous parties for political cronies, which often turned into sexual orgies. In a contemporary political ballad *Oates Boarding School in Camberwell*, a fund-raising party for Titus Oates, there is the following description:

> There shall all provision be made
> To entertain the Best.
> Old Mother Cresswell of our Trade
> For to rub-down our Guest:
> Three hundred of the briskest Dames
> In Park or Fields e'er fell
> Whose am'rous Eyes shall charm the Flames
> Of the Saints at Camberwell.

The references are to her houses in Whetstone Park and Moorfields, but the important point is that Sir Thomas was using public funds to support the ineffable Oates. It was a well-established precedent for the City to mobilize its 'daughters' to entertain foreign worthies. Mrs Cresswell remarked that some of the guests 'wore Cloakes of Geneva cut' – a euphemism for Puritan clients.

'At Gifford's, Creswel's and elsewhere, where precise Damsels doe appear', according to the play *Gallantry à la Mode* (1674), Mother Cresswell always stressed: 'Costlie Cloathes & Riche Furnishinges advance the Profitt & Advantage ... for the Price of the Vendibles notably encreases when dispensed in a Splendid Magnificent shoppe ... just as in other Trades.' She opined that the really wealthy customer 'lookes onlie for the best Commodities whiche can then be solde at the deerest Rates.'

In the same year Elkanah Settle's farce *The Empress of Morocco* – a parody on Macbeth – first appeared. In the epilogue, Hecate and the other witches sang:

A Helthe! a Helthe! to Mother Cresswell
From Moorfieldes fled to Millbanke Castle
Shee puts off in a rotten new-rigg'd Vessel.

Millbanke Castle was a nickname for the palace of Whitehall, and the verse validates the existence of an establishment within the Court.

It is at about this time that things began to go wrong. Sir Thomas had thrown his influence to support the legitimation of Charles's bastard son, James, Duke of Monmouth, a Protestant, on whom Charles 'doated'. This angered the Duke of York, the rabid Catholic heir. Sir Thomas' support for Titus Oates also put him in deep water, and in Mrs Cresswell's debt. Philosophizing one day on 'the terrible punishments inflicted by ignorant bawling scurrilous drunken sweep-kennels [politicians and judges] upon frail women', she urged the women to become more artful: 'in every particular a Man can be outdone by an animal; the Horse is swifter, the Ox is stronger, the Goatte is more salacious.' True love was a luxury a whore could not afford: 'If Fortune deserts a Man, then the Whore must desert him too. A Whore is a Whore! shee is not a Woman!'

While riding high she forgot some of her own basic principles. Prosperity and influence went to her head – she sometimes called herself Lady Cresswell and made a great play about her staunch religious beliefs as a pillar of orthodox Anglicanism. On the other hand, she said, 'a facade of piety was a basic business principle', and she enjoined her maidens 'to develop a double portion of hypocrisy.'

In the end it was Titus Oates who brought about her downfall, when he inconveniently uncovered the Popish Plot, hounding many innocent people to death or beggary and dreadful anxiety. There was a suspicion that Cresswell's had harboured the scoundrelly double-agent provocateur Captain Thomas Dangerfield, who was wont 'to adjourn to the house of Mother Cresswell the noted bagnio keeper'. He was a frequent visitor there, and put the dagger in when he testified that 'Jesuitt Priestes frequently used this notorious establishment.'

Dangerfield was the *chèr ami* of Elizabeth Cellier, a well-known and respected midwife who had attended the Duchess of York; a kind-hearted woman who visited the poor and those who languished in prison. She made no distinction in the religion of

the persons she treated. Pregnant women were supposed to be kept apart, and from 1618 reprieved from death until the child was born – then they were hanged. Cromwell changed all that and usually gave them a general pardon.

Mrs Cellier made the dreadful error of falling in love with Dangerfield, becoming a Catholic in January 1679 and embracing her new religion with great fervour. Dangerfield requited her love and devotion by villainously involving her in his activities, of which she was quite unaware. He instigated a raid by intelligence officers, who found in her cellar a meal-tub (a bran tub) with some papers purporting to be a plot to overthrow King Charles and the restoration of the Catholic religion. She was then to become known as the 'Popish Midwife'. Not until Dangerfield's activities were unmasked was she freed and acquitted of all charges on 11 June 1680 – the King then expressed his admiration for her steadfastness and courage.

In the course of this brouhaha she earned the enmity of Mrs Cresswell, who publicly attacked her on 18 September 1680 and intimated that she was a prostitute. From time immemorial houses of prostitution have been recognized places for plotting and espionage, if only because any man was welcome and no questions asked – except that in Christian lands any circumcized man was barred by law. After enduring many vicissitudes she had the satisfaction of witnessing Mrs Cresswell's decline and the discomfiture of all her enemies.

She Dies Well

When the hubbub of the meal-tub plot had died down, Mrs Cresswell's business was still flourishing, and she was still very rich. Captain Bedloe and Richard Head both attest to the comfort and elegance of the furnishings and food and drink at her Whetstone Park house as well as enthusing over the ladies they enjoyed there. Mrs Cresswell also claimed that there was always a Bible at hand, and she was at pains to insist that 'Aretinian Postures' were not permitted, *vide* Thomas D'Urfey:

> I'm for the Orthodox Plain manner
> Nor will put Popish Tricks uppon her
> Or with Italian methods treat her
> As if she were a four-legg'd Creature!

There is however a suggestion that flagellation was available to those who asked for it. In the ballad *A Narrative of the Old Plot* in

July 1684 there is a mention of 'flogging at Cresswell's in Camberwell.'

The beds, she insisted, must always be clean and tidy and all smells of whatever nature must be avoided – under the arms, from the genitals and the breath. The girls had to cultivate a gracious presence and cultured speech, and to eschew overmuch drinking, all swearing and ribaldry, and, above all, be careful not to get the pox. Each girl was to douche with a mixture of wine and vinegar or water if she had any doubt as to the client's cleanliness – there was however a resident 'phisitian' to deal with emergencies.

Mrs Cresswell's greatest expertise was in supplying virgins to exigent English noblemen. Dr Iwan Bloch calls this 'the English vice', but foreign worthies also demanded English damsels with this warranty. As for espionage, there is no better known way of worming-out state secrets than an infatuated VIP blurting out state secrets to his temporary inamorata. Mrs Cresswell knew all about virgins, pseudo-virgins and 'restored' virgins – no client would be disappointed.

Moreover, a bawd whose premises the King deigned to visit was bound to be patronized by his courtiers. One of these was Anthony Ashley-Cooper (later Lord Shaftesbury), a close confidante of His Majesty – he was also known as 'that lecherous Goat Antonio'. Thomas Otway in *Venice Preserv'd* (1682) damned him:

A Senator that keeps a Whore
In Venice, none a higher office bore:
To lewdness every Night he ran
Show me, all London, another such man!
Match him at Mother Cresswells if you can!

Shaftesbury was also known to be a bugger when he wanted a change.

In all her endeavours Mrs Cresswell had been helped and protected by her powerful friends at Court and, especially, in the City of London. Since 1661 she had not had a brush with the law; but in 1681 ominous clouds began to gather, proving that while money and cunny were good commodities, prostitution and politics are a dangerous mixture. The King's health was now failing, and he had, after all, decided that his brother, James, Duke of York – a rabid Catholic – was to succeed him. (Charles at the end reverted to Catholicism.) This shift angered large numbers of powerful Protestant interests, particularly in the City of London, who favoured the Protestant illegitimate son, the

Duke of Monmouth. Tumults occurred and insurrection threatened; one time James had stated 'I shall make no concessions! My Father made concessions and he was beheaded!'

In the forefront of the opposition was Sir Thomas Player, now a Member of Parliament, and a very powerful group of City magnates including the Lord Mayor and many aldermen. In February 1681 the rashly outspoken Player attacked the Duke of York saying that: 'The City would raise no more Money to pay the Whores at Whitehall [and certainly] not for an arbitrary Government … the Crown was at the disposal of the Commons, not the King.' The King then brought pressure on Sir Thomas in a number of ways, but had to move carefully, and this brought another pressure to bear on Sir Thomas.

Mrs Cresswell was one of the first to feel this cold draught. *The Impartial Protestant Mercury*, no. 64, of November 1681 reported that on the previous Tuesday:

> The famous Madam Cresswell was, on Tryall of *Nisi prius* at Westminster, convicted after above Thirty years practice of Bawdry … some of her Does most unkindly testifying against her.'

She was to be sentenced at the next session. The procedure was unusual.

Nisi prius was a writ in a civil action, ordering the sheriff to provide a jury for a judge in Assizes. Bawdry, however, was usually dealt with in a magistrates' court. It was a shrewd blow, aimed at her because she was one of the most powerful financial supporters with a steady cash flow. She remarked later: 'that a Malignant Jury had dispossessed her of her lovely Habitation … which I have many Years kept in Moorfields to the Joy and Comfort of the whole Amorous Republick.' There was no difficulty in getting her 'Does' to testify against her. She was a strict taskmistress, and they bore little gratitude towards their benefactress and protectress, knowing that while they were in prison, she could bribe her way out of trouble. *The Bridewell Whores' Resolution* (1660) moaned:

> Jenny and Betty do the Lash defy
> and swear they'll use the Trade untill they dye.

although they ended:

> Tho' Sorrows we know, let me tell ye
> To the Game we will never be slack
> Ye may make a good use of your Belley
> Tho' Lashes discomfort your Back!

The Bridevvel Whores resolutio

OR,
The Confeſſion of the Twenty Four Back-ſliders.

Jenny and *Betty* do the Laſh defie, | And ſwear they'l uſe their own without repentin
And ſwear they'l uſe the trade until they dye; | *Bridewell* afflicts their backs, but let me tell ye,
To them the Siſters all are now aſcenting, | They are not tormented below their belly.
 Tune of, *Tell me no more you love.* With Allowance. *Ro. L'Eſtra*

The ſorrows that I have known,
 to no Man I will relate;
For Men without ſhame are grown,
 and I curſe my unlucky fate;
We Women are chiefly ador'd,
 ſaith Jenny you know it is true;
We often by Men are imploy'd,
 to act what they'd have us do.

Then Jenny reply'd with a grace,
 the torments I have ſuffer'd to day,
In Bridewel this diſmal place,
 does fright me from what I could ſay.
Our backs they do ſcourge and laſh,
 and give us the name of a Whore;
But ſomething I'll ſtill and baſh
 although my poor back is ſore.

'Tis twenty to one but we'l live,
 in ſpight of our civil Trapans;
The Officers ſeign to give
 four Pipes, four Poggins, four Cans;
Then with a ſhort Staff they beguile,
 and to the next Juſtice they take us,
To forbear we do give them a Smile,
 but they Swear by great Oaths they wi
 (make u

Our Siſters here may complain,
 and I think here is twenty four;
But our ſorrows are all in vain,
 though we ſerve day and night each hour
Our Gallants now will not come near,
 leaſt they the ſame ſawce ſhould find;
They like not our Whipping here,
 yet privately ſwear they'l be kind.

Contemporary broadsheet depicting *The Bridewell Whores' Resolution, c.* 1640

Mrs Cresswell's enemies were cock-a-hoop. Sir Roger 'Crackfart' L'Estrange insinuated in his *Observateur* of October 1681 that her fervent Protestant principles were founded upon monies obtained from 'true Protestant concupiscence'. However, he was Mrs Cellier's intimate friend and 'inseparable Consort', so his bias is understandable.

Be that as it may, Mrs Cresswell was back in business again in 1682, but by this time the King had strengthened his position against Sir Thomas and his supporters, who lost much support when the King appointed a new Lord Mayor. This debacle was celebrated in John Oldham's *Satyres uppon Jesuittes* (1683):

> Presto Popola Pilkington
> Shit upon Sheriff Shute.
> Cuckolding Clayton no less ill …
> Sir Thomas has gone to Cresswell
> and Somebody has the Gout!

Gone were the days when Charles II would visit her establishment and everybody was respectful to her power. Sir Thomas' misfortunes were directly linked to her in a popular lampoon of 1683, *A Pasquil or Pasquinade: The Last Will & Testament of the Charters of London*, which purported to be a bequest to the Chamberlain of the City of London:

> TO SIR THOMAS PLAYER: I leave all the Manor of Moorfields with all the Wenches and Bawdy Houses thereunto belonging, with Mrs Cresswell for his immediate inheritance to enjoy and occupy from the Bawd to the Whores downward, at nineteen Shillings to the Pound cheaper than any other Person, because he may not exhaust the Chamber by paying Old Arrears nor embezzle the Stock by running new Scores.

Despite her attack on the 'malignant Jury', Mrs Cresswell admitted later, 'However my Enemies have been, they left me sufficient to support the small remainder of my dayes'; but the next blow was a demand for 'Three Hundred Pound' – a Bond for Sir Thomas' unpaid debt. Her financial position was then summed up (not quite accurately) in Nathanael Thompson's *Loyal Songs*:

> Bobbing about in Kent and Camberwell
> For which thy Stock lay waiting:
> Where's all that Money now? Can'st tell?
> If nott, thou'rt near to breaking.

The poem concludes with the phrase, 'Not being paid, the worn-out Cresswell's broke.' And so she was.

When next heard of, Mrs Cresswell was in the House of Correction or Bridewell, which is curious because for a civil offence (such as the non-payment of a bond) she should have been in Newgate or a debtors' prison. She probably hoped one of her old friends would bail her out, because in George Shell's *The Whores' Rhetorick* (1684) he affirms her *cri de coeur* 'that she still had worthy and Eminent Debtors ... who had been King's Lieutenants, Lord Mayors and Sherriffs of the City of London [and] some of them indeed made me but ingratefull Returns for all my Favours ... they would be juster in paying their Debts and more mindfull of their old Friend!' These were surely political debts and demonstrates how far she had departed from her avowed principle – 'never lend a Penny to a friend.'

She was by now an ailing woman; all contemporary accounts refer to her 'hacking cough', which may well have been consumption acquired in her early career as a prostitute. Consumption was a whore's occupational disease, the result of sojourning in damp and filthy houses of correction. In his *London Spy* (1707) Ned Ward described the horrors of Bridewell, inveighing particularly against the monstrous indecency and cruelty of public whippings on half-naked young women. Both administrators and keepers were cruel extortioners, and ill paid. For example, in January 1683: 'A Poore Woman and her Husbande' applied for the matronship of Bridewell, the salary being set at between forty and fifty pounds the year. It is implicit that any shortfall was made up of bribes for favours done and brutalities withheld.

However, wherever she was Mrs Cresswell was well able to alleviate her lot by bribery, although that could not alter the filthy surroundings, awful stenches and polluted atmosphere. By this time, about 1684, she would have been about sixty – then deemed very old.

She is generally reputed to have died in Bridewell but the exact date cannot be ascertained because the records are lost; but she is supposed to have reverted to a certain piety, as described in James Grainger's *Biography of England*:

> SHE DESIRED by her Will to have a sermon preach'd at her Funerall for which the Preacher was to have Ten Pounds; but only upon this express condition that he was to say no thing but was well of her.

There was some difficulty in getting someone to undertake this

task, but eventually one was found, who gave a general dissertation on mortality and then:

> By the Will of the Deceased it is expected that I should mention her and say nothing but Well of her. All that I shall say of her therefore is this. She was *born well*, she *liv'd well* and she *died well*, for she was born with the name Cresswell, she liv'd in Clerkenwell and she died in Bridewell.

To paraphrase Dr Johnson, even in a pre-lapidary encomium a priest is not upon oath and this would have been a splendid, fitting epitaph – except that most of her activities were in Moorfields and Whetstone Park, and her mansion in Camberwell surely deserved a mention. In any case, this pleasing story is unproven, and is probably based on John Merston's reference in *The Dutch Courtezan* (1625) to whores: 'tis moste certayne they must live well and dye well, since they most commonly live in Clearkenwell & dye in Bridewell'.

Probate of her Will was granted on 29 October 1689, wherein she asked to be buried in the parish church of Knockholt in Kent. She left a very considerable estate and substantial legacies, leaving much to the Percival family, who were her cousins; 'Twenty shillings to the poore of Knockholt', and a gold watch to her friend Margaret Clarke. Two of her girls, Anne and Jane ffranks, were allowed to pay off a debt of £100 in six-monthly instalments; and the residue of the estate was given to the small daughter, Mary Smale, of 'her kinsman John Smale of Knockholt', and all the monies left in trust for this child.

However she was not buried in Knockholt nor in Bridewell and her final resting place is unknown: but she was not soon forgotten. In 1684 George Shell, a personal acquaintance, published *The Whores' Rhetorick*, which is effectively a manual of instruction by Mrs Cresswell to aspirant bawds and whores. When it was reprinted in 1685 it bore the sub-title, 'Or Mrs Cresswell's Last Legacy'. There is also a mention of a book, '*La Vie de Maman Cresswell*' which is clearly a translation of an English original, though this cannot now be traced.

Mrs Cresswell merits a *niche* in English history, if only because she is the only bawd known to have meddled in the highest politics.

11 From the Monastick Bigot to Phlegmatick William

James II's path to the throne had not been easy, especially after he turned Catholic for his marriage with Mary of Modena in 1674, an act which made it expedient for him to 'retire' to Holland in 1679 to ride-out the anti-popery campaign. He returned in 1682 to rally his supporters, and when Charles died in February 1685 James changed his tactics on ascending the throne in order to placate the Protestant moguls of the City of London by playing down his own lecherous past. John Evelyn noted on 14 February: 'that the new King's court was exceedingly changed into a more solemn and moral behaviour; the new King affecting neither profaneness nor buffoonery'.

James had turned overnight into a paragon of virtue. To demonstrate his rectitude he sent Louise de Querouialle, now Duchess of Portsmouth, packing back to France, and his own mistress, Catherine Sedley, was told to leave her 'Grace and Favour' house in St James Square. (He interrupted this liaison for about a fortnight.) His composure was a little perturbed when his nephew, Charles' bastard son – and a Protestant – the Duke of Monmouth, attempted to take over the throne, but his execution and the subsequent carnage of his followers caused a violent quarrel with Parliament, which led to his flight five years later.

Bawdry at Court was discouraged by the respectable Queen, but general bawdry was little disturbed by these momentous events. Mrs Cresswell's contemporaries, Lady Southcott, Graydon's, Gifford's and Potter's, were still diligently serving the *beau monde*, and the general public was still being catered for by diligent 'common' bawds. (The new King still held the wine licence monopoly and is not known to have divested himself of this valuable 'perk'.) The new fashionable diversion was the *Folly*, a pleasure-boat moored off Bankside since 1662, which had been patronized by Charles for its food and dancing. By 1685 it had become a floating whorehouse; the Swiss traveller Baron von

Offenbach who visited it in 1707 described it as 'a low tavern and bawdy-house'. (Virtue triumphed in the end: by 1710 it was a meeting-place for dissenters.)

In the summer of 1687 James established the Mayfair, off Piccadilly, 'for serious tradeing' and to divert custom away from

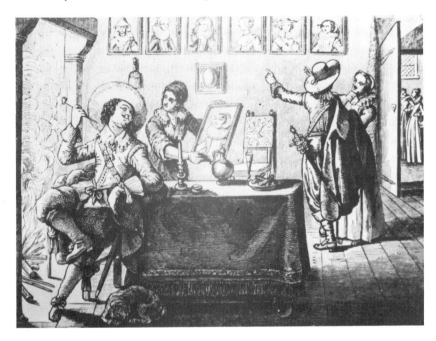

De Schoene Majken, 1530, the most luxurious whore-house in all Europe. The portraits of the girls on the walls depict the available bawds from whom the visitor to Antwerp would choose his fancy

the Bartholomew Fair which was a very sink of iniquity. Almost immediately the Mayfair became a hive of disrepute, many whorehouses closing-in, even closer than Covent Garden, then just becoming a vegetable market and on its way to becoming London's sexual rendezvous.

Meanwhile James' reign was crumbling, and in November 1688 his son-in-law, Willem, Stadholder of Orange, landed with an army 'to defend the Protestants but not to persecute Papists'. When James' daughter Anne defected to join her sister Mary, James fled never to return again. He died on 6 September 1701 aged sixty-eight of a cerebral haemorrhage brought on by syphilis – 'A Monastick Bigot Prince who had lost three kingdoms for a Mass.'

The 'Phlegmatick Dutchman' was quite familiar with licensed brothels; the Netherlands then boasted the most famous and largest of them all, *De Schoene Majken* in Antwerp. The envy of every European bawd; it was soon to be rivalled in Covent Garden. William had only one mistress, Elizabeth Villiers, whom he had met in Holland in 1678 and who came to England with him in 1688. When some puritanical Court lady blew the gaff to the Queen in 1694, Elizabeth was married off to Lord George Hamilton, who was created Earl of Orkney in 1696. She must have had great sex appeal for she was described as 'ungainly, of bad complexion with a squint, but with a good figure, good manners and intelligent'. (The Queen, who was very much in love with her husband, 'was much distressed' at this liaison.)

Punishments were much the same as in former years, although the cage began a new lease of life, instead of ducking which had been hitherto utilized for errant females, including bawds. The whipping-post was also much used. There was a much used whipping-post and cage at the Drury Lane end of Lewkenors Lane from about 1640: the cage often being used as a prison. On 9 July 1641 it is recorded that a prostitute was in the cage 'to relieve her a Truss of Straw 1s 6d'. Four days later it is recorded 'Paid for a Shrowde for anne wyatt in Cage. 2/6d'. Cages are first mentioned as early as the reign of Edward III, c. 1350.

Lower-class women were all regarded by the gentry as whores or potential whores, and many a respectable girl might be raped in the street at eve. In King William's time crime was aggravated by gangs of 'theeves' from lawless areas such as 'Alsatia' – where Kingsway now stands. The Middlesex Sessions register reflects various aspects of these crime waves. For example:

29 August 1687 GRECIAN PETRO ... convicted of intention to rape Anne Perkins, aged seven. FINED 40 shillings to be whipped.

May 1693 SARAH STRATFORD ... woman of ill-fame for procuring Elizabeth Farrington for 20 nobles. To stand in the Pillory for an hour between 9 & 12 a.m. for three days ... then three months in Newgate ... without bail or mainprize.

In 1692 the London Society for the Reformation of Manners was established. They were vigilantes informing the local authorities of breaches of the peace and morals – cursing, swearing, drinking, Sabbath-breaking, sexual misbehaviour – between 1692 and 1725 92,000 poor whores were whipped or sentenced to prison. 'Rich Drunkards or Swearing Merchants were never brought before my

Lord Mayor', said one commentator. The society provoked great animosity among the general public for its snooping.

The new coffee-houses were beginning to be places of assignation, provoking a spate of pamphlets and petitions against coffee. One of the best is that of 1674, *The Women's Petition Against Coffee*! It complained that, 'it eunuched our Husbands' because of the 'heathenish abhominable liquor called coffee … crippled our Gallants … men come with nothing Stiff except their Joints … this Puddle-Water'.

The coffee-houses became houses of assignation, if not actually fronting for whore-houses.

There was also the Bawds Initiation Club, which allegedly met at Lady Southcott's brothel in Old Dunkirk Square (today Albemarle Street in Piccadilly) to discuss common problems in the 'Cunicular Warehouses'. There were also occasional mishaps, such as that of Sir William Davenant who (*vide* Aubrey) 'gott a terrible Clapp of a handsome Black Wench that lay in Ox Yard, Westminster, which cost him his Nose.'

By this time bawdy-houses were to be found all over London, although the well-known old centres were still flourishing. In 1693 the *Guide de Londres* published in Paris by François Colson mentions 'les Maisons de Grays Inn ou vous trouverez une jolie et agreable promenade'.

The Middlesex Sessions Register for May 1693 records the conviction of Mrs Smith of Rosemary Lane: 'known to entertain Women and Theeves … the Constables founde three naked women and three naked men dancing and revelling naked, Buff-balls or Buttock-balls'. In King Charles' day the 'Buff-ballers' had been dangerous aristocrat hooligans who had committed rape and murder almost unchecked, always in the nude.

In December 1695 Queen Mary died, and the King was overwhelmed with true grief. What little Court life there had been now stopped completely. In 1698 the great palace at Whitehall caught fire and was completely destroyed: over the centuries it had accreted into about a thousand rooms linked to the main building by a great number of alleys and corridors. Nothing now remained of the congeries of residences, so that everyone, courtiers, courtesans, bawds, whores, flunkeys, catamites and buggers had to seek other accommodation. This set up a building boom never before known, which brought prosperity into areas as far apart as Covent Garden and semi-rural areas such as Bloomsbury. On 8 March 1702 King William was thrown from his horse and died. His sister-in-law Anne ascended the throne – the last of the Stuarts – prematurely old at the age of thirty-seven,

having to be carried 'In extream agony of the Gout' to her coronation in Westminster Abbey. She was not without experience of 'le condition humaine' – she had been married-off to a stupid oaf and had seen all of her fourteen children die at birth or after short illnesses.

Anne was genuinely shocked at the extent of obscenity in behaviour, speech and print, and the bawdiness of the theatre especially shocked her – 'The Play was incidental to the main business of prostitution!' This was succinctly expressed in Dryden's *Prologue* to Thomas Southerne's comedy *The Disappointment* (1700):

> The Playhouse is their Place of Traffick, where
> Nightly they sit to sell their rotten Ware
> Tho' done in Silence and without a Cryer
> Yett he that bids the most is still the Buyer!
> For while he nibbles at her am'rous Trap
> Shee gets the Mony: he gets the Clap!

Consequently, on 24 January 1704 the Queen ordained that there must be 'reform of the Indecencies and Abuses of the Stage'. Gentlemen were now forbidden to climb on the stage after the performances or go backstage afterwards and 'play about' with the actresses. Moreover a censorship was imposed on plays and playwrights.

There was great prosperity: the newly established Bank of England and the Fundings increased speculation, and the markets and the wealth thus accrued was invested in land and building developments. This latter activity helped the bawds, for whereas in the past she had to go to the countryside to get fresh goods the new systems of inter-city coaches and wagons brought fresh unused goods straight into the termini where the bawds could approach the innocents with tales of well paid immediate employment: procuresses could then be seen with groups of small children to be hired out for prostitution.

This was the time when nefarious bawds like Mother Whyburn and Mother Needham established their careers, picking-up girls on the cheap, housing them in brothels not far removed from slavery, using them like animals and throwing them away when they were worn-out or diseased. There were also 'wholesalers' who bought children from poverty-stricken parents and then resold them to 'retail' bawds.

The streets were the happy hunting grounds of Mohocks and Sparks, aristocratic hoodlums whose fun was obtained by interfering with women in the streets or eating-houses, ill-treating

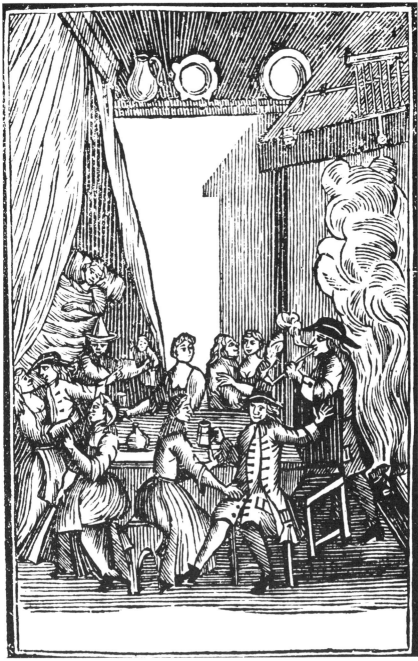

A low-class coffee-house in St James, *c.* 1700. The courtesan in the foreground is picking the cully's pocket. Meanwhile, the Devil, in a conical hat, urges everyone to embrace the sinful life

them, frequently injuring them, and fighting the Watch with their drawn swords relying on their rank to save them from official punishment. The violence became so outrageous that, in January 1712, the Queen issued a Proclamation against vice which *inter alia* laid down that all persons who kept 'Bawdy-houses, Musick-Houses, Gameing Houses' should be effectually prosecuted and punished. It had little effect.

> On the night of March 9th 1712 five *Mohocks* – all Peers and Persons of Quality created a Riot in a Strand tavern in the course of which the landlady was killed ... the Gentlemen laughed and ordered that she be added to the bill.

The Queen ordered an immediate enquiry; the High Constable, John Salt, who had released these miscreants from custody was removed from office. At the subsequent trial all were acquitted – which stirred the Queen to issue an Edict offering a reward of £100 and immunity to informers, since the magistrates had stated that nobody would come forward to give evidence and 'the bawds had been taken in their own bawdy-houses' and had had to be acquitted because 'none could be found to testify against them.'

These attacks continued until one evening an armed watchman in the Strand suddenly turned on three of them, wounded and arrested them. All were fined 3s 4d at the Old Bailey, but thereafter Mohock activities were channelled into the hell-fire clubs. One of the leading lights was Philip Wharton, later Duke of Wharton, 'protector' of such worthies as Mother Whyburn, Mother Needham and the ineffable Colonel Francis Charteris.

Fashionable bawdry now revolved about the coffee and chocolate-houses of St James' Street and Pall Mall, wherein whoring could be done in the most luxurious surroundings without interference.

The London Season was over on 1 June, when all Society dispersed to their various resorts of relaxation; cleverly set out in the ballad *In the Long Vocation* (1700), the 'long vacation' being the summer months when the law courts were closed. The first few verses of a very long effusion will suffice:

> In the Long Vocation when Business was scanty
> But Cherries – and Whores – extraordinary plenty ...

> When the Quality withdrew to their Grottoes of Pleasure
> And Ladies to the Wells to spend their Lords' treasure

When decrepit old Sinners to Bath did resort
For venereal Distempers, as well as the Sport

When the Cits did retire to their Countrey-houses
Leaving Servants at home to lie with their Spouses

When the season was too hot for the Goggle-eye'd Jews
To exercize their Faculties in Drury Lane stews

When Sodomites were so impudent to ply on th'Exchange
And by Daylight the Piazza of Covent Garden to range

When Theatre's Jilts would swive for a Crown
And for want of brisk tradeing patrolled round the Town

When Drapers smugg'd Prentices, with Exchange Girls most jolly
After Shoppe was shut up, could sail in the Folly.

There are valuable nuggets of information in the ballad not evidenced elsewhere, such as that out-of-work actresses engaged in part-time prostitution and even, upon occasion, as ambulant prostitutes, and that professional buggers braved the universal opprobrium to solicit in the daytime. The Jewish reference is curious: the first Sephardim – Spanish and Portuguese Jews who had fled to Holland and thence, under Oliver Cromwell, had been admitted to England in 1653 were still easily distinguishable in the *purlieus* of Drury Lane where they frequented the taverns and whorehouses. The first Jewish-owned brothel is not recorded until some fifty years later.

In 1710 the young Baron von Offenbach spent five months in England. He observed that the *Folly* houseboat was now named the *London Diversion*, 'selling Wines and Beer – prodigious dear', and also noted 'the great quantity of Moors of both sexes, the females in European dress with uncovered black Bosoms.' The day of the black bawd had not yet arrived.

The ailing Queen held very few Courts, and those that were held were dull, so that the noble and the wealthy devised other ways of passing the time apart from gambling and playgoing. In 1708 the extremely rich and jolly, Allan, Lord Bathurst, 'fond of dancing, wenching and the begetting of children at home and abroad', maintained a small harem to which several bawds contributed their choicest wares: for these pursuits seemingly, since he had no other qualification except great wealth, he was made a baron in 1712 and an earl in 1772, dying in 1775 at the age of ninety-one.

Perhaps the most significant phenomenon in the Good Queen's reign was the rise of the 'Mothers', by which sobriquet the most prominent bawds became known, playing their part in contemporary social history. Most have faded from historical knowledge but at least three became historical figures. These are Elizabeth Whyburn, Sarah Lodge and, above all, Elizabeth Needham.

12 The 'Pious' Mother: Elizabeth Whyburn

By far the most famous bawd in Queen Anne's reign was the bizarre Mother Elizabeth Whyburn, daughter of a well-respected London clergyman and a direct descendant of the great Puritan divine, Canon Percival Wiborne MA. She was born in London in 1653, genteelly brought up and educated in a home much frequented by eminent doctors and theologians, including such luminaries as Dr Fernando Mendez, Court physician to Charles II and an orthodox Jew. As a teenager she was sent to Italy to be groomed, where she became acquainted with Italian elegance, Italian luxury and Italian morals. After being seduced she made some study of the customs and running of the best Italian seraglios.

On her return to England she was introduced to Court circles, becoming friendly with all the reigning Toasts of the Town as well as many gentlemen of the first rank. While in Italy she had acquired some knowledge of medicine, becoming well-known amongst noble lechers for her anti-arthritis and anti-venereal concoctions. Although in 1677 she married Edward Brook (of whom nothing more is known) she retained her maiden name throughout her career. (However in 1714 she is listed in the rate book as 'the widdow Wyburn'.)

By 1679 she was operating a discreet business from handsome premises a few yards from Drury Lane theatre, extending her connection to actors and actresses and well-heeled playgoers – maintaining all the while a façade of religion by regularly attending St Martin's church nearby.

By 1707 she had become intimate with another popular figure, John Jacob Heidegger, son of a prominent Zurich clergyman but intimately involved with musical and theatrical circles in London. He was a man of great charm and wit and of good address – but he was so ugly that he was nicknamed 'Count Ugli'. By 1713 he was producing Italian opera at the Haymarket Theatre, but by

1715 was running his remarkable 'Masquerades', which attracted the First Quality because of their gaiety and lewdness. He was also Mrs Whyburn's paramour and full partner in her whore-house, which was supported and nourished by his patron, the dissolute Philip, Duke of Wharton, thus ensuring her a long life free of embarrassment from the Law. (She also had some unspecified arrangements with Mother Needham and King Charles' old mistress, Moll Davis.)

Her nymphs were most carefully selected, many of them as small children. Every morning, bible in hand, she made the rounds of inns and taverns to see what offerings the countryside had sent to London. She also went to the Lock Hospital at Knightsbridge, claiming that her medical knowledge enabled her to send a 'slightly pox'd' girl to Moll Davis' Gravel Pits nearby for cure and convalescence: for a suitable douceur she might spring a likely lass, even from Bridewell. A contemporary critic dubbed her 'the Antiquated She-Captain of Satan', dressing-up her kitlings with paints and patches and always calling them 'young milliners' or 'parsons' daughters', hiring them out at extravagant prices. Every girl was stripped and examined 'just like a Butcher might chuse a Mare at Smithfield', before restoring her virginity 'for sale to a Person of the Quality.' She claimed that the Royalist poet Sir John Birkenhead had been a client by 1679, when she was twenty-seven. She recalled that Sir John had supplied His Grace the Duke of York (James II): 'with a gross of cundums' newly imported from Holland by Dr Fernando Mendez, the Court physician.

Amongst her clients was Dr William Beveridge, Bishop of Bath and Wells, who indulged in flagellation; and the renowned Court physician, Dr Richard Mead, who enabled her to keep abreast of venereal discoveries. Her house also entertained the two bastard sons of Charles II, the Dukes of Richmond and St Albans, as well as Alexander Pope and John Gay, both of whom mention her in their works.

In those days Drury Lane was in the centre of high fashion. Through the activities of the Court, the theatre and high fashion, her brothel flourished mightily. Only the *crème de la crème* of harlotry could make assignations in her establishment. One of her star performers was Sally Salisbury (*née* Pridden), the very first of the new breed of 'High Harlots' or 'Great Impures'. Her charges were so high that 'shee made Folks pay vastly Dear for what they had but they paid the greatest Price for the greatest Pleasure.'

In 1713 a slight cloud appeared when Heidegger's *Masquerades* became so outrageously pornographic that he had to turn to

opera and serious music to avoid prosecution; and in consequence of a fracas in her house caused by that madcap Sally Salisbury, there was a raid. Sally was arrested and charged with disorderly conduct – Mother Whyburn narrowly escaped a charge of keeping a disorderly house.

She certainly had some good traits: just before her death it was noted that 'altho' she did a World of Mischief … no beggars were turned away from her house without some help'. When she died in November 1720 'an elderly churchgoing woman' in St Martin's parish, a memorial was erected some weeks later:

> MUSE, stop awhile, for thou hast cause to mourn
> And shed a Tear o'er pious Wisebourne's Urn …
> Within thy walls the rich were every pleased
> From thy gates no Lazar went unfed.
> South Sea Directors might have learnt from Thee
> How to pay Debts and wear an honest Heart.

She died intestate, and her very considerable estate had to be administered by the Registrar of Probate, who recorded that 'she was Elizabeth Whyborne otherwise Percy'; nothing is known about any Mr Percy. As for Heidegger, his *Masquerades* had become so very pornographic that in 1721 George I made an enactment against them. None the less this 'principal Promoter of Vice and Immorality' lived pleasantly to a great age, long after his paramour had been forgotten.

13 Jolly Sarah Lodge

In sharp contrast to the life of the sober Mother Whyburn, the career of Sally Lodge demonstrates a great deal of cheerfulness and *bonhomie*: but there is surprisingly little hard evidence about her beginnings. She was born in 1680 in very poor circumstances, her father being a barber who 'married' her mother just before her birth: this, however, may be an invention to show that she was legitimate. The posthumous ballad about Sally sheds a little light:

> While Tonsor shav'd, his Consort stitched,
> By neither Trade were they inrich'd;
> But died in debt – poor idle pair,
> And left me to our Vicar's care.

> Under his Spouse I learnt my Creed,
> She taught me how to Darn and Read.
> I pray'd and Work'd and conned my Book
> But soon my native Fields forsook.

She was taken into domestic service but was dismissed for some petty theft and then apprenticed for five years to a dressmaker, the good vicar having advanced seven pounds for that purpose. She complained that it was drudgery and that she was treated like a slave; so at the age of fourteen she ran away to become a whore, in which new ploy she was successful enough to be able to set-up a high class bagnio in 'the parish of St Martin's-in-the-Fields' in or near the Strand – an excellent milieu for that business, not too far from the Court, so that it was patronized by the First Quality. How much her services were esteemed is demonstrated by Alexander Pope's encomium, written in about 1720:

> My Little LODGE, tease me no more
> With promise of the finest Whore
> That cundum was e'er stuck in.

Give younger men the beautious Dame;
Alas! I'm passed the am'rous Flame
 and must give over Fucking.

The next five verses explain how and why the writer is unable to make further use of her valuable services, mainly because he is aged and 'cold customers like me are entirely lost to Gallantry'. His 'little bawd' would starve if she had to rely on his endeavours. He sighs however and mentions that he still dreams hopelessly of 'my charming Fanny Fielding!' It is intriguing to note that cundums were being used in high-class whore-houses by 1720.

 The poem discloses for the first time that the great beauty Frances Fielding was available for sexual favours – the whole family of the Earls of Denbigh were very impecunious, looking avidly for every means to raise money. Frances was most probably the daughter of the notorious bigamist Beau Fielding, one of whose victims was Barbara Castlemaine, whom he 'married' towards the end of her life. (He was, incidentally, a member of the 'No Nose' Club of victims of syphilis.)

 Sally's prosperity was cut short when she became the victim of an Irish confidence trickster who left her penniless and stripped of all her gains. She was no longer young nor beautiful enough to go 'on the game', and was – seemingly – unable to go back as a madam. She was induced to emigrate to the West Indies where she became mistress to a rich planter, enjoying great splendour and ease:

Tribes of black slaves around me wait
and fan me when I sleep and dine.
No Indian Queen was half so fine.

but in the middle of this honeymoon her protector died, leaving her unprovided for. His unfeeling family shipped her back 'and she landed at Tower Stairs with little left.'

 She discovered that a great many of her former 'flames' had gravitated into other arms, nor was it possible to re-establish her bagnio. She had perforce to resort to prostitution until eventually an old friend gave her a job as barmaid at the Whale on Wapping Broadway where she dispensed:

Rum, Brandy Punch – a Wapping Queen
measuring-out tots to Sailors keen.

and seemingly enjoying herself, meanwile getting fatter and fatter until she developed dropsy, dying suddenly in 1735 being only fifty years old – but still boasting that she was 'well-known

throughout the British fleet.' A eulogy, 'A Genuine Epistle ... to the late famous Mother Lodge' is very good-humoured, and John Gay, who knew her summarized her life:

Servant, Prentice, Whore, Mistress, Thief, Deserter
Dupe, Derelict, Emigrant, Nabobess – final Failure.

but the real picture is of a rumbustious amoral woman who loved her tipple.

14 The Vicious Mother: Elizabeth Needham

Elizabeth Needham comes into history in about 1710 as a highly successful bawd operating from a luxurious brothel in Park Place, St James – a most rich and fashionable area a few hundred yards away from the royal palace. All the other inhabitants of the place were scions of the nobility and gentry – the very fact of her presence there infers that she had the right connections and came from the same stock. Indeed her early prestige and continually arrogant behaviour, coupled with the surprising lack of interference from the minions of the law as well as the Society for the Reformation of Manners, indicates that she was well-born and enjoyed powerful protection. She was born about 1680, and it is possible that she was kin to the Nedhams, Earls of Kilmory. During her long career she used a number of aliases, including Bird and Trent. She was a good-looking woman and a first-class organizer, but she was also known for the harsh treatment given to the girls in her brothel.

Some of her girls she had picked up as children or bought from indigent parents; some were chosen from the ranks of the poor; the principal qualification was that they were young, lovely, virginal and docile. She also recruited in the country-side, sometimes visiting the villages, but more usually meeting the coaches and wagons rolling into London seeking fame and fortune in the metropolis. She could be seen at the Swan near old Holborn Bridge or at the Bell in Wood Street off Cheapside. Sir Richard Steele remarked in *The Spectator* (January 1712) that while visiting the Bell: 'who should I see there but the most artful Procuress in Town examining a most beautiful Countrey girl who had just come up in the same Wagon as my Things.' Tom Brown described her as 'plying close at Inns upon the coming-in of wagons and the GeeHo coaches and there you may hire fresh Countrey Wenches sound and plump & juicy – well qualified for your Business.'

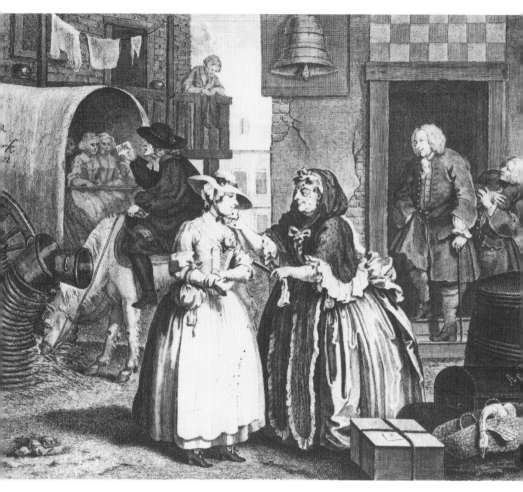

Mother Needham meeting fresh goods up from the country at the Wood
Street wagon terminal in Cheapside

Even then she had a reputation for bad language and hot
temper. Alexander Pope warns would-be clients in his *Dunciad*:

Try not, with Jests obscene, to force a Smile
Nor lard your Words with Mother Needham's style.

The regime was very strict; the very clothes on the girls' backs
were hired out to them. As a tallywoman, she pocketed all their
earnings to recompense her outlays. Any girl who failed to pay
these exorbitant sums for the hire of clothes, trinkets, laundry and
so on, would be mercilessly harried to double her exertions. They

were the slaves of Brutish patrons, compelled to drink with and fondle every diseased drunken noble lout. Those who fell into debt or disfavour would be hurried without mercy into a debtors' prison, there to rot until the debt was paid. Those who grew too old, or fell into disfavour with the clients, were summarily ejected and thrust into the street. Those who were sent to patrol the streets, if they failed to bribe the constables, were quickly hauled before a magistrate and carted-off to Bridewell, but they could expect no help unless they guaranteed to pay Mrs Needham. Those in the brothel were treated as if they were slaves in a harem; she was a taskmistress who treated them like cattle. Mother Needham was not doing anything out of the ordinary – in supplying rich lechers with nubile young girls she was merely dispensing with the marriage part of the transaction – such behaviour was regarded generally as normal – the alternative was destitution or starvation.

For many years Needham conducted her business in Park Place with great success – she was fortunate with her neighbours, who included George Hamilton, Duke of Orkney, the complaisant husband of William III's mistress; George Montagu, Marquis of Halifax; Lady Tankerville and Barbara Castlemaine. With such neighbours there would be little or no interference from the constabulary; and, in any case, only the First Quality were allowed to patronize her establishment – the young Prince of Wales was known to drop in occasionally.

Then, in 1721, came the first brush with the law. The *London Journal* of 2 November reported: 'November 2. Committed to Newgate, Elizabeth Bird *alias* Needham for being accessory to a felony'. There are no details of the charge nor of any penalty. It was probably a minor matter of conspiring to supply a young virgin to a dissatisfied customer; and the matter was settled amicably with a little 'golden ointment' suitably smeared. It certainly did not affect her business, for in 1722 the poetess Mrs Blount burbles, 'For want of You ... to Needham's we must hie.'

The next brush with the law was on 23 July 1724 when it was reported: 'On Monday last the noted Mother Needham and Mother Bird were committed to Newgate, their houses having been searched the Night before [Sunday night] by the Peace Officers who found two women in Bed with two Gentlemen of Distinction.' The gentlemen were bound over and the women were all bundled off to the Tuthill Bridewell for hard labour, accompanied by three other females 'of the same stamp.' Again, there is no record of a conviction against her – undoubtedly the 'Gentlemen of Distinction' intervened to save their old friend.

(There is no other record against Mother Bird – it was one of Needham's aliases.)

By this time Needham had become deeply involved with Colonel Francis Charteris, and their activities were being followed closely by the minions of the Society for the Reformation of Manners. On 10 April 1725 it was reported:

> The famous Mother Needham *alias* Bird *alias* Howard *alias* Blewitt was again apprehended on Sunday last April 4th for keeping a Disorderly House. 'Tis likewise said she has made ample discoveries relating to several of her own profession.

On this occasion she was fined one shilling and sentenced to one hour in the pillory at Westminster, although there is no record that this was ever carried out – undoubtedly golden ointment was again smeared.

It is easy to explain the various aliases. When procuring young girls at the wagon stations it was necessary to use a false name and a false address. The potential bawd or seducer would be called under the alias to interview the victim – she might be seduced straight away. It was of course a felony, but by such stratagems both bawd and client often escaped because it was difficult for the victim to identify the seducer. Clearly, in this instance, Needham had 'fingered' some other bawds – there might be honour among thieves but there was little honour amongst bawds whose motto was '*Sauve qui peut*'. In this instance Mother Needham may have suspected that some other competitor or that implacable whore-hunter, Sir John Gonson, might have tipped-off the authorities.

There can be no doubt, however, that the prime cause of her undoing was her association with Colonel Charteris, a scandalous character then known as the Rapemaster-General of Britain. He was kin to the Earl of Wharton, had been in the army and cashiered for theft and embezzlement, but nevertheless had made money by dubious property deals. His weaknesses were a terrible sexuality and an insensate partiality for young virgins. He used false names and addresses (to which his servants were privy) to lure unsuspecting girls into his clutches, but his behaviour was so arrogant and violent that he courted trouble. In 1717, in St James' Park, he drew his sword against a constable who overcame him, 'knocked him silly', and hauled him before the magistrates. Being a gentleman, he was let off with a caution, but shortly afterwards he raped a young virgin, Sarah Selleto, in The Scotch Arms Ale House in Pall Mall and was compelled to pay for her bastard child.

He was a card-cheat, once taking £3000 from the Duchess of Queensberry by using a small hand mirror to reflect her hand – he was barred from other clubs for similar offences. His house in Scotland was a veritable seraglio with a full-time matron, Mary Clapham, whom he treated with contumely and kicked out after years of faithful service. Once, when indicted on a charge of rape and assault, a victim identified him in the following terms: 'This is the huge raw Beast that in guid faith got me with Bairn. I know him by his nasty Legg for he has rapt it round my Arse mony a guid time.'

The colonel made arrangements with a number of bawds to pick up fresh country girls, but his association with Needham was closest of all. For about twenty years she supplied him with: 'Strong lusty fresh countrey Wenches of the first Size, their Buttocks as hard as Cheshire Cheeses that would make a dint in a wooden Chair & work like a Parish Fire engine at a conflagration.' For such paragons he would pay Needham twenty guineas, but he was not the easiest of clients. On one occasion, when he lived in Bond Street, she procured a young virgin of seventeen, but he opined 'she was too young for his rough usage', whereupon:

> Mother Needham fell into a Passion, violently protesting that he was using her ill because she had been at great Pains and Expence … should she be obliged to offer the girl elsewhere it would blow her Market since few Gentlemen would chuse what the Colonel had rejected and the girl might be on her Hands for a long while or have to be disposed of to some Player or even a Barrister or else she had to make her into a Hackney-harlot in a week.

For his various crimes Charteris was given a Royal Pardon on New Year's Day 1722 at the intervention of the Duke of Wharton, but this 'Disputatious quarrelsome bully' continued his wrongdoings. Shortly afterwards, he played a confidence trick on Alderman Francis Child of Child's Bank, in respect of a *Letter of Advice* for £5000, which in fact he had never sent. He bullied and pestered the old banker so relentlessly at his coffee-house that the banker eventually paid him off to get rid of him.

Despite all these alarums and excursions, Mother Needham's own seraglio was still operating; but Alexander Pope in his *Imitation of the Odes of Horace* (I.ii.133-5) gave her a veiled warning:

> Not thus at Needham's your judicious Eye
> May measure there the Breast, the Hip, the Thigh
> And you will run to Perils – Sword and Law.

In *The Rake*, John Gay inveighing against gambling joints, says, 'At White's he maddens and at Needham's burns.'

Eventually Nemesis struck when a young maidservant Anne Bond: 'being without a place Mother Needham came upon her while she was sitting outside her lodgings. She wanted a respectable Situation so Mrs Needham sent to Col. Charteris' Town House in George Street, Hanover Square on the *alias* of Captain Harvey.' As soon as she realized his intentions she put up a great fight, managed to escape and ran crying to some neighbours for help, who called the constables. At the Old Bailey on Friday 17 February 1730, he was found guilty of rape and sentenced to death. Due to Wharton's intervention, he got a King's pardon after a short spell in Newgate – but public anger at this travesty of justice was immense.

On 24 March 1731 Mrs Needham was charged before Sir John Gonson and convicted of keeping a disorderly house in Park Place, St James. She was committed to the Gatehouse Prison in Westminster, brought back again to court on 29 April and sentenced: 'to stand in the Pillory over against Park Place on April 30 ... and once in New Palace Yard, Westminster and to find Sureties for good behaviour for three years'.

These pilloryings were witnessed by 'a vast and hostile crowd' who were further incensed because she was allowed 'to lie down upon her Face' to save injury – a tactic which was actually illegal, but again golden ointment was used. However the contemporary *Daily Advertiser* reported: 'notwithstanding which evasion of the law and the diligence of the Beadles and a number of other Persons who had been paid to protect her she was so severely pelted by the Mobb that her life was despair'd of.'

There was indeed a fatality: the *Gentleman's Magazine* reporting that a boy was killed by falling upon iron spikes, which he had climbed to see Mrs Needham in the pillory. She was indeed badly injured and died shortly thereafter, but the actual date is a mystery because there is conflicting testimony.

A broadsheet entitled *Mother Needham's Lamentation*, observed for 6 May: 'She was a Matron of Great Fame and very religious in her way, her constant Prayer being that she might get enough by her Profession to leave it in time and make her peace with God.' She is reported to have said when dying that what most affected her was the terror of standing again in the pillory.

Some references in the Middlesex Sessions Registers for June and July give the impression that she was still alive then. At the Quarterly Sessions on 25 June there was a complaint by local tradesmen of 'vile people' and 'midnight debaucheries', which

led to the setting-up of a Committee of Justices who on 14 July 1731 issued forty-six warrants: 'the following have been indicted for keeping Disorderly Houses and Houses of Ill-fame (including) Elizabeth Needham *alias* Bird *alias* Trent.'

Although this offers proof that she must have been alive in July, she may well have been very ill and had 'retired' to one of her Drury Lane houses. She probably died during August, for in early September appeared a broadsheet, *Mother Needham's Elegy & Epitaph*:

> Ye Ladies of Drury, now weep
> Your voices in howling now raise,
> For Old Mother Needham's laid deep
> And bitter will be all your days.

> She who drest you in Sattins so fine
> Who train'd you up for the Game
> Who Bail on occasion would find
> And keep you from Dolly & Shame

> Now is laid in her Grave ...

Another broadsheet states that she had started prostitution at the age of fourteen and that 'her Parentage was obscure'. It explains she had 'good skin and features' and many rich admirers, and that she had helped Colonel Charteris 'to above one hundred Maidenheads which she pick'd up at the Carriers'.

Hogarth knew her well and drew her as 'the handsome old Procuress' in plate I of his painting *The Harlot's Progress*, in the background showing Charteris' valet Jack Gourlay. She is depicted as 'a middle-aged woman, simpering beneath her patches on her Face, well-dress'd in Silk' cozening the innocent Kate Hackabout for Charteris. Kate Hackabout was a real person who later grew into a drunken termagant after Needham's death.

Charteris died at his country seat near Musselburgh in February 1732 and there was a great riot at his funeral, the crowd almost tearing his body out of the coffin and 'throwing dead dogs and offal into the grave'. His death prompted a number of books and pamphlets resurrecting Mother Needham's name and fame, one of which details her greeting him in Hell, reminding him of her suffering 'on the Woodden stool on which your Needham died' – he asks her to ransack her store in Hell and 'fetch Francisco a young Brace of Whores!'

There is no evidence of a last will and testament under any of the names which she used, nor do we know whether she left any

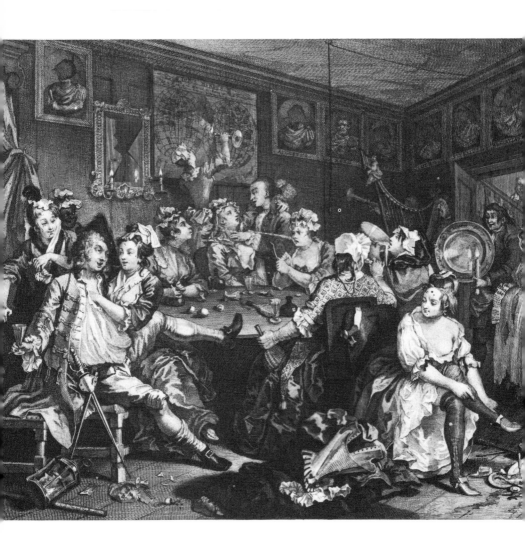

The Rose Tavern, Covent Garden. A scene from Hogarth's *Rake's Progress* in 1733 and 'the Resort of the worst Characters in the Town, male and female, who make it the Headquarters of Midnight Orgies and drunken Broils'

considerable estate – none of the memoirs indicates wealth. Perhaps she was no worse than many of her contemporaries – her association with Charteris simply guaranteed her posthumous renown.

She was not, of course, the last of the Mothers but none comes down to posterity with such a hateful reputation.

15 'Good People, Ve Haf Come Only For Your Goods!'

The advent of George I added a new dimension to the English social and sexual scene; this was financial and political corruption on a scale never before experienced. He was scrupulous in his own financial affairs but condoned with a cynical laxity the outrageous corruption by his entourage and friends. He arrived at Greenwich on 18 September 1714 with 307 persons in his entourage, which included his two mistresses, Countess Sophia von Platen and Countess Ehrengard Melusina von Schulenberg.

Von Platen, witty and vivacious, was 'a mountain of fat' who was quickly nicknamed the Elephant and Castle, while the beautiful 'tall thin and humourless' von Schulenberg was nicknamed the Maypole. Both were equally unpopular – on one occasion when Ehrengard Melusina was being booed in a crowd, she cried 'Good beobles, vy you abuse us? Ve haf come only for your goods', and a wit in the crowd riposted 'Yes! and for our chattels, too.'

However, King George revived the Courts and thereby: 'Gloom was dissipated, Ladies resumed their wonted Powers, Gaiety and Frolicks promoted frequent Intercourse and modest Intrigues,' warbled the author of *The Nocturnal Revels*. John Hervey, who was actually participating observed, however, that the Courts were 'boring and smelly', the ladies being 'painted powdered and patched' to dispel the odours 'of not washing very often with anything so common as soap and water … and they had to hide their laughs behind their fans because their Teeth were rotten.' Fleas were to be found 'in the wigs of the First Quality and buggs in their Beds.'

There was opportunity for malicious gossip too. Horace Walpole, at a drawing-room function in the palace in 1716 noted: 'Happening to meet the Duchess of Portsmouth [Louise de Querouaille] and the Duchess of Orkney [William III's mistress], My Lady Dorchester [Catherine Sedley] exclaimed 'Damme!

who'd have thought we three Whores would have met here!'

Huge fortunes were being made on the Exchange by reckless speculation and the middle classes were creating the basis of banking and industry. The lesser gentry entered into commerce and manned the new Civil Service. The ranks of apothecaries, dentists and doctors were swollen from ex-leeches and barbers. Debauchery was encouraged by a host of drinking and gambling clubs and a great increase in such 'diversions' as child-rape, flagellation and buggery.

There was a great increase in bawdy-houses of inferior quality. William Stow in his *Remarks on London* (1722), a street directory, mentions the red-light districts: 'Newtner's Lane [Lewkenor's Lane] ... the wickedness of its inhabitants having gained it the name of SODOM, it is now given the nice name of Charles Street ... in Codpiece Row [later Coppice Lane] ... by Hockley-i-th' Hole ... there is now Bear and Bull-baiting ... in Hogg Yard in Tuttle Fields [Tothill Fields, Westminster] there is a new Bridewell for the Correccion of Strumpetts.'

In the Bridewells and prisons the conditions were unspeakable: there are bloodcurdling contemporary descriptions of 'the Holes' and 'cages' of misery and tales of horrible deaths – 'places of barbarous obsceneness in a civilized Nation', of practices 'fitt onlie for Savages.' Fines on bawds and prostitutes usually ranged between a shilling and three shillings and fourpence, plus a whipping or a spell in the pillory. In 1716 'Barbara Jarrett, Bawd of Wapping ... was whipped bare to the waste from Old Gravel Lane to Wapping' – a distance of two miles; her neighbour Margaret Shadrack was 'Whipt at the cart-arse ... then sent to Newgate for a Month'. Phillis Hansford, although pregnant, 'was whipt from her brothel the Adam and Eve in Ratcliffe – part of the sentence was suspended till after the birth of the child.

In 1719 the magistrates complained to the King that there were:

So many Night-houses & houses of ill-fame wherein Liquor was served ... such a large number of Gameing-Houses which they could not tackle because of strong hatches on the street-doors with sharp Iron spikes ... often guarded by Souldiers who refuse toe allow the Constables to enter the inner Rooms.

In February 1721 the Kings Head Tavern was raided, and Richard and Elizabeth Hayward were arrested. Elizabeth was the famous Mother Hayward, whose brothel in Russell Street was patronized by all the Quality of that time. Both were stood in the pillory and had to give a 'Surety for good behaviour for Seven Years' – but they were soon back in business in nearby Charles

Street from 1721 to 1733, with a short spell in 1740 at Rose Street until Mother Hayward died in 1743. Richard then moved back to Charles Street until he died in 1747.

In November 1721 it was reported that 'the celebrated Mother Hopkins ... had departed this life a few days ago (her seraglio was in Earl's Court, just off the Strand) and had 'left £600 to a Gentleman ... called the Captain who was the Prime Manager of her Affairs'. She had been at the same address since 1706 – she claimed to be one of Moll King's cronies.

Mother Jolley of the King's Arms Tavern in Drury Lane was sentenced in 1721 'to hard labour and a whipping'; and the year ended with Mother Elizabeth Hall, who ran a successful house in Russell Street from 1715 to 1733: 'likely to be charg'd with Murder ... having hit a Client on the fore-head with her Patten till he was past all Hope of recovery ... she is better known as Bess.'

Not all the cases are so dreary. Alice Thorpe 'who had been a trainee in Mother Whyburn's establishment ... and who is now a most notorious prostitute ... had married the son of a rich City Merchant, Mr C ... and on the following Monday had married a prominent City Grocer ... and three others who have been bit by her Fine Appearance.' She was lucky just to be fined 'for being a Nuisance'.

In September 1722 a guardsman and three women were indicted, 'being found in Bed all together'. The three women were sent to Bridewell, but the soldier pleaded 'that he had undergone enough Punishment fornicating with three women at the same time', so that the Bench 'for once lett him go about his Business'.

The centre of bawdry was now shifting to Drury Lane – the current name for prostitutes was 'Drury Virgins'. In 1724 the High Constable of Holborn set out with a posse 'to beat-up that quarter of some Vermin who infest the Hundreds of Drury.' They raided brothels, gambling-houses, inns, taverns, thieves' kitchens, mollies-houses and counterfeiting workshops – also gathering-up two mignons of Richard Haddock, of the Turk's Head bagnio in the Strand, reported to be 'an honest stews', in which there were actually some baths. (Haddock was one of the most famous whore-masters in Covent Garden.) These mignons were Betty Saunders of the Blue Posts Chocolate Shop and Sophia Lemoy, 'who kept a seraglio with the sign over the dore Chocolate and Coffee House ... wherein a constant Grace of three or four Harlots were ready to serve their Persons'. Another young lady caught in the net was Nancy Dawson, later to be known as a dancer at Covent Garden Theatre and a courtezan of the highest rank.

One other case deserves a mention. Peter Borges (or Burgess)

and Susannah Hutchins were charged with stealing money from an un-named 'Person of Quality'; Susannah was charged separately with stealing 'four Golden Guineas & one Golden Moidore', but she denied this saying that the money was payment for whipping the plaintiff, in consequence of which 'she had worn out a pennyworth of Rods'. When told to carry on the flagellation, she had asked for more money to buy more rods; whereupon the client threatened her 'to swear a robbery' – a dreadful threat carrying the death sentence. The judge accepted the word of the person of quality, whereupon Susannah 'pleaded her Belly', but a panel of matrons found she was not pregnant and she was remanded for sentence: It was then disclosed that the plaintiff was His Excellency Baron Carl Sperre, the Swedish Ambassador, who then withdrew the charge, whereupon Burgess was reprieved and Susannah 'hath obtained a Pardon.' This is one of the very few cases of flagellation brought to Court.

The apoplectic George I died appropriately of apoplexy on his way to Osnabruck in January 1727, unmourned by his British subjects. His son, a lecherous little man, ascended the throne at the age of forty-four and was to command the same degree of unpopularity as his father – but bawdry had little to fear from him.

Meanwhile several of the mothers were still marching on, but a new genre in a new milieu was about to be created.

16 Covent Garden: The Grand Seraglio of the Nation

Under George II the Court was undeniably gayer, but the King's own gross manners did not improve their quality. John Hervey mentions in 1727 that 'he had been at Court last night; there was Dice, Dancing, Sweating and Stinking in abundance, as usual' nor were matters much improved by the King's habit of showing his displeasure by turning his backside on any nobleman to whom he was speaking. Indeed, some Whigs and Patricians founded the Rump Club, restricted to those to whom the King had shown his arse.

George II was as lecherous as his father, and, in consequence, did not much interfere with the activities of bawds; indeed on at least one occasion, accompanied by his equerry, Thomas Hall, 1st Viscount Gage (described by Hervey as 'a silly busy petulant profligate'), he visited Tom King's coffee-house in Covent Garden. The King began to ogle a pretty woman at the next table, whose escort naturally took umbrage, upbraiding the King and drawing his sword, shouting and threatening the King until Lord Gage began to draw his own sword. The King then pulled at his sleeve, murmuring, 'This Person does not know me!', whereupon both of them withdrew.

As early as 1709 Covent Garden was known as the rendezvous for every kind of dissipation and debauchery. *The Tatler* said that every house 'from Cellar to Garrett is inhabited by Nymphs of different orders so that persons of every rank can be accommodated'. By 1725, 'the front windows of the *Piazza* were filled from seven at night until four or five o'clock in the morning with Courtezans of every description ... who in the most impudent manner invite the passengers from the theatres into Houses where they were accommodated with Suppers and Lodgings, frequently at the expense of all they possessed.'

Curiously enough, in the earlier days of Covent Garden, the focal point for almost a generation was not a brothel but Tom and

Moll King's coffee-house, situated in the shacks in the market opposite the arcade known as the Piazza. Tom was a public-school boy, educated at Eton, his father being squire of Thurlow in Essex and his mother the daughter of Lady Elizabeth Cordell. At Cambridge he was known as the 'Joly Dogg', but he left the university 'under a cloud in November 1716' and drifted about Covent Garden as a handyman and waiter.

Mary was born in a garret in Vine Street, St Martins-in-the-Fields in 1696, her father being a poor, feckless, drunken cobbler, and her mother a most respectable woman with a fruit and greens stall in Covent Garden Market. At fourteen, Mary was put into service with a lady in nearby Charles Street, but it irked her and she took a stall in the market, specializing in nuts and becoming well-known as an honest business-woman with a lively wit.

Sometime in 1717 she 'married' 'Smock-fac'd Tom' – so nicknamed for his smooth manners – but the marriage slipped a little and she was befriended by William Murray (later first Earl Mansfield and Lord Chief Justice) who introduced her into the world of fashion and to various scions of the nobility, as well as reigning beauties like Sally Salisbury and Nancy Dawson, who showed kindness and understanding to young Moll. She had one sterling quality – when all others were dead drunk she remained sober. Still keeping her stall in the market, she amassed a fair sum of money.

Meanwhile, Tom also had accumulated some money and they got together again and decided to open a coffee-house, taking one of the row of shacks opposite St Paul's Church at a rental to His Grace the Duke of Bedford of twelve pounds per annum. Selling coffee at 'a Penny the Dish' and working very hard, they rented a second and then a third shack – and still could never accommodate all their customers. Because of the market they worked very long hours, and during the fruit season they had to keep open all night.

This paid off, because the young rakes and their misses could make their assignations there. It was so popular that 'every Swain from the Star & Garter [the nobility] down to the humblest … could find a *Nymph* there'; but at Moll's insistence there were no beds in the establishment except their own in the attic – a wise precaution, which saved endless trouble from the Law in future years. An additional attraction was 'Tawny Betty' – a very comely and pleasant black girl who acted as waitress. A contemporary ballad describes Moll as 'the *Fat Priestess* … known by her comely Face and portly mien and Voice sonorous' inviting all to Bacchanalian rites. There one could meet not only the High and

Mighty but also the reigning Toasts of the Town, such as Betsy Careless (just taking over Sally Salisbury's domain) and the young up-and-coming Fanny Murray. All the lovelies were 'drest up fine and pritty and elegantly as if going to a Box at the Opera'. After midnight they would be joined by the young bloods coming from the 'Field of Blood', a brothel in nearby Charles Court. By then Moll's coffee-house was crowded with 'Bucks, Bloods, Demireps and Choyce Spirits of all London'.

On 20 August 1730 Moll was delivered of a son, also Tom, who was sent at fourteen to Westminster School. He left four years afterwards to make a career as an actor, then as an actor-manager – although at no time did he appear to acknowledge his parentage.

Not all was sweetness and light. On 31 May 1736, Moll was involved in a fracas during Mass at the Sardinian Ambassador's chapel nearby. Some time later she and her nephew, William King, were charged with keeping a disorderly house, but they were released on bail. In 1739 George Augustus Steevens observed, 'In one of the rooms you might see grave looking men half mizzy-eyed eying askance a poor supperless Strumpet asleep on a Bench her ragged Handkerchief fallen, exposing her bare Bosom on which these old Lechers were doating. This was the Long Room.' Then Tom would come in and turn out anyone who did not order a drink. Jolly 'Clarett Drinkers' would play jokes and horse around. There were two small rooms only for drinking. In one, 'it was common to see half-a-dozen "Ladies" scratching one another for possession of a man whose Person they cared for as much as a Sexton cares for a Corpse', while in the other room, men and women were making 'a Jollity' – rioting, shrieking murder, breaking bowls or simply fighting. That insatiable whore-hunting magistrate Sir John Gonson was always thwarted because he could not charge her with keeping a bawdy-house: a disorderly house only merited a fine.

Every bawd in Covent Garden could be found at Moll and Tom's, having a chat or a drink or tally-broking or lending money, or seeking out their girls who might have slipped out for a while. Famous 'Mothers' could be found there, such as Mrs Needham, Mothers Burgess and Griffiths and the less well-known Mother Lewis, Mother Page and Mother Catey. Moll and Mother Hayward were bosom friends, looking out for cullies on whom 'to play a Finesse' – their secret argot for a confidence trick. A waiter would bring up a tray of broken crockery, and would then charge a much drunken customer anything up to twenty pounds for 'the damage he had done ... and extra for the broken china'.

Other important visitors were Richard and Elizabeth Haddock, who ran the hot baths. Moll strongly disapproved of Dick Haddock's *modus operandi*, but did not reject his company.

Meanwhile, Tom was drinking himself to death and no longer useful in the business. They had bought 'a gentle villa' on Haverstock Hill in Hampstead in which he died in 1739. From this time the coffee-house was known as *Moll King's*, now becoming 'the haunt of every kind of Intemperance, Idleness, the Eccentric and Notorious in every walk of Life ... Noblemen would go in full Court Dress with swords and Bags in rich brocaded Coats, and walk and talk with ... Chimney-sweeps, Gardeners and Market-people.'

With Tom's death, Moll's character changed. She became quarrelsome, earning the sobriquet of 'The Virago', and taking to drink. Her behaviour landed her in Court on 9 June 1739, when she was fined £200 for keeping a disorderly house, sentenced to three months in jail and required to find security for good behaviour for three years. She refused to pay the fine and spent three months in Newgate, during which time she negotiated with the High Bailiff to reduce the fine to £50. Her sojourn in prison was not very onerous because 'she bribed liberally where it would be best appreciated and received many distinguished visitors.' Her nephew William ran the business in her absence. She is known to have bribed witnesses on previous occasions and been acquitted, but this was a small victory for her persecutor, Sir John Gonson.

She retired to her Hampstead villa in about 1745 with a considerable fortune, living very quietly and renting a pew in the nearby church on Haverstock Hill, not far from the Load of Hay tavern (now the Noble Art). Her friend Nancy Dawson was to live next door from 1761; known in 1888 as Moll King's Row, the street is now known as Dawson's Terrace. Moll died peacefully in her bed on 17 September 1747 and several encomiums were published, the best being *Covent Garden in Mourning*. Her memory remained vivid for another generation.

Many of her cronies also became famous in their time, their whore-houses livening up 'the Garden' till the end of the century. Their girls would slip over to Moll King's for a drink or a gossip until they were rounded up again. The broadsheet *The Paphian Grave* (1738) describes such an occasion:

Each vacant bagnio is desert seen
From Haddock's, Heyward's – down to Mother Green.
 Refrain from tears ye *Haggs of Hell* – refrain

Each girl will soon return and bring a Swain
Loaded with Gold, who at vast Expence
For to support your curs'd Extravagance!

Richard and Elizabeth Haddock were known in the Piazza and the Strand as early as 1721. Richard gained a spurious reputation for respectability for his bagnio, the Turks Head, in the Strand, but he was in fact one of the worst whore-mongers, his ploy being to rent small establishments ostensibly to be used as coffee- or chocolate-houses, or as milliners' shops, with one girl as manageress and two or three 'waitresses' or 'milliners'. These nubile nymphs would offer, 'refreshments and themselves' to customers in the back rooms. He took a large percentage of their earnings besides charging them between two and three guineas a week as rent. He hired out extras such as 'decanters and glasses, a few ricketty chairs and tables and old beds ... not worth in all above Ten Pounds ... against a Note of Hand for Forty Pounds.' If they failed to pay promptly or upset him – or his wife – he would call in the debt at once and put the defaulter into the debtors' prison, refusing to bail them out unless they paid up and promised to behave themselves in future. (It was this tactic which displeased Moll King, who upon occasion would help out a 'hard working girl but not an expensive Courtezan' with a loan. Sophia Lemoy was one of his trustys – she may have been a partner – having been caught up in 1724 running the King Street chocolate-house. In 1727 she was managing the house in Bridge Street 'selling twopenny glasses of *Usquebaugh*', and she was still there in 1733.

Upon Richard's death in 1748, Sophia Lemoy managed his brothels until Elizabeth's death in 1754, when she became executrix of Haddock's estate and ran the three brothels in the Piazza until 1762. They were then taken over by a Mr Howland and in 1765 by Mother Thornton who carried on till 1780. Haddock also owned the Blue Posts in Exeter Street (in which the unlucky Betty Saunders was caught in 1724); in 1740 the *London Journal* noted that it was one of those houses, 'a *Café* as they call it ... constantly graced by three or four painted harlots.' He had yet another brothel in Russell Street from 1733 to 1745.

Mother Dillon alias Mrs O'Neale ran the brothel the Blakeney's Head right next door to the Police Office in Bow Street, while her husband ran the Lottery Office nearby. Mother Nan Griffiths was popular enough to merit a puff in Edward Thompson's poem *The Demi-Rep* (1766):

When Mother Griffiths bawds a little Muse
And makes the Master Laureate to the Stews:
Oh! Mother Griffiths, bawdry Matron, Hail!
With Langhorne's loose Effusions at thy Tail!

William Langhorne was then Poet Laureate, and presumably well-acquainted with her establishment, although no trace of a puff can be found in his extant poems; to add to the confusion there were several Griffiths around the Garden. The most likely candidate is Margaret Griffiths who operated in King Street from 1710 onwards.

Somewhat better known was Mother Burgess, whose speciality was flagellation. In *The Paphian Grove* (1738) her forte was exposed in the following verse:

BURGESS now does bemoan her absent fair
And with their quick return:
But let my MUSE advise to ease your pain
Back to your Flogging-shop will return again.

With Breeches down, there let some lusty Ladd
(To desp'rate Sickness desp'rate Cures are had!)
With honest Birch excoriate your Hide
And flog the Cupid from your scourged Backside!

Here was a clan of brotheleers. William Burgess started in Russell Street in 1711, moved to Hart Street in 1719, and was still there in 1753. Thomas occupied no fewer than five houses in Drury Lane from 1711 onwards paying an annual rent of £60. James operated from James Street from 1720 to 1740, and John was in Bow Street from 1727 to 1733.

Little is known about Mother Cane, who is first noted in December 1730 when 'Mary Row *alias* Mother Cane *alias* Dixon … was fined Two Marks and sentenced to six months … for keeping a Disorderly House.' Seven years later Mother Cane's aliases were Shute and Monk, when she was up before the Middlesex magistrates for keeping a disorderly house in Bedfordbury (a small winding lane linking Chandos Street with St Martins Lane). She was sent to the Tothill Fields Bridewell for three months but fined only one shilling, 'on account of her extreme poverty', which evidences a sharp decline in her business. She was clearly well known to Moll King since she was included in the list of her cronies in 1739; and there may be a link between her and the young Elizabeth Bridget Cane born in 1750 whose antecedents were obscure; her father was allegedly a poor Methodist shoemaker, and she rose to be one of the most famous and richest

of all the Georgian courtesans, eventually marrying Charles James Fox in 1795 and dying at the age of ninety-one.

Little is known about Mother Green and her Hart Street whorehouse: but a Joseph Green operated in Henrietta Street as early as 1710. Mothers Haveman and Page together with Mothers Lewis and Catey still remain otherwise unidentified; but far and away the most famous of all Moll's cronies was 'the Empress', Mother Jane Douglas, who for more than thirty years dominated British whoredom.

17 Charming Betsy Careless and Mother Jane Douglas, the 'Empress of Covent Garden'

The sad death of Sally Salisbury in April 1724 in Newgate, after her unfortunate attempt to kill her faithful lover Sir John Finch, left a gap in High Harlotry which was to be filled by a nymph from the Shakespeare's Head. She was known as Betsy Careless, although born Carless, of very humble birth, and became 'a peerless Beauty … the Gayest and Wittiest of all the Courtezans around Covent Garden'. Henry Fielding recalled that in his youth he 'had seen her on the balcony of the Playhouse and remarked on her modest and innocent appearance and a pity she was on the way to ruin in such company', until he remembered that only a few days earlier he had seen her 'in a bed at a bagnio … smoking tobacco, drinking Punch, talking and swearing obscenely and cursing with all the impudence and impiety of the lowest most abandoned trull of a soldier'.

As a young girl she had been 'protected' by the gay and riotous young barrister Robert Henley, later to become the first Earl of Northington and Lord Chancellor of England. He cast her off when her drinking and licentious behaviour threatened his own career – although he was no paragon of virtue and was known as 'the Great Buck Henley' in 1735. He was still keeping contact with her when in 1733, under the name of Elizabeth Biddulph, she was operating from a sleazy alley known as Tavistock Row on the south side of Covent Garden. She then moved into the Piazza until 1735, her constant paramour then being Sir Charles Wyndham, 'an unexampled instance of Debauchery who had more than once acquired instead of a Virgin, a *Verole*'. Before homing-in on Betsy, he had sponged on other Covent Garden whores, such as Mrs Latimer and the capricious Nancy Featherstone. It was said that he was not so much attached to Betsy as to her house, in which he was living scotfree and

elegantly. However, his lordly presence encouraged other lordlings to her bagnio. Later he succeeded to the Earldom of Egremont.

Although Betsy had been a highly successful whore, she was no businesswoman. She was too incompetent to learn how to run a brothel, and she was a heavy drinker. Within two years the bum-bailiffs forced her to vacate her home in the Piazza, which was then taken over by Jane Douglas. Betsy moved to very inexpensive premises, advertising in the *London Journal* in 1735:

> Mrs Betty CARELESS from the Piazza in Covent Garden NOT BEING ABLE to make an End of her Affairs as soon as expected intends on MONDAY NEXT to open a COFFEE HOUSE in Prujeans Court in the OLD BAILEY where she hopes that all her FRIENDS will favour her with their Company notwithstanding the Ill-situation & Remoteness of the Place since her Misfortunes oblige her to remain there.
>
> NB. It is the Uppermost House in the court and Coaches and Chairs may come up to the Door.

It was too late. Drink and debauchery took their toll. In October 1739 the *Gentleman's Magazine* carried the announcement: 'WAS BURIED from the Poor-house of St Pauls, Covent Garden the Famed BETTY CARELESS who helped the gay Gentlemen of this Countrey to squander £50,000.'

The house in the Piazza was to become very famous under its new owner, Jane Douglas. She was born in Scotland about 1698, of a good family – there was a plethora of noble but indigent Douglases in London trying to make a living – but John Gay called her 'that inimitable Courtezan', when she was free-lancing from a splendid house in St James, Piccadilly. She was then, 'a Tall Straight and Genteel Woman with a clear Complexion and a very dignified Deportment'. Her clientele was drawn from the very highest in the land, including William, Duke of Cumberland, whom she always addressed as 'Great Sir'. He showed his appreciation by presenting her with some massive silver plate, which was prominently displayed on her sideboard and was popularly known as 'Billy's Bread Basket'.

She entertained peers, princes and men of the highest rank, 'all of whom were fleeced in proportion to their Wealth and Dignity', and also 'Women of the Highest Rank … who came *incognito* … the Utmost secrecy being preserved'. Jane Douglas' paramour at this time was John Williams, later to be created first Earl of Fitzwilliam.

In 1735, for some reason not explained, she moved into the King's Head at no. 13/14 the Piazza. It formed half of a very large

premises, very commodious and with an internal privy – then a great innovation. Superbly furnished and decorated with Old Masters on the walls, resplendent in gilded frames, 'Demi-reps of an inferior class resorted thither' now, as well as many actresses anxious to earn some extra money. Peg Woffington 'often sacrificed there at the Altar of Venus' when she was hard up. By 1743 it was described as 'a Cattery' and Mrs Douglas as 'a great flabby fat stinking swearing hollowing [sic] ranting Billingsgate Bawd ... and Whore to Lord Fitzwilliam.' Thus Sir Charles Hanbury-Williams' spiteful description, but, through drink and debauchery, she had indeed grown very fat.

The brothel was much patronized by the captains and agents of the great East Indian ships, who gave Jane Douglas and her nymphs 'expensive presents of Silks and Jewels and Money ... Chintzes and Damasks and glittering China.' Through her close connection with the Duke of Cumberland she was assured of custom from army officers at home and on leave, particularly those from India who were as generous as the Nabobs. (Mother Hayward once spitefully remarked of this, 'that if a Dogg was to come into her house from India she would give him a fine dinner as an acknowledgement of the many fine presents and many Long Bills paid to her by Christians from those parts'.) One of her best clients was Dr Richard Mead who, although he came seldom, always spent a hundred guineas: 'his great Delight was to have a number of Wretched Women dance before him!'; but as he was researching into venereal disease he was no stranger to other famous whore-houses.

Mother Douglas was also mindful of her clients' welfare and bought 'Cundums by wholesale from J. Jacobs, *Salvator & Cundum-maker* in Oliver's Alley in the Strand ... selling them by retail at very high profit'. She also sold them nostrums like Dr Misaubin's pills 'prepared by him at the Green Hatch and One Lamp in Holborn', as a specific against venereal disease.

From time to time her 'peaceful honest tradeing' was interrupted by Sir John Gonson's antivice squads, which cost her fines and even short spells in prison, and a longer one between 1747 and 1750. Not long before she died, Thomas Legg wrote a ballad *Covent Garden*:

> Dear DOUGLAS still maintains her Ground
> EMPRESS o'er all the Bawds around;
> (Where Innocence is often sold
> For Hard Cash! for shining sordid Gold)
> By Craft she draws th'unwary in
> And keeps a Publick House of Sin!

In 1759 she was arrested together with Jack Harris, charged with procuring a girl and having 'taken poundage from her', but it was reported that 'the veteran Abbess of the Piazza' preserved her liberty by finding bail.

In 1749 William Hogarth, who frequented her house to draw the characters in his satirical paintings, depicted her in *The March to Finchley*. She is also seen in an engraving by Thomas Burke, *A Constable's Ramble*, showing the up and coming courtesan Betsy Weems (Wemyss) and six men. Mother Douglas is finely apparelled with rings on all her fingers, the constable is dead drunk, and rather strangely there is a Jew in the corner putting his wig in the chamberpot.

In 1760 the playwright Charles Johnson met her and observed: 'Her Face presents the remains of a most pleasing sweetness and beauty ... her body bloated by drink and debauch ... her legs swelled out of shape.'

She died at her house in the Piazza on 10 June 1761: 'full of years and riches, thanking God for the continuing successes of the Army and the safe return of many of her Babes of Grace in the Forces.'

The house and its contents were sold off by her friend and neighbour, the famous auctioneer Abraham Langford, who made many witty remarks as he auctioned 'the fine Old Masters, rich Furniture and costly properties.'

With Mrs Jane Douglas' death in 1761, it can be said that the era of the old-style whore-houses ended. Her successors were no longer bawds but madams and 'Abbesses', and their establishments became 'Nunneries' graced by nubile 'Nuns'. Covent Garden was to give way to St James', although old-fashioned prostitution was still available eastwards in Farringdon Ward and its environs around the City. However, no history of Covent Garden's night-life would be complete without details of the infamous tavern known as the Shakespeare's Head and its *deus ex machina* Jack Harris.

18 The Shakespeare's Head
and Harris's Lists

In 1638 Inigo Jones began to build 'stately buildings in the Piazza for Persons of the Quality … [the houses] rising two stories' on the estate of the Duke of Bedford abutting the Strand; however Hollar's map of 1640 indicated a tavern, undoubtedly the only one since prior to 1720 the houses on the Piazza: 'were forbidden to be converted into public Ordinaries of Victuallers-Houses or for the sale of Coffee, Chocolate or any Liquors.'

The tavern was the Lyons Head, of which no more is heard. The famous market for fruit and vegetables was not established until 1705, from which time the ambience starts to deteriorate.

Many of these large houses – some with a frontage of fifty feet – were by 1720 converted into coffee-houses or taverns. By 1721 all the persons of the quality had moved out of this Piazza, with the exception of Lord Andrew Archer and Lord Mordington, both of whom were running gambling-houses. Some of the larger premises were split in two. One of these was no. 13/14, where in 1726 Sarah Ann Gardiner ran the Shakespeare's Head coffee-house on one side and Abraham Lewis the Bedford Head coffee-house on the other. They had one thing in common – a bad reputation – being often in the news for riotous behaviour of the gentlemen of the quality and the whores and drunks who patronized them.

Mrs Gardiner died on 12 June 1735 and was buried in the nearby church of St Paul's. Her tavern, no. 13, was taken over briefly by John Colebourne. By 1740 one William Horseley was paying the rates 'for the tenants', one of whom, Richard Crofts, was 'paying the rates for the northern part of no. 13,' the Shakespeare's Head. He was doing well because the cook, Mr Twigg, 'provided good food' while Crofts provided 'good ambience', so that the place was patronized by such as the directors of the great East India Company 'and the Captains of its ships'. Indeed the principal rooms were known as 'clubs' – respectively the Madras, the

Bengal, and the Bombay. After indulging in good food and copious drink these convivial nabobs demanded good sexual intercourse, which was readily available at Mother Douglas' establishment immediately adjacent.

By 1747 the tavern had been taken over by a vintner, Mr Packington-Tompkins, his head-waiter and general factotum being John Harris, usually known as Jack. From this time it became the very Mecca of courtesans, largely due to Harris's flair in reviving an old device first credited to Simon Fish in Henry VIII's time – a regular catalogue of whores (although the old Divine wanted to warn that 'one burnt with Lepry of one woman can bare it to an other').

Harris' first lists were hand-written in 1747, but the demand was so great that in 1758 a first edition of *The New Atlantis* 'price 2s 6d sewed' was printed – no copy survives. Shortly afterwards, no fewer than 8000 copies were 'subscribed for'. It was a small book about six inches by four, with a hard cover, the title page reading:

> HARRIS LIST OF COVENT GARDEN LADIES or the NEW ATALANTIS for the year 1761 to which is annex'd The Ghost of Moll King, or A Night in Derry's. London. Printed for H. Ranger near Temple Bar.
> MDCCLXI

Therein is an alphabetical list of women's names, with the vowels missing but easily recognizable, followed by a series of vignettes – often not very flattering, each vignette occupying about half a page, with addresses where she may be found, her speciality and her charges. It was something of a cachet to have one's name included and certainly ensured an increase in business. A sample vignette in the 1747 list, describing a young lady who later became one of the most famous courtesans, must suffice:

> Perfectly sound in Wind and Limb: a fine Brown Girl rising nineteen years next Season. A good Side-box Piece – will show well in the Flesh Market & wear well. May be put-off for a Virgin at any time these twelve months. Never common this side of Temple Bar but for six months. Fit for High Keeping with a Jew Merchant NB. A good Praemium for this same … if she keeps out of the Lock she may make her Fortune and Ruin half the Men in town.

This young girl was Fanny Rudman, soon to gain great fame as Frances Murray and be chased by Princes and the greatest noblemen. She had already 'been on the game' for four years and had had a rough time. She said later that she had been:

Enroll'd on his Parchment List as a new Face ... and thereafter had been introduced to the Whores' Club at the Shakespeare's Head which met every Sunday evening to pay Harris his Poundage and discuss and compare notes with the Sisterhood.

Harris took twenty-five per cent of their earnings, and they had to give him a written undertaking before enrolment to forfeit £20 if they had given wrong information about their health.

In 1759 Harris was arrested (together with Mother Douglas) and brought before Judge Saunders Welch 'for procuring a girl for a Gentleman and taken Poundage from her'. He was committed to Newgate as a 'common pimp and Procurer of women for bawdry purposes'; the informing harlot had probably objected to paying poundage to both bawd and pimp – very conveniently she disappeared. After this there appeared *The Remonstrance of Harris* in which he 'set forth his many Schemes in Town and Countrey for the Service of the Publick', in which he allegedly avers:

> The whole amount of the Charge against me is that I am a Pimp: I grant it ... that I need not be ashamed of the Profession from its Antiquity and the Honourable. Nay!

Thereafter he was known as the 'Pimp-General to the People of England'.

His tavern is described in 1755, 'with drunken and starving Harlots ... and wanton embracing of Girls on the sanded floor ... who complained that it soiled their Clothes.'

In May of that year James Boswell picked-up a couple of girls in the Piazza and:

> Having a little Money took them for a Drink in the tavern where they were shown into a good Room & had a bottle of Sherry ... found them good for amorous play ... and solaced by existence with them one after the other ... enjoying High Debauchery with genteel Ceremonial.

Next day he found that one of them had given him gonorrhoea, which made him *hors de combat* sexually for some weeks.

Thomas Brown in *The Midnight Spy* (1766) called it the 'Black Hole of Sodom' because there were 'flogging Cullies ... unnatural Beasts ... being scourged on their Posteriors ... by the *Posture Molls.*'

The last Genuine Harris List is that of 1765, now in the State Library in Brussels. Harris died in that year and is buried in

Frontispiece (facing page) and title page from *Harris's List* of 1773. The book lists all the most famous demi-reps, including Mrs Hamilton of whom it is laconically recorded, 'The public has enjoyed her.'

HARRIS's LIST

O F

Covent-Garden Ladies:

O R

MAN OF PLEASURE's

KALENDAR,

For the YEAR 1773.

CONTAINING

An exact Defcription of the moft celebrated Ladies of Pleafure who frequent COVENT-GARDEN, and other parts of this Metropolis.

THE SECOND EDITION.

LONDON.

Printed for H. RANGER, Temple Exchange Paffage, Fleet-Street.

M DCC LXXIII.

nearby St Paul's on 18 May 1766. It was continued for a while by Sam Derrick, but he too was to die in abject poverty in March 1769. No complete collection of these lists exists: that for 1764 is in the Lewis Walpole Library at Farmington, CT, USA; the British Library has the volumes 1788 to 1791.

The Bedford Head was no better than its house-mate and is frequently mentioned; of even worse repute was the Rose Tavern in Russell Street, in which it was said, 'the real *Rake* gambles fucks drinks and turns night into day there'. It was famous for its posture girls who specialised in strip-tease and flagellation. In plate 3 of Hogarth's Rake's Progress (1733), a Posture Moll is seen unclothing herself preparatory to being whipped or performing any other posture demanded of her. In *The Adventures of a Young Gentleman* (c. 1745) there is a graphic description of what ensued 'after Miss M ... the famous Posture Girl had stripped and climbed onto the table ... each Gentleman filled a Glass of Wine and ... placed their Glasses on her *Mound of Venus* ... (what time all of them were drinking their Bumpers) as it stood on that tempting Protuberance'. One of the best known such striptease artists was the young Jewess Amy Lyon, who as Emma Hart, was eventually to become Nelson's Lady Hamilton.

Last, but not least of Covent Garden's sexual luminaries was Elizabeth Weatherby, who ran the Ben Jonson's Head, on the Playhouse side of Russell Street as a coffee-house after Moll King died. It quickly attracted 'all the Rakes, Gamesters, Swindlers, Highwaymen, Pickpockets and Whores' who had been wont to drop into Moll's place. The entrance fee was just the price of a cup of *Capuchin* coffee so that 'a great number of Venus' votaries attended ... to serve all Ranks and Conditions, from the Chariot-kept Mistress down to the Twopenny Bunters who ply under the Piazza'. What it was really like is evidenced by a report in 1756:

> The unfortunate Strumpet who had been starving in a Garrett all day long while washing her only and last shift, upon making her appearance at Weatherby's might probably meet up with a greenhorn Apprentice-Boy ... if his finances were in proper plight he might be induced to tip her eighteenpence worth of Punch ... and be deluded to go to a Horse-pond bagnio ... for the remainder of the night.

Mrs Weatherby's main claim to fame is her launching and protection of the famous courtesan Lucy Cooper, whose beauty and charm made her the successor to Betsy Careless. Also to be found there was the Wall-eyed Beauty, Betsy Weems (a scion of

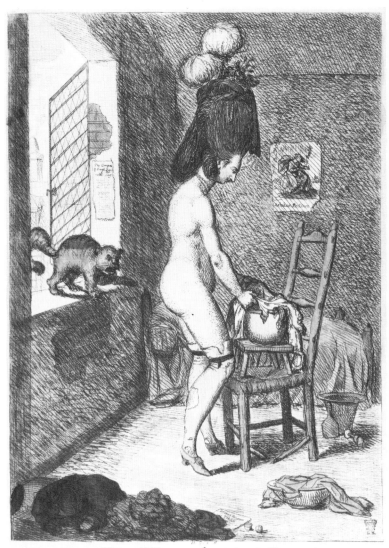

THE WHORE'S LAST SHIFT.

Publish'd Feb'y 9th 1779 by W.Humphrey.

William Humphrey's depiction of *The Whore's Last Shift*, 1779. Thought to depict a promiscuous lady of the Court. The cat on the window-sill has a particularly fiendish and lecherous look

the noble house of Wemyss), who had a glass eye. In a very lewd song in *The Gentleman's Bottle Companion* (1768) she is eulogized in the opening stanza as 'Bet Wymes, of Wedderby, the pride', cavilling at the success of her friend and rival Lucy Cooper:

> Must Lucy Cooper bear the Bell
> And give herself such Airs?
> Must that damnation Bitch of Hell
> Be hough'd by Knights and Squires?
> Has she a better Cunt than I
> Of nut-brown Hairs more full?
> That all Mankind with her do lye
> While I have scarce a Cull?

Despite the handicap, Betsy Weems (or Wheems or Wemyss – there seems to have been great difficulty in getting the spelling right) was just as highly successful in her career as any of the other rival beauties. She was to die in 1765. Lucy, after some brushes with the law, in 1769 was 'left without friends or money after a long confinement and now destitute of beauty and past the time when youth supplied the place of charm'. She tried to run a bagnio of her own in Bond Street, and died in poverty in 1772. Elizabeth Weatherby was to die in 1765 – although another woman of the same name was operating a high-class brothel in St James Street, Piccadilly, until 1774.

The ultimate centre of attraction to all beaus, Venus' handmaids and literati was Bob Derry's infamous Cyder Cellar – generally just known as Derry's – in Maiden Lane. The *Meretriciad* (1765) wrote of Lucy Cooper:

> Bob Derry's where the Harlots throng
> Cit, Souldier, Sailor and some bearded Jew
> In triumph reeling, bore Thee to some Stew.

In the ensuing riot there described, the constables took 'the captive Queen Lucy' before the magistrate because two Jews were killed; and it is possible that the 'long confinement' was the long sentence she received. Thompson's ballad continued:

> The Shakespeare's Head, The Rose and Bedford Arms
> Each alike profits from my Lucy's charms …
> Fat Wheatherby sunk now in eternal Sleep
> Weep! Weep! my Lucy – Wheatherby's no more.

Bob Derry's was to sink to ever lower depths: it finally closed down in 1832.

In 1736, in a pamphlet entitled *A Trip Through the Town*, appears

one of the earliest references to 'young Jews of the tribe of Mordecai' frequenting the Covent Garden whorehouses: 'three or four times a week, particularly on Sundays ... with Upright Gait, Morose Speech and pretty smooth Countenance.'

By this time the younger generation of the Sephardic Jews – of Spanish and Portuguese ancestry who had fled to the Netherlands to escape the murderous Inquisition – were completely anglicized. They were no whit inferior to their Gentile contemporaries in foppery and lechery and wearing swords – except on the Sabbath – and freely spending money on drinking and loose women on Saturday evenings – the Sabbath ended at sundown.

Their generosity to their mistresses and whores is depicted in Hogarth's the *Harlot's Progress*. The earliest record of a Jewish bawd occurs on 15 August 1724 when: 'Rose Marks was convicted of keeping a Disorderly House in Duke's Place, St James ... causing a great Disturbance.' She pleaded poverty and was fined thirteen shillings and fourpence 'and required to find a Security for Good Behaviour in the sum of Two Thousand Pounds for one year'. Clearly the magistrates doubted her poverty.

These young Jews were in general popular in bawdy houses: they were heavy spenders and good lechers, but they were not heavy drinkers. They were invariably kind and courteous to womenfolk, which was a great virtue when drunken brutality was a whore's great hazard. *The Female Rake* (1736) dealing with the reformation of whores has the lines:

> Leave to young Levites that Praiseworthy Care
> Of saving Souls by Vigil and by Prayer.

It is probable that the famous bawd known as Mrs Gould was a Jewess keeping a (more or less) Jewish brothel. Elizabeth Gould or Gold opened a bagnio in 1742 on the west side of Bow Street, and by 1745 she occupied much better premises at No. 11 Russell Street adjacent to the Little Piazza, later called the Hummums when, for a while, there were real hot baths which were real brothels as well. In imitation of Mrs Goadby her seraglio was well appointed and well staffed. It was 'a Quiet House' with an eclectic clientele. She had the backing of the wealthy Jewish Notary Public, Moses Moravia, ship-owner and ship-broker, who up till 1752 was well esteemed. In June of that year he and his partner were fined, pilloried and jailed for a year for conspiracy to defraud an insurance company. He died in poverty in 1767.

Mrs Gould would not permit any bad language: 'No woman who was addicted to intoxication or used bad language was

allowed to enter her establishment. Her clientele consisted of wealthy City Merchants, Brokers, and Bankers who would come to her House on Saturday evenings and stay over until Monday mornings.' They were looked after in luxurious surroundings with a cuisine of the very highest order, with the finest wines served by impeccably trained personnel. Their sexual needs were taken care of by carefully hand-picked and educated young ladies of 'the best Quality and the greatest Discretion'. It was a quiet respectable house 'for respectable Gentlemen glad to get away from the Noise and Stresses of the Exchange'. If they wanted noise and excitement they had only to go a few yards around to the Piazza.

Since the establishment was run with quietness and discretion, it avoided all disturbances and never attracted the unwelcome attentions of the law's minions. It was occasionally mentioned in the fashionable press. In *The Court of Cupid* (1765) Mrs Gould is equated with Mrs Goadby in the ranks of the highest bawds, although she is said to have been 'waddling', which suggests a certain embonpoint common to all successful bawds.

In March 1769 disaster struck the Hummums and the adjacent buildings were destroyed by fire, but she seems to have re-established her business at the corner of Russell Street and Bow Street. She is mentioned again in *The Meretriciad* (1770) and in *Nocturnal Revels* (1779), the latter implying that she had by now retired 'with a handsome fortune'. (There was a Mrs Gould running a brothel in Wells Street off Oxford Street in 1793, but it is doubtful whether it was the same lady.)

19 The Great Bawds

Mrs Jane Goadby

In the autumn of the year 1753 the haut ton of London was beguiled by a quite new development, devised to assist the noble and the rich even more in their amorous adventures. The lady who introduced this new type of French brothel to England was Jane Godby, usually known as Mrs Goadby.

Mrs Goadby had visited France frequently and was much struck with the houses, the decor, the cuisine and, above all, the superb management qualities of Mesdames Justine and De Montigny in the prestigious Fauberg St Honoré catering for the highest in the land. She was also impressed by the establishment run by Madame de Gourdan in the Rue des Deux Portes, which catered for a rather wider range of lechers. From the first two ladies Mrs Goadby learnt how to give maximum ease and comfort to the nobility, from the latter she absorbed knowledge of the techniques needed to empty the pockets of a much greater and less exigent clientele.

Madame de Gourdan's *maison de tolerance* had one 'open' entrance on the Rue des Deux Portes, for those not ashamed to be seen entering a brothel, and a more discreet entrance through an antique shop in the Rue de St Saveur. Through the first entrance one entered some rooms designated *La Maison d'Abbotage* (literally, an abattoir), kept for common prostitutes and providing quickies at low rates for the less wealthy customers, the 'abattoir' signifying that all the 'meat' was fresh daily. The other section was much more *recherché*.

In this section, voyeurs could watch the process of examining and cleaning-up of the *mignonnes* newly arrived; this facility was generally offered only to the wealthiest clients who could then take their pick. In *L'Infirmerie* the nymphs could dress up as nuns, or fairies, or whatever was needed to tickle the jaded appetites of the elderly gentlemen, or even arouse them with perfumed

switches for their buttocks. This particular salon was furnished with erotic paintings around the walls as well as sparkling mirrors. There was the *Salon de Vulcan* with special chairs in which girls could be strapped so that very exigent clients could exercise any sadistic manoeuvre, but there was a spyhole to ensure that the girls were not unduly harmed. Finally there was the *Salon des Voyeurs* where they could witness other people's activities and participate if they so wished.

Accordingly Jane Goadby determined to emulate these examples, making allowance for love in a colder climate, and in 1751 she rented a house in the newly fashionable Berwick Street off the Oxford Road. By 1754 she was renting two houses to cope with the expanding business. She had decided to cater for the up-market clients, and these new large premises were furnished with every luxury and modern conveniences then known – although chamberpots still had to be carried down and emptied in the backyard. Baths too, were available, the same poor overworked maids having to traipse up and down with the hot water vessels. She recruited servants, lackeys, a chef to ensure the finest French cuisine, a surgeon and a carriage. She accepted only the most beautiful and charming girls without distinction as to race and colour – or even religion – believing that girls from different lands and cultures added spice and variety to fornication. If there was the slightest suspicion of ill-health or deformity the girl was rejected. She also made it clear that her house-rules were to be accepted without question at all times on pain of expulsion.

She fitted out the girls with beautiful gowns bedecked with the finest French lace and silken underwear bought in Paris, so that they should be dressed with distinction to match the great distinction of the guests. To ensure that their behaviour was modest and decent, all gastronomic and alcoholic excess had to be avoided. The girls spent from midday till late afternoon in the large and elegant drawing-room, where some would play an instrument and others might sing in accompaniment, or just sit and embroider or arrange flowers. During this time, and at meals they were encouraged to drink soft drinks and milk, again not to excess so as to avoid bad breath and rotten teeth. No intoxicants were allowed – although Mrs Goadby had to bend her rules somewhat to allow alcohol to the guests, enjoining that the girls, while urging their paramours to drink expensively, should themselves drink very sparingly so as always to be on their best behaviour. It was a serious crime to conceal from her any gifts or monetary remuneration over and above the very expensive fixed

price of admission. (In this she differed from her French mentors – they made no charge for admission.) The gentlemen usually arrived after the theatres – and Parliament – had closed. They were encouraged to follow the French custom of offering a silk handkerchief to the *mignonne* they fancied, and, if she accepted it, she belonged to the donor for the rest of the evening and night. A superb supper would be served and there would be dancing and music until the small hours, and the bed linen would be fresh and clean.

Clearly the Disorderly Houses Act of 1751, forbidding music and dancing and other pastimes in London in unlicensed premises, was disregarded: but Mrs Goadby's extremely select clientele ensured a blind eye from authority, and even the 'Informers' from the Society for the Reform of Manners. In 1760 she moved into even more commodious premises in nearby Great Marlborough Street. Here she could call upon the services of the high-class courtesans of the day, who would be sent for and brought back in the establishment's own ornate coach. Some of these were graduates from Mrs Goadby's own academy, including the noted Kitty Nelson, who was to cause her grief by opening-up in opposition later on. The most famous graduate was Elizabeth Cane – much better known as Mrs Armistead – a 'tall finely turned-out Beauty with a perfectly symmetrical body', who came into Mrs Goadby's care when she was abandoned by her parents. At nineteen she was reckoned to be the most elegant and lovely courtesan in London. Mrs Goadby 'first put her into the care of a rich Jewish Merchant against a Bill of Sale', but Elizabeth Cane was pursued by much bigger fish. Using Great Marlborough Street as a sort of headquarters, Elizabeth Armistead passed from one noble lecher to another, from the lecherous Earls of Loudoun and Cholmondeley to the Duke of Dorset and eventually into the embrace of George, Prince of Wales who, many years later, when King George IV, still treated her with friendly regard when her husband, Charles James Fox died.

In 1765 Mrs Goadby received an encomium in *The Meretriciad*, 'waddling to the side of Mrs Gould' – her rival and contemporary – and the 'Old Goat', the Marquis of Queensberry reckoned that she was as good as Mrs Johnson of Jermyn Street. *Nocturnal Revels* in 1779 said she was still 'laying in stocks of clean goods warranted proof for the Races and Watering Places during the coming summer'. (The publisher of this book was one M. Goadby, but the connection is unclear.)

In 1771 one Robert Goadby – presumably her husband – died and was buried in the prestigious church of St Paul's, Covent

Garden, and this may have caused some slackening off of her activities. Soon after 1779 'she retired to a fine country property acquired with the great riches she had accumulated in thirty years of honest trading'. Her niche in the hall of British bawdry is secure; she set a standard of luxury and grace to be emulated and praised by all her successors, not least the remarkable Santa Carlotta Hayes.

Santa Carlotta Hayes

Of all Mrs Goadby's successors and imitators, only Charlotte Hayes possessed that theatrical flair allied to astute business acumen to ensure not only great success but also great and lasting fame. Indeed, she was the living proof that crime – if bawdry IS a crime? – does pay!

Charlotte Hayes, Lucy Cooper and Nancy Jones were three pretty and lively gamines from the same slum background who burst out of obscurity into the bright sunshine of the highest class whoredom, each achieving a measure of fame and fortune and public acclaim – except poor Nancy who was struck down by smallpox which ruined her looks and her health, reduced her to abject poverty and led to an early death at the age of twenty-two from syphilis in the Kingsland Lock Hospital. All three were born about 1725 and were 'on the game' almost from childhood. Lucy's brilliant and bizarre career was entwined with that of her 'protectress' Mrs Weatherby before she died in September 1772: all three were known to Jack Harris in about 1750.

There was a Joseph Hayes living in Tavistock Street, Covent Garden between 1720 and 1727, who was most likely Charlotte's father: her earliest days are centred about Derry's Cyder Cellar and the Bedford Arms mixing with the theatrical set. As a lively lovely teenager she was taken up by a rising young barrister, Robert 'Beau' Tracey, then living in chambers at the Temple. He was absolutely besotted with Charlotte, who could count upon him to do almost anything she wished. He readily gave her money, although he knew she was whoring and drinking it away in Covent Garden taverns. Edward Thompson, in *The Meretriciad* (1761), attests to her charm and beauty 'without paint' in 1751. Suddenly, in 1756, Tracey died, and although deemed rich, his financial affairs were in such disorder that Charlotte did not benefit therefrom. Because of her thriftless extravagance she found herself in debt and in the Fleet debtors' prison. This 'misfortune' was in fact to lead her on to fame and fortune, for in

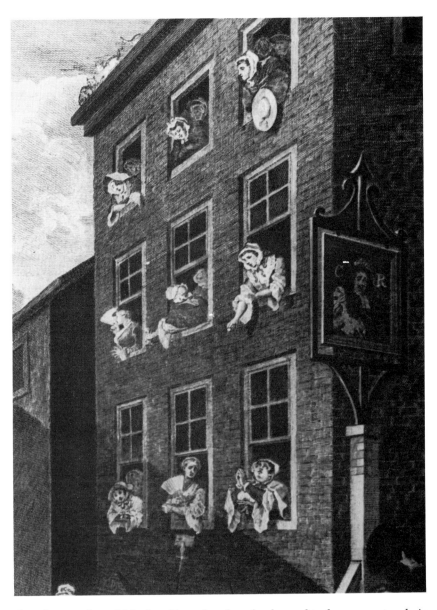

That famous bawd Mother Douglas, hands clasped to heaven, stands in the bottom window on the right, and with her 'Cattery' cheers the soldiers marching to defeat Bonnie Prince Charlie. From Hogarth's *March to Finchley*, 1750

prison she met 'Count' Dennis O'Kelly son of a 'poor squireen
from Tullow in County Carlow'. However before her incarcer-
ation Charlotte seemingly was already running a brothel around
Berwick Street because she was able to help O'Kelly along, and
from this time their lives were inextricably and affectionately
intertwined. He was gay and handsome and well-built and
through an amorous dalliance with a lady of quality – and a
remarkable knowledge of horses – he was enabled to mix with the
highest nobility on the Turf. He was in prison for a fraud
committed 'upon an American' and was only saved from a worse
fate by Charlotte's friend Sam Foote who put in a good word for
him with Sir John Fielding, the Bow Street magistrate. Charlotte
'fed and cloathed him and made him a Gentleman … in the Fleet
… when he was in wretched tatters scarcely covering his
Nakedness'. She also manoeuvred through the 'Day Rules'
(which enabled prisoners to go out during the day and come back
at night, against a *douceur* to the Jailer), whereby he was able to
make money at gambling on the horses, much of which Charlotte
salted away for him until they were released under one of the
Insolvency Acts in about 1760, shortly after the death of George II.

According to *Town and Country Magazine* (September 1770),
Denis furnished the money and she furnished the 'Nuns', but this
is a piece of spite, for in 1761 she opened a brothel in Great
Marlborough Street, Denis being 'The Prior', and a useful
super-pimp because of his rich and noble racing contacts. By 1769
'their gains in their different pursuits kept pace with each other …
[they have] between them £40,000'. In 1769 O'Kelly bought a
half-share in the Duke of Cumberland's horse Eclipse (born 1764),
which never lost a race in its entire career. In April 1770 O'Kelly
bought the other half-share and made a great fortune – The
Eclipse Stakes is still run to this day.

Charlotte's brothel was regularly graced by the presence of
such as the Duke of Richmond, the Earls of Egremont and
Grosvenor and dozens of the lesser nobility including Lord
Thomas Foley and Sir William Draper – all mighty gamblers and
wenchers. Foley helped Denis to secure a Captaincy (later a
Colonelcy) in the Middlesex Militia – although he could never get
him admitted to the Jockey Club, despite Denis' friendship with
the royals. Even so, despite her success, she realized that the only
way to great wealth and great influence was to run an
establishment even grander than that of her mentor, Mrs Goadby.

Accordingly in 1767 she moved into a large and elegant newly
built house at No. 2 King's Place, St James, a stone's throw away
from the royal palace and fashionable Pall Mall. Another

advantage was that it was next door to the extremely fashionable gambling club established in 1753 by William Almack, patronized by the same coterie which frequented Charlotte's seraglio. She furnished the house in great style and luxury, and, following an ancient prescript laid down about AD 1347 by the *Maison de Debauche* in Avignon, she called her new venture a 'Cloister', of which she was the 'Mother Abbess', and her young ladies, all *merchandises choisies*, were the 'Nuns'. Sam Foote thereupon dubbed her 'Santa Carlotta' and the house 'Santa Carlotta's Nunnery'. (However *Town and Country Magazine* (1769) called it Santa Carlotta's Protestant Nunnery, 'which however administers absolution in the most desperate Cases without Confession.') The principal difference was that in Avignon the fixed prices were nailed to the door while Charlotte's menu had no *prix fixe*.

Her nuns were hand-picked, most beautiful and shapely, and thoroughly trained in all the amatory arts to please the noblest and the richest potentates to whom money was no object. Well-fleshed City aldermen and merchants were important clients, as was the swelling diplomatic community anxious to enjoy home comforts.

She prided herself upon providing for the 'rich Levites … from Bevis Marks' (the area in Bishopsgate in the City which was then the centre of the community), and numbered among her clients the foremost Jewish magnate of the day, Gideon Abudiente, better known as Sampson Gideon, England's richest banker and a founder of the Stock Exchange; another client was the great financier Isaac Mendes.

Charlotte was equally scrupulous in fleecing Jews as well as Christians, remarking once that: 'rich Jews always fancy their amorous abilities never failed … while in her House they could forget all their worries on the Stock Exchange.' She referred to their generosity to her nuns, particularly that they always treated the girls 'with the greatest Civility, usually rewarding them with Golden Guineas.'

Charlotte, however, was not very generous with her nuns; her attitude towards them was strictly businesslike. She sold them fine dresses, lovely French underwear, gold rings and bracelets, necklaces and earrings – and gold watches – one of the *sine qua nons* of the successful Georgian courtesan. She also charged them for food, board and lodging, linen and washing: in this way, although the girls earned very large sums of money they were nearly always in her debt, unless rescued by some Maecenas who bought them out.

On the other hand she had taken many young orphans off the

street where they were like to die of tuberculosis, given them a
roof over their heads and a fairly easy way of earning a living. In
some cases she bought children from destitute or uncaring
parents; and upon occasion she would buy a girl from another
bawd at a price based upon the child's beauty and bearing or
accomplishments – the more so that her most exigent clients
demanded virgins. In a brothel, this word is elastic. There were
many girls whose deflowering needed rectifying, and Charlotte
boasted that many of her girls had been virgins very often – as
many as a hundred times! Some of her best nuns, like Kitty Young
or Nancy Feathers and even sweet young Harriet Lamb, were
passed off as virgins over and over again. Harriet, who had been
seduced by Sir Pennington Lambe and left abandoned at
Charlotte's house, was a great favourite and pet. Edward
Thompson observed in *The Courtezan* (1770):

> Hail, Harriet Lamb, who makes her daily food
> The Lamb, the Maid, from different causes feel,
> From different Feelings, licks the Butcher's steel:
> Kind Charlotte Hayes, who entertains the Ram
> With such delicious, tender, nice House-lamb!

Harriet was 'rescued' by Lord Sidney and circulated amongst his
many noble friends, growing up as the lovely and graceful actress
Harriet Powell. Eventually she married the Earl of Seaforth in
1779, just a few months before she died.

Another maiden was a certain Miss Shirley 'who had gone
through twenty-three editions of virginity in one week … being a
Bond Street bookseller's daughter she knew the value of repeated
First Editions.' Charlotte observed that a Maidenhead 'was as
easily made as a Pudding'.

Every girl was vetted by the resident physician Dr Chidwick,
who was Charlotte Hayes' personal doctor. All her fillies had to
be sound in wind and limb (one can see Tattersall's influence in
many observations made during her long life.) There were special
devices to help elderly clients. These included the special beds
made by John Gale and later modified by Lord Grosvenor for his
own bawd, Mrs Weston. They were known as 'Gale's Elastick
Beds' and were exclusive to Charlotte; when she gave up the
business there was a scramble amongst the other top-quality
bawds to secure them. It was said that Dr Chidwick had the
resources of the whole *Materia Medica* to treat all mishaps due to
over-indulgence and over-strain and venereal maladies.

She avoided the latter hazard so far as possible by supplying
'Mrs Phillips' famed New Engines' tastefully bound up in silk

purses and tied with ribbon. Theresa Phillips' shop in Half Moon Street (now Bedford Street, Covent Garden) was well-known for her 'Bladder-Policies' and 'Implements of Safety for gentlemen of intrigue'. Charlotte supplied these cundums at an inflated price to all her clients. In passing, Mrs Phillips also did a considerable business in dildoes, although there ought not to have been much call for them in a brothel.

Her charges were astronomical, for she took into account that the actual numbers of the *crème de la crème* of Society were relatively few – at most a few hundred persons – but the high cost guaranteed exclusivity. The house was large and four stories high, but even so there were times when its accommodation was overstretched. She would have to find room for all who demanded it, for to refuse an exalted client was unthinkable. In her *Memoirs* there purports to be a tariff for a 'full house'. Although this must be taken with several grains of salt there is a solid substratum of truth. The date was Sunday 9 January 1769, which perhaps accounted for the overcrowding.

For Alderman Drybones	Nelly Blossom, aged 19 who has had no-one for four days and is a *Virgin*.	20 guineas
For Baron Harry Flagellum	A girl younger than 19. Nell Hardy of Bow St. or Bett Flourish of Berners St or Miss Birch of Chapel Street.	10 guineas
For Lord Sperm	A beautiful and lively girl. Black Moll of Hedge Lane, who is very strong	5 guineas
For Colonel Tearall	Mrs Mitchell's servant, a gentle woman from the countrey who has not been out in the world.	10 guineas
For Dr Pretext	(after Consultation Hours) a sociable young person with white skin and soft hands. Polly Nimbelwrist or Jenny Speedyhand.	2 guineas
For Lady Loveitt	(Just come from Bath and disappointed in her love-affair with Lord Alto) and now wants something better. Captain O'Thunder or Sawney Rawbone.	50 guineas
For H.E. Count Alto	A fashionable young woman for an hours play only. Mrs O'Smirk from Dunkirk Square or Miss Gracefull from Paddington.	10 guineas
For Lord Pyebald	To play a game at Piquet and for *titillatione mammarum* & no other object; Mrs Tredillo of Chelsea.	5 guineas

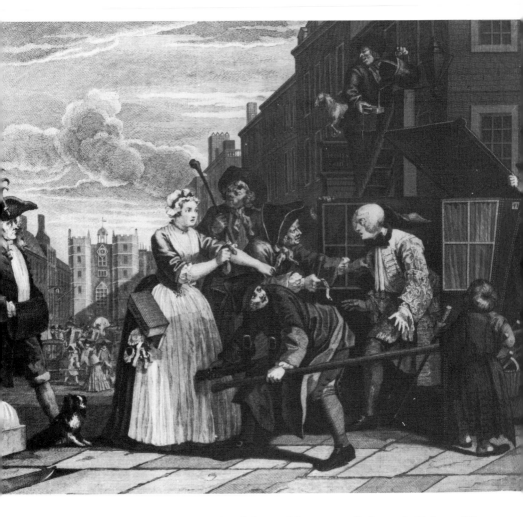

Tom Rakewell is arrested for debt on his way to St James's Palace. His former seducee, Sarah Young, vainly offers her purse as a bribe to the bailiff for his release. From Hogarth's *Rake's Progress*, 1773–5

Since these distinguished guests had indicated their requirement, outside experts had to be brought in to reinforce the existing staff. Each hireling is given an apposite pseudonym, which cannot now be traced, but most of the clients can be identified. Alderman Robert Alsop was Charlotte's neighbour in Great Marlborough Street: he had been Lord Mayor of London in 1752. Two posture molls were needed for Henry Paget, second Earl of Uxbridge, to whack his backside; while two hefty Samsons

were needed for the nymphomaniac Lady Sarah Lennox after her disappointment with Lord William Gordon. She was known as 'Messalina' in 1769. Lord Pyebald was the aged lecher Hugh, Viscount Falmouth whose predilection was known all over the town. The Colonel remains unknown but he was content with masturbation.

To accommodate this surge in demand (*vide* the *Memoirs*), Charlotte had to utilize the landing of the three-pair-of stairs: a sofa in her drawing-room, while Lord Harry was appropriately whipped in the attic nursery. Lord Pyebald, who was only able to fondle a tit or two was put in the card-room, popularly known as the *Salon de Chastité*, and Lord Sperm was given Charlotte's own bedroom.

1769, which started as a year of promise, was to prove rather traumatic for both Charlotte and Dennis. He had lost large sums of money in gambling, and Charlotte was loath to lend him more money because she was on the point of buying a house at Clay Hill near Epsom racecourse. In April, her old friend and early lover, Sam Derrick, died, leaving her 'my new system of Brothels, my apology for Whoredom and my *Treatise Upon Fornication*, not yet published'. He also left her his 'new edition of Harris' Lists … the profits from the first edition being reserved for my old friend and mistress Charlotte Hayes … for her great services to the fair.'

In October she had a brush with the law when a young girl named Lucy Fields was brought into her establishment, after having been made drunk and seduced by the Hon. Mr Wimpole, and perforce became one of her nymphs. She later married Wimpole, quarrelled bitterly with him and shot him. Charlotte appears to have been in some way implicated, but saved herself by 'a lavish application of bail money into the right palms'. She and Dennis went back to Great Marlborough Street, occupying two adjoining houses, and in 1770 they were married. (It was alleged that Dennis had already been married when he had first come to London and decamped with the girl's fortune, but there is no proof of this.)

Meanwhile No. 2 King's Place was in charge of a trusted manageress, Miss Ellison (or Allison), who carried on until 1778 when she was described as 'verie poore'. In 1771 Charlotte had taken over No. 5 King's Place, which house was to become the most famous brothel in London. She now divided her time between King's Place and Clay Hill, where she played host to Dennis' royal and noble guests – the Prince of Wales and the Duke of Cumberland would often dine there during the racing season, and M. le Duc D'Orleans was also a frequent visitor.

There was, however, one rule on which Charlotte insisted at Clay Hill: 'On no account whatsoever was any guest permitted to play or make bets of any kind at her table or in her house'. There was no ban on sexual congress with any nuns who might be present.

These extravagances took their toll on Charlotte's health and purse and by 1775 both were overstretched; Dennis's finances were also somewhat precarious. She left the running of Clay Hill to Dennis' nephew Philip O'Kelly and went back to London to live in Half Moon Street, Piccadilly.

The 1770 edition of *The Meretriciad* eulogized her as follows:

So great a Saint is heavenly Charlotte grown
She's the First Lady Abbess of the Town;
In a snug entry leading out Pell Mell
(which by the Urine a bad Nose can smell)
Between th'Hotel and Tom Almack's house
The Nunnery stands for each religious Use:
There, there, repair, you'll find some wretched Whight
Upon his knees both Morning Noon and Night!

The hotel was the Golden Lyon founded by Richard Haines in 1732 at the corner of King's Place and King Street, and by 1763 it had been extended and rebuilt.

There was plenty of competition from other 'seminaries' claiming to be of equal worth. The principal competitors were Mrs Mitchell and Mrs Goadby: indeed *The Courtezan*, while praising Charlotte, goes on to say, 'This morning, when I'm fond of all things new, I go to Goadby's.' To counter all this, Charlotte would take her beauties and parade them in St James Park, and she sought all sorts of publicity. At the notorious *Grand Bal d'Amour* held in January 1772 at the Pantheon in Oxford Street (now Marks and Spencer's) – although the proprietor had announced that very morning that 'all women of the town' would be excluded – a furore was created when Mrs Mitchell and Charlotte led their bevies of nuns on to the dance floor.

Charlotte now came up with a brilliant idea. Captain Cook had just discovered Tahiti, reporting that their handsome young men and lovely maidens copulated in public. She sent a circular to all her most especial clients inviting them to a 'Tahitian Feast of Venus', which would start at seven o'clock precisely when 'twelve beautiful spotless nymphs all virgins will carry out the Feast of Venus as it is celebrated in Oteite', under the instruction of Madame Hayes who 'will play the part of Queen Oberea herself', inferring that, as in Tahiti, all the maidens would be about eleven years of age upwards. 'Twenty-three Gentlemen of

the highest Breeding ... including five Members of Parliament' turned up punctually. Charlotte had also mentioned that the proceedings would be improved with the help of 'Pietro Aretino's Inventions Imaginations and Caprices.' The whole decor in her great drawing-room had been arranged to highlight these 'postures', and she had engaged a dozen well-endowed athletic youths to face the twelve advertised maidens, whose beauty could not be doubted although their virginities might be suspect.

Each youth presented his nymph with a dildo-shaped object wreathed in flowers and the couples then copulated with great passion and dexterity accompanied by appropriate music until the spectators had excited themselves into a frenzy and invaded the floor, doing their best to emulate the examples just demonstrated. This 'Cyprian Feast' lasted about two hours, by which time the participants were exhausted and sat down to partake of a sumptuous supper. It was a *succes fou* and none cavilled at the astronomical charges. Charlotte did not repeat it, but it was copied by other hostesses.

Although she was supposed to be preparing for retirement, she was still recruiting new talent. She visited the many new Register Offices for domestic servants where the girls from the countryside were lined up in rows. However, each potential employer had to give an address to prove bona fides, so Charlotte could hardly use her own name and address. In 1769 she rented a house in King Street as Charlotte Flammingham, and in 1775 another one in King Street North. Sometimes she hired a room or rooms for a day and might choose up to twenty girls for 'audition', wining and dining them in glamorous surroundings until they were tipsy and would later find themselves in bed with a man.

In 1774 Dr Chidwick was treating Charlotte for what would now be called a nervous breakdown and spending a great deal of time resting in Dennis' new Piccadilly mansion, next door to his friend and patron the Earl of Egremont. In 1775 No. 5 King's Place was taken over by Catherine Matthews, who had a very successful run there until it passed to the even more successful Madame Dubery.

Charlotte was still carrying on in Great Marlborough Street, and this was to cause her some aggravation in late 1776 when she was once more in prison, 'at the suit of the Creditors of James Spilsbury of Russell Street, a bankrupt, for non-payment of work and labour ... in making fitting adorning & trimming divers Cloaths Garments and Masquerade Dresses.' She had already admitted the debt, but had spent almost six months in the

Marshalsea preferring to sit rather than pay. These clothes were clearly for the use of her own girls. When Dennis, ever busy elsewhere on his horses, was apprised of this, he paid up and she was released. In 1779 *Nocturnal Revels* indicates that she was still active in her profession, and in 1784 Rowlandson caricatured her as still top of the bawds. In 1785 there was the amusing incident when one of her regulars, Lord Dundas, was giving the Prime Minister, William Pitt, a lift in his carriage when leaving Parliament. They stopped at Mrs Hayes' mansion in Berkeley Square, and Dundas invited Pitt in to partake of the lady's hospitality. Pitt, known to be puritanical as far as sex was concerned, politely declined, although Charlotte was at the door to welcome him in.

In 1785 O'Kelly bought the Duke of Chandos' great estate at Canon's Park but he did not enjoy it for long, dying on 28 December 1787, aged sixty-seven. He was buried on 7 January 1788 in the nearby cemetery of Whitchurch. In his will he referred to his wife, 'Mrs Charlotte O'Kelly (late Charlotte Hayes) living here with me', and left her *inter alia*: 'An annuity of £400 secured upon the estate at Canon's Park ... payable each quarter day without deductions or abatements.' He also left to Charlotte 'silver, jewelry and the she-parrot called Polly'. This remarkable bird, according to the *Gentleman's Magazine* (1787):

> talks and sings correctly a variety of items and corrects itself if it makes a mistake in a bar ... and ... is reputed to be able to recite the 104th Psalm ... O'Kelly paid fifty Guineas for it.

On 7 October 1802 Charlotte wrote to her step-nephew Andrew O'Kelly that: 'Polley was taken ill Saturday night with a Purgeing and a bloody Flux; she died on Sunday morning'.

Andrew Dennis O'Kelly stayed in the Piccadilly mansion until 1788 and then moved to a house in Piccadilly at the corner of Half Moon Street and Charlotte lived there with him: all the Kellys maintained a warm relationship with her. Andrew was very long-suffering with her because of her never-ending extravagances. She was in the Fleet Prison in about June 1798, and early in 1801 wrote 'of the goodness of you and your father'. In 1811 she was still living in Canon's Park 'then aged 85 years', and she died in 1813 when the house in Half Moon Street was vacated, and Andrew Dennis went back to Ireland. The tradition of her house was faithfully carried on by Mrs Matthews and Mrs Dubery.

Miss Fawlkland's Temples of Love

The most recherché establishment of sexual service of the élite was the bizarre triple-brothel in St James Street run by Miss Fawlkland. There was no other quite like it at that time, and none have been recorded subsequently. It really began with the marriage of the penniless seventh Viscount Falkland, Lucius Carey, who married a rich brewer's daughter, whose son Lucius Frederick, a gallant soldier, 'paid off his mistress' when he married in 1760, with a very considerable sum to enable her to start a new career.

Her name was Elizabeth Keep, but for business purposes she changed her name to Fawlkland and founded her 'academy' in three interconnected houses in St James Street, then one of the most fashionable places in London. The house on the left was the Temple of Aurora, the one in the middle was the Temple of Flora, and the one on the right the Temple of Mysteries. The whole operation was conducted with a military precision, as befitted the ex-mistress of a noble soldier who became Commander of the British Forces and died in action in 1780 in Tobago. The 'governesses' who managed the first two were Elizabeth Scott, and Jane Joliffe, and they seemed to have commenced operations about 1765.

The first temple was aptly named, since it was to be the 'dawn' of a new life for a dozen girls aged 'between twelve and sixteen', who were 'hand-picked from those brought to the establishment by their parents', and it was claimed that many came from homes of a very superior quality. There can be little doubt however that these children came from orphanages or from destitute parents, and that some were bought in from dealers. The two 'governesses' taught them to read and write, to be clean in body and habit, and to behave like little ladies. They were well-fed and well-clothed and regularly examined by a doctor to ensure good health. They were also given the run of a library, which in the main consisted of erotic books designed to 'arouse their sexual consciousness'. For physical exercise they were taken each day into St James Park to get fresh air, closely supervised by the two duennas to see that they behaved correctly and were not molested.

At this stage, it was averred, no clients were allowed to have any contact with these little virgins – an unlikely tale considering that this was a brothel, but good publicity to whet the clients' appetites. When they reached the age of sixteen they were

transferred to the Temple of Flora, where they were introduced to the real thing, and if they showed particular flair and expertise they were transferred to the ultimate sphere in the Temple of Mysteries. There were supposed to be a dozen nymphs engaged in the mysteries 'of which six came up from Aurora', which would infer that somewhere along the line there had been some slip-up, although by this time none could have been virgins.

The subscription fee for the comparatively limited number of personages who were deemed eligible to join the Temple of Flora was prohibitively high, because at that stage all the girls were virgins. Real virgins were demanded by this eclectic clientele, and if they had been trained in the amatory arts as well, so much the better. Miss Fawlkland claimed that amongst her clients were two royal dukes and a group of earls led by James Hamilton, eighth Earl of Aberdeen, and including Lord Loudoun and his lecherous coterie. Later these were joined by Henry Thomas Carey, the son of her lover, who had become the eighth Viscount Falkland upon the death of his grandfather in 1785. He was a lieutenant in the 43rd Regiment of Foot and a real chip off the old block. He claimed to be a Whig in politics, earning the caustic comment from another Whig nobleman 'To be a Bully in a Brothel, a Hector of a Tavern or a Keeper of a Faro Table is the highest point to which ... this Noble Peer soars. Noise and Ribaldry ... supply the place of wit: obscene Songs are the only Tribute he can offer to the Whig Party.' Fortunately for all concerned he died, dead drunk, in the White Lion Inn in Bath in May 1796 at the age of thirty-one.

Behind all this excellent publicity was the stark fact that Miss Fawlkland was a procuress of young children to be violated by a tight group of wealthy and, in the main, elderly lechers using their power and their money to enjoy real virgins. The onset of the Industrial Revolution brought thousands of young girls into the urban districts, but insufficient employment was yet available.

In 1739 Captain Coram had founded his 'Hospital ... to rescue the Infants misbegot of respectable Girls'. Within weeks the hospital had been overwhelmed. In four years, out of more than 15,000 admitted, no fewer than 10,000 had died from whooping cough and diarrhoea and tuberculosis: and that despite the fact that the nurses got a bonus of ten shillings for every child that survived.

There was little or no check upon the children once they had left the orphanage, and it was by no means unusual for the ill-paid nurses to sell children to bawds. Miss Fawlkland often protested that she was doing a Christian deed – they could earn more than domestic servants.

Miss Fawlkland's academies were still flourishing in 1779 and there is a passing mention of her in 1780. She probably died about 1785, for in the following year the premises were occupied by Sarah White, whose occupation is not specified.

Madame Elizabeth le Prince

While Mrs Goadby is credited with running the first French-style *Maison de Tolerance* in England, a Frenchwoman domiciled in London established the first real French brothel in London a couple of years later. Elizabeth le Prince opened her maison in about 1750 in Great Marlborough Street off Oxford Street – on the fringe of Mayfair. She stayed there until 1766 when she moved to South Molton Street, where she remained until 1777.

Her house was conceived in the most elegant style and with great panache, designed to attract and cater for the fast-growing *corps diplomatique* from ambassadors to residents, offering them the same services and delights as those to which they were accustomed in their homelands. Hence, her first *mignons* were imported from France doubly attractive, for they spoke French, then the language of diplomacy and the Court.

These Parisiennes became popularly known as 'Les Amourettes': one of their first conquests being the young Frederick Howard, fifth Earl of Carlisle – although he admitted that 'he winced at their charges.' Later this young man took up with Kitty Kennedy who was to become one of the reigning toasts of London. *En passant*, these girls were compulsive gamblers and were often broke; but as they were known as the 'Best Flesh Market in Town' they had ready acceptance in the diplomatic circles, amongst whom was the well-known *flaneur* Count Haszlang – impecunious but always welcome in Society for his recommendations. There was a small frisson when Madame le P promised him 'a virgin of good ancestry acquainted with the best families ... who spoke perfect French ... Mademoiselle la Roche' a lady with whom he spent a very pleasant evening. The following day, boasting of this conquest to his colleague the Russian Minister, His Excellency thought it might be the same young lady that he had enjoyed a few nights earlier. He bet the Count twenty pounds that if he sent a message to Miss Reynolds at the Bedford Head in Covent Garden, Mlle la Roche would appear. And so it was. The Count was enraged: Madame le P was embarrassed and

at pains to assure the Count that it would never happen again. Elizabeth la Roche, well-born and well-known in amatory circles, used the name of Anne Reynolds while she was living in Newman Street: she and her sister, who had been briefly mistress to King Louis XVI, had lived in Paris.

Among her best known clients was the Russian Minister, Count Alexei Musin-Pushkin. She introduced him to the opera singer Elizabeth Gamberini, whose terms 'Twenty guineas a week, a Carriage and new Liveries for her servants' were rejected by the Count as too high a charge 'from a mere dancer.' No whit abashed Madame le P fixed her up with the Tripolitanian Ambassador, the Aga Hamid, who in turn passed her on to his successor Ibrahhim Aga, although she was also being intimate with Lord Robert Spencer. This kind of sexual musical chairs was an accepted feature of Georgian society, and the introduction fees charged by the best bawds were an agreeable supplement to their incomes. However, it would seem that Madame la P's business waned somewhat, since she is noted as a bawd in Harris's List of 1790 and that is the last reference to her.

Mrs Elizabeth Weston

Elizabeth Weston differs from the other bawds in that she was never a prostitute who had worked her way up. She was the sister of Edward Weston, factotum and general *homme de confiance* to William Stanhope, second Earl Harrington – an incorrigible lecher – as well as serving as a close friend and adviser of Richard Vernon, Earl of Grosvenor: indeed he was sometimes called 'Grosvenor's Chief Pimp'. Elizabeth started her career with Lord Grosvenor's backing, being assured not only of his own custom but also that of his numerous friends, especially in the diplomatic corps.

Mrs Weston opened up her brothel in Bolton Street, Mayfair, in 1765 and quickly built up a substantial and very discreet business, and remained untroubled by the Law or the minions of the Reform Society. She seems to have been a sensible and understanding woman and she encouraged the most famous Toasts to use her facilities. There Lord Grosvenor could meet his inamorata, the famous actress Clara Hayward, at least twice a week; and Lord Harrington, described as 'a Person of the most exceptional immorality ... a nobleman who sacrificed all appearance of Decency ... for the lowest amusements of the lowest brothels', who bore the nickname 'the Goat of Quality'.

Her discretion was demonstrated in her ability to keep the lecherous Lord Grosvenor's affairs going, while simultaneously satisfying the wanton demands of his wife Lady Henrietta Grosvenor. She understood the needs and frustrations of married ladies whose husbands left them unsatisfied; Lady Henrietta was regarded as 'all too accessible', but it was her affairs with the immensely rich spendthrift John Turner, and then with the even richer Sir Gregory Turner that aggravated her husband; and the aggravation turned to hatred when she took up with HRH the Duke of Cumberland. His petition for divorce was rejected, and he had the mortification 'of seeing his title, Coronet, Liveries and Emblazonments abused [by] … a Prostitute'.

She was responsible for launching such beauties as 'The Three Graces' – Elizabeth Armstrong, Miss Carter and Miss Stanley – all of whom were popular in noble circles, as well as the charming Watson twins, furious phaeton-drivers with whom the Prince of Wales was much taken. The most electrifying was probably the 'equilibrist' Isabelle Wilkinson, a wire-dancer from Sadlers Wells, who (thanks to Mrs Weston) was occupying an elegant establishment in Marylebone, courtesy of the Swedish Ambassador, Baron von Nollekens.

There was also the lovely 'little Harriet Lamb', then pleasuring the future Duke of Grafton, and Lady Penelope Ligonier, beautiful daughter of Lady Pitt-Rivers, renowned as the most beautiful woman in all England. Lady Penelope's activities were really scandalous: she eventually disappeared from the London scene by running away to Yorkshire with an army man whose rank is variously stated to have been that of a trooper, a sergeant and a captain.

Both Count Haszland and the pseudo-French cocotte Anne Reynolds/la Roche were regular visitors, despite the little awkwardness noted earlier but perhaps Mrs Weston's greatest success was in launching a little cockney waif born in Wapping and turning her into Mrs Benwell, who in 1780 was listed as one of the thirteen most elegant courtesans in London.

Lord Grosvenor also proved himself useful in another, rather unlikely, sphere, when he found a way to improve the Gale's beds bought by Mrs Weston from Charlotte Hayes' sale. He inserted an extra spring, to which was attributed 'the uncommon vogue which Mrs Weston's house now enjoys' (*Nocturnal Revels*, 1779). She was still in business in 1790.

The Lesser Greats

With an apology to George Orwell in the paraphrase 'all these bawds were great but some were greater than others', some brief consideration must be given to several ladies working in the same milieu, those who were regarded with respect by the cognoscenti, although they did not reach the heights of publicity as their greater sisters.

Nancy Banks was one of Charlotte Hayes' pupils. She was a handsome, polite, intelligent child, an orphan taken in early to Charlotte's seraglio and quick to learn the value of money and realize that a fair sum of it was needed to go into business on her own. Within a few years she had amassed enough to rent a 'very genteel house in Curzon Street, Mayfair' in about 1763, 'very luxurious and geared to the taste of the St James' customers, many of whom had enjoyed her own favours earlier on'.

Although she kept a couple of boarders, her establishment was more of a house of assignation patronized by the most beautiful and famous of the reigning courtesans. It was said that 'she guaranteed to them stout handsome athletic and vigorous Riding Masters, drawn from the most affluent and generous circles of the haut ton'. It was also claimed – although it may be doubted – that an occasional visitor was the prince who was later to be George III, but it is quite certain that some of his brothers made use of Nancy Banks' services. Moreover, when any of the demi-reps was temporarily unattached or even financially embarrassed, Mrs Banks could quickly find them a beau. Her commissions from this sort of introductory service were considerable.

Her manageress was a shapely creature named Elizabeth Stevenson, who later appeared frequently in the news at such fashionable watering-places as Tunbridge Wells; by 1784 she was mistress to Francis, fifth Duke of Bedford. One of her boarders was Mary Ferguson 'who was willing to tackle any customer ... be he Jew or Gentile, fair or dark, straight or crooked ... just so long as his Money was not *Light*'. 'Light' coins were gold coins which had been 'clipped' round the edges to reduce their value, and were well enough known in bawdy circles to be nicknamed 'Buck's Light Guineas', being a common ploy for bilking madams and whores alike. She had started out as an ambulant whore at the Shakespeare's Head, after being seduced by 'that dissolute lounger ... Sir Charles Barry'. Thereafter she had been taken into

Mrs Banks' establishment, and by 1771 she had opened her own brothel in Little Stanhope Street, Piccadilly. She was famous enough to have been one of the two madams to bring her 'train' into the Pantheon *Grand Bal d'Amour* in 1772.

Another boarder was Sally Hudson, 'who was so prudent that within a couple of years she was able to save two hundred pounds to take a House of her own'. As a demi-rep she is occasionally mentioned in the popular press, and the last mention of her is in Harris List of 1780 as 'the famous Mother Hudson'.

Her most famous protégée was Betsy Coxe, who came to Mrs Banks after she had left Charlotte Hayes. Of Betsy it was claimed, 'No Age or Clime ever produced so perfect a model of Voluptuous Beauty'. She adopted her name from that Colonel Coxe who 'rescued' her from Mrs Banks' house, but she was a most tumultuous character; the long-suffering Colonel tired of her debauches and extravagances and threw her out after four years, whereupon she went back to Mrs Banks, who fixed her up at once with Lord Thomas Foley and John Graeme, Earl of Alford. In later years Betsy became a termagent, and all the veneer so arduously implanted in her by Mothers Hayes and Banks went overboard. One later critic recorded 'let a Waiter at Ranelagh delay providing her with Tay, or a Link-boy for her Coach, then to the Rage of Moorfields she will add the Language of Billingsgate and the Discipline of Hockley-i-th-Hole'. In 1784 she had been abandoned by her latest lover and 'left indigent and dependant on the Sisterhood for charity.'

Other famous demi-reps who honoured Mrs Banks with their presence were the elegant and refined 'Hon.' Charlotte Spencer, the lovely actress Clara Hayward and the remarkable 'equilibrist' Isabella Wilkinson of Sadlers Wells who, 'after leaving Mrs Banks became mistress to one of Butcher Cumberland's aides, Sir Richard Perrott Bt.' – a shady and unscrupulous character. Isabella was later to be found at the most prestigious whore-houses in London, Mrs Prendergast's, Mrs Dubery's and finally Fanny Bradshaw's, where she met the Venetian Resident Count Giovanni Battista Pizzoni, who thereby earned the proud sobriquet of 'Wilkinson's Pizzle'. In 1772 she was mistress to Count von Nollekens, the Swedish Ambassador.

Nancy Banks retired from business shortly after 1779. She seems to have been a good-natured tolerant woman, quietly running a family bordello of a superior sort. She was still alive in good health and good spirits in 1795.

Of equal calibre was Elizabeth Mitchell, an experienced bawd from a family of professional bawds originating in Covent Garden

as early as 1727, when one Richard and Mary Mitchell ran a house in the Piazza. Richard died in 1747 and the Widow Mitchell carried on till 1755. Elizabeth was charged in 1740 with keeping a house of ill-fame in Bow Street, but by 1756 she had taken over the Bedford Arms, where she entertained 'each degree from Lords to Cits: from Authors down to puny Wits.' Quick to appreciate the possibilities of going upmarket, by 1765 she was already in Berkeley Street, with a very high reputation, finding 'Studs of Quality for Ladies of Quality' and recruiting the young, unsatisfied wives of elderly husbands who were seeking sexual gratification or even just wanting to earn extra money for jewels or fine clothes. In this way some sought through this means to gain an entrée into High Society. It was stated that over her door Mrs Mitchell had the motto 'IN MEDIA TUTISSIMUS', since within her doors everything was allowed. Possibly her most famous boarder was the outstanding beauty Emily Colhurst, whose father was a rich Piccadilly master-draper. While serving in his shop, she was seduced by Lord Loudoun, 'who set her up in a fine house and fine Carriage and … £500 a year', but the fickle peer threw her out within three months. Her father rejected her, so she went to stay with Mrs Mitchell and became one of the great Toasts of the Town. One of her captures was John Wilkes, that great advocate of Liberty who also took many liberties with young ladies. Sadly, young Emily was an anti-semite, averring that she would 'have no commerce with the Sons of Circumcision'. In 1775 Emily was still searching for the nobleman who could support her 'in luxury and Grandeur'.

Meanwhile, in 1770 Mrs Mitchell had moved into No. 1 King's Place, and, to her undoing, had acquired a lover, 'who ruined her by his exactions'. She had moved out of King's Place by 1772, but was still active in her profession elsewhere is evidenced in 1777, when the Temple of Prostitution mentions that she was finding fine studs for ladies and also had facilities for flagellation. She was dead before 1779.

About the year 1750 there could be found 'on the Corner of Playhouse Passage in Bow Street next the Theatre … a very reputable brothel' run by a 'fine tall young woman with blonde hair, sparkling eyes and splendid teeth' named Frances Herbert – popularly known as Fanny. She had for several years been the mistress of a wealthy City gentleman who financed her, and even 'in his later years still came occasionally to see how his investment was prospering.' Unlike most madams, Fanny also had her own *beaux garçons*, and she married one of them, Thomas Bradshaw, and set up in a fine genteel house in Queen Anne

Street. (In 1772 Bradshaw is described as 'a notorious Procurer … the Provider *Macaroni*. He died conveniently and suddenly while taking the waters at Bath.) She therefore stopped operating in Bow Street and made the abode in Queen Anne Street 'one of the most polished Receptacles for Amorous Intrigue' in which could be found the Bird of Paradise (Gertrude Mahon), the 'frolicksome' Miss Wilkinson and the 'lively' Miss Tooth – three of the most famous courtesans in London.

The Bird of Paradise was then having a torrid affair with the Portuguese Minister, Chevalier Luis Pinto de Balsameo, popularly known as 'Mahon's Pintle', while Miss Tooth was enjoying the favours of the Genoese Minister, Count Francisco-Maria D'Argeon, nicknamed 'Tooth's Argento' because he was a never-ending fountain of money for her.

Fanny Bradshaw herself disported herself with the 'Noble Cricketer' – John Frederick Sackville, third Duke of Dorset, 'an arrogant, haughty, ignorant, illiterate' nobleman, whose amorous exploits were innumerable: and it was said that he found solace in 'Fanny's ample bosom'. In that capacious bosom could also be found Hugh Percy, His Grace of Northumberland, 'although he was not then in the full vigour of his youth.' In 1779 Fanny was still 'a vivaceous Creature and a still desirable Peice … although on the wane in life' (she was only about fifty) and having a fine time with the 'Long Trowell', otherwise Lord Cholmondeley. Her house was then the rendezvous of the top demi-reps, Elizabeth Armistead and Kitty Kennedy. Fanny was still alive in 1795.

Catherine Nelson, best known as Kitty Nelson, is first mentioned in Harris List in 1746. She was taken into Mrs Goadby's establishment by 1754. There she met Mr Nelson, who was busily taking note of all Mrs Goadby's best customers. He persuaded Kitty to marry him and leave Mrs Goadby, and they started a brothel in Wardour Street. Naturally Mrs Goadby was 'very vex'd', and by dint of a campaign of calumny she ruined Kitty's chances. Her ruin was compounded by Mr Nelson trying to kidnap a Miss Williams. The attempt was bungled, Nelson absconded, and Kitty, a foolish dupe, was lucky to get away with her life. She then set up a faro table in Gerrard Street, and later a house of assignment for demi-reps in Bolton Street, Mayfair, where she had a modest but steady success. Heavy drinking and much debauchery eventually made her very fat and blowsy, and in 1779 *Nocturnal Revels* remarks that 'she gets worse and worse', which marked almost the end of her career. Shortly afterwards she died 'in the poorhouse'.

Finally, there was Eleanor 'Nelly' Elliott, one of the three respectable daughters of the impecunious Captain Elliott of Chelsea. All three were clever, but Nelly, born in 1739, was also beautiful. There being no money to launch the girls into society, they had perforce to go to work. Nelly was employed in one of the Bond Street millinery shops and was seduced by Henry Dundas (later Viscount Melville). He set her up in a nice apartment in Marylebone and gave her five guineas a week – and abruptly deserted her within three months, forcing her into prostitution. She then lived with a rich West Indian creole planter named Hamilton and was thenceforth known as Mrs Hamilton; but he went back to Jamaica, leaving her penniless, and so she went on to Harris List in 1760. Through this, she met another 'protector' who set her up in Newman Street in a house of intrigue, part-brothel/part place of assignation. There were only two rooms 'for copulatory purposes'. She was not by nature a real madam, but a good-natured, amiable, jolly and sociable woman, who loved to give convivial parties, to which well-known demi-reps were welcome to come with or without escorts. She had a 'select list of First quality Ladies prepared to accommodate fumbling old Keepers'. She rented a house in Curzon Street between 1766 and 1769, but she eventually went back to Newman Street in 1770. With all this good living and jollity, it was reported in 1779, 'that Nelly is grown so fat and unwieldy' that she was finding it very hard to contort herself to satisfy 'little Lord Suffolk'. Since she was still only 'fair, fat and forty', she still had many years of cheerful, convivial life before her, barring accidents.

20 The King's Place Nunneries

Running between King Street and Pall Mall were a number of alleys – originally stableyards leading into Pall Mall – the best known in the eighteenth century being Bingham's Yard. John Bingham, a builder, was the progenitor of the Earls of Lucan. It was then taken over by another builder, John Baker, who renamed it George Court, building five very commodious mansions. At the King Street entrance in 1732 stood a famous tavern, the Golden Lyon – which stands there to this day. In 1763 William Almack, a valet in the service of the Duke of Hamilton, opened up a palatial gambling-house at the Pall Mall entrance of the alley, which since about 1744 had been re-christened King's Place. Under that name it achieved a fame unsurpassed in British bawdry, all the mansions now being famous brothels, the habitués of Almack's exclusive gambling-club being assiduous visitors.

Almack's sponsor was the royal Duke of Cumberland. This enabled the *crème de la crème* of Society to visit the *crème de la crème* of harlotry now resident in 'Nunneries' – this being a less offensive sobriquet than whore-houses. Indeed in 1767 Edward Thompson gibed that the Nunneries stood between the Hotel and Almack's, and the alley 'could be recognized by the smell of Urine.'

By a pardonable error in translation, King's Place and its brothels became known overseas as '*Les Bordels du Roi*', and the alley's location immediately adjacent to the royal palace and the mansions of the highest nobility compounded this error. (King's Place today is known as Pall Mall Place, a quiet narrow alley running between No. 51 Pall Mall and No. 47 King Street. In about 1990 it was blocked at the Pall Mall end.)

Since it would have been too coarse and unmannerly to call such splendid sin palaces mere brothels, they were called 'Nunneries', in which young and eager 'Nuns', under the control of sedate 'Abbesses' would administer to the wishes of noblemen

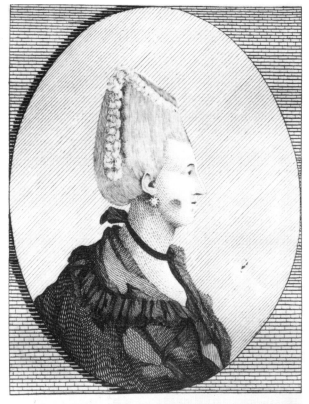

A LADY ABBESS *of the* 1.ᵈ CLASS .

Pub accor to act by Darly March 30 1773 39 Strand .

A Lady Abbess of the First Class, 1773, of dignified
and refined appearance

and gentry. The best impression of the excellence of these
brothels is found in the diary of the Baron D'Archenholz, who
visited London in 1773. After praising the beauty of English
women, their dress and deportment, it shocked him to be told
that there were 50,000 prostitutes in London, including 'kept
mistresses', and hundreds of more or less private 'houses' –
especially in Marylebone, where 'without these lettings thou-
sands of Houses would be empty'. He went on to describe:

The Noted Houses situated in a little street in St James, called King's Place in which a great number of nuns are kept for People of Fashion, living under the direction of several rich Abbesses. You may see them [the nuns] superbly clothed at public places, even those of the most expensive kind. Each of these Convents has a Carriage and liveried Servants, since these Ladies never deign to walk anywhere but in Saint James Park … [the prices were so exorbitant] as to exclude the Mob entirely and only a few very rich people could afford to aspire to the favour of such Venal Divinities … the Houses were magnificent and the furniture worthy of a Prince's palace! Women are instantly brought in Chairs, and only those celebrated for their Fashion, Elegance and Charms have the honour to be admitted … the Domesticks speak in Whispers … and every Device to restore old men and debauched youths will be found … More Money is exhausted in one night in these Bagnios … than would maintain all the Seven United Provinces [of the Netherlands] for six months.

He also remarked upon 'the line of Coaches which could be seen driving up to the narrow King's Place'.

What the worthy baron failed to mention was that many of these coaches belonged to the 'High Harlots' being conveyed to this Mecca of debauchery. The junketings in King's Place were far outside the reach of the great majority; and the glittering publicity hid the immense amount of poverty and misery, unemployment and frustration suffered by multitudes of men and women. For the prostitutes – even the successful ones – the ever haunting fear of venereal disease or pregnancy destroyed their peace of mind, and if perchance they found their way into a hospital, the treatment would be rudimentary and the place would be infested with 'buggs'.

Such disturbing matters and thoughts did not in the slightest way affect the thoughts of the visitors to King's Place. These nunneries were run by professionals – indeed the pick of the professionals, several of them from professional families of trained bawds. This, by and large, must be counted as the reason for the great and continuing success of King's Place, which *vide The Builder* of 21 September 1844 stated that: 'it is still a den of Infamy', and had been known so since 1744 and still, 'in 1868 has no very delicate fame.'

Amongst these Abbesses a few are conspicuous for having, by their efforts, kept the King's Place flag flying over half a century. First and foremost was Mrs Sarah Prendergast.

Mrs Sarah Prendergast

The Prendergast family were already well-established in the environs of St James before the middle of the eighteenth century and, like many other such families, can be traced back somewhat earlier to Covent Garden. The first in the new 'West End' appears to have been Joseph Pindergas [sic] with a whorehouse in Bury Street, St James, Piccadilly, from 1759 until 1790.

His son Charles had a similar establishment in Charles Street, nearby, from 1771 until 1775. His brother Jeffrey married Miss Sarah Warren in February 1731, and it was this same Sarah Prendergast who was the brains of the family. It was she who seized the opportunity in late 1774 to lease a house in King's Place (still then known to old-timers as George Court) at the stiff rental of £45 per annum. Her brother-in-law Charles had moved into the house next door about the same time.

Suffice it to say that her house was luxuriously furnished and equipped with all the modern conveniences of that age: suffice it also to say that all her nuns were beautiful, charming and fully trained. She kept only one or two hand-picked girls for the delectation of the casual visitors, one of them being a sparkling creature named Amelia Cozens, who some years later herself entered the bawdy sisterhood and rented one of the King Street houses.

Another was much more interesting. She was Nancy Ambrose, daughter of a Portuguese-Jewish merchant named Abrahams, whose sister Eleanor was a well-known actress and had been mistress to Sir Robert Walpole. Her other sister, Maria, was then mistress to Sir Edward Walpole. All were well-educated, well-mannered and polyglots. Some years later Nancy also became an actress, and with Eleanor became intimately involved with the famous actor-manager Charles Macklin, 1790. When, later, they were both broke, Sir Blake Delaval, Bt., succoured them for a while in lodgings in Marylebone.

One of her most faithful supporters was 'Old Lord Fumble' – William Earl of Harrington – one of the greatest lechers in the town. He had come to Mrs Prendergast upon the recommendation of another debauchee, Sir Robert Atkyns, since up to that time he had patronized Elizabeth Johnston, a foremost bawd of great repute in Pall Mall who had recently died. Old Lord Fumble was in 1773 described, in the *Westminster Magazine*, as 'a Person of the most exceptional immorality ... a Goat of Quality.' Mrs Prendergast resolved to leave no stone unturned to satisfy this

exigent but immensely rich client, whose recommendations would be invaluable. First she tried him with her three lovelies, but none were to his taste.

She then sent to Mother Butler, a sort of wholesaler, whose 'warehouse' was in the Sanctuary at Westminster, asking for a couple of fresh country tits. Mother Butler at once sent over 'Country Bet' (Elizabeth Cummings) and 'Black-eyed Susan' (whose surname is lost to posterity).

The old Earl approved of them, began 'his manual operations' and allowed them to play with him. After a couple of hours' dalliance, he announced that he was highly gratified and rewarded each with three guineas. Neither girl was satisfied, as they had been led to believe he was more generous, and this dissatisfaction was compounded when they returned to the Sanctuary and Mother Butler demanded her poundage of five shillings in the pound of their earnings. Susan, a neophyte at the game, paid up, but Betsy refused, whereupon Mother Butler impounded her clothes. Betsy at once complained to 'the Rotation Officer at Litchfield Street next Leicester Square' and charged Mother Butler with theft. On Monday 10 November 1778 Mother Butler was charged with keeping a house of ill-fame and ordering Elizabeth 'to go in company with another woman of the lowest order to meet the Earl of Harrington at the house of Mrs Prendergast who keeps a seraglio in King's Place ... and [Mother Butler] had kept a Gown, a Handkerchief and other Garments. It then transpired that Mrs Butler was actually the wife of Sergeant Spencer Smith, of the 1st Regiment of Grenadier Guards, and young Elizabeth declared that he aided and abetted his wife by 'fetching Coaches to take the girls who were picked up by his wife ... to furnish the seraglios in King's Place with girls whom she dressed as country maids ... and moreover that the Earl attended Mrs Prendergast's seraglio on Sundays, Mondays, Wednesdays and Fridays ... having two Females at a time.

The popular scandal-sheets picked this up and published it widely, and his Lordship 'flew into a great passion, stuttering and swearing and ... waving his Cane and shouting "Why! I'll not be able to show my Face at Court"'. After a great deal of pleading, Mrs Prendergast succeeded in mollifying the old lecher by sending round and buying up every copy of the newspapers whersoever; and promising him that neither girl would be able to show her face in London ever again – although privily she gave Bet five guineas to drop the prosecution.

She circularized all her clients to assure them that all steps had been taken to ensure that such a thing would never happen

again; and she scolded Mother Elizabeth Butler for her imprudence.

Something spectacular would none the less have to be done to restore complete confidence and she decided on a *Grand Ball d'Amour* at which 'the finest women in all Europe would appear *in puris naturalibis*', listing the ladies concerned. As the expenses would be immense she solicited subscriptions, and the old lord started her off with fifty guineas; altogether she collected more than seven hundred guineas. In addition to the 'professional

Newsmonger or whoremonger?
'Buy a Gazette? Great News!'
An itinerant paperseller, *c.* 1700

Ladies' such as Lady Mary Adams, Mrs Stanton of Red Lion Street, Mrs Goldsmith of Castle Street, Miss Lodge of Mayfair, Isabella Wilkinson and the Bird of Paradise, there was Lady Henrietta Grosvenor ('of moderate Beauty, no Understanding & excessive Vanity') and Lady Margaret Lucan ('both disguised as Mother Eve except that they had covered their Faces with fig-leaves'). Another in the Galaxy of Pulchritude was the young lady who called herself the Hon. Charlotte Spencer. Her father was a substantial coal dealer in Newcastle and owned ships as well. An only daughter, she was taught dancing, music, Italian and French, but the bleak northern clime did not suit her and she ran away and was involved in a 'Fleet Marriage' in London, whereupon her father disowned her. She claimed that 'Harris the Pimp' charged Lord Robert Spencer £500 for her seduction;

thereafter she always called her the Honourable. Yet another was the actress Harriet Powell, then in her prime.

After the show, everyone present danced in the nude for a couple of hours, and then sat down to a marvellous cold collation. Carriages were then called for, and it was remarked that my Ladies Grosvenor and Lucan, as also the Bird of Paradise, 'disclaimed their attendance-fee plus the cost of the sedan-chair hire', telling the hostess to give the money to the servants.

This wonderful affair restored everybody's faith in Mrs Prendergast: it also netted her a profit of more than a thousand pounds. Old Lord Fumble still 'repaired to King's Place as long as he could crawl to Mrs Prendergast's four times a week to indulge his Whims with a Brace of New Faces', but he died a few weeks later 'to Mrs Prendergast's great Affliction'. Nevertheless, despite the great affliction, she was still going strong in two houses until her retirement in 1788 with a considerable fortune after thirty years 'unmolested by the Law or Reforming Busybodies'. She had turned shabby George Court into glittering King's Place, and given it a reputation never to be matched again by any other coterie of bawdry.

Black Harriott Lewis

The most bizarre of the King's Place nunneries was that conducted for a while by the negress known as Black Harriott – and certainly the only black woman ever to occupy a house in this select enclave. She was a native of Guinea, who had been captured as a child in a slave raid and shipped to Jamaica, where she was bought at auction by Captain William Lewis, formerly in the merchant service, but by then owning a plantation near Kingston. She was a beautiful and intelligent girl and was quickly taken into the Captain's bed. He developed a great affection for her, and fathered two children upon her in three years. She was taught to read and write, given lessons in good manners and deportment, and also to do the accounts. Although he was a widower, there could be no question of marriage with a black slave, but she was generally known as Harriott Lewis.

About 1766 he visited England, taking Harriott with him and introducing 'his jetty mistress' into the wealthy circles in which he moved. In these circles there was not too much sexual apartheid. Many nabobs and noblemen had black or brown mistresses: George Bubb Dodington, the immensely rich par venu friend of 'Poor Fred', was 'a very *Maecenas* ... but of

repellent appearance with a huge Belly and a huge sloppy Wig.' He had a black mistress, Mrs Strawbridge, 'A very handsome tall and imperious Beauty' and also so jealous that Bubb Dodington managed to keep his marriage secret for seventeen years before she died. He doted on her, 'kneeling publicly in ecstasy before her' according to Horace Walpole and writing 'A Song about Mrs S'. He eventually secured a peerage, becoming Lord Melcombe

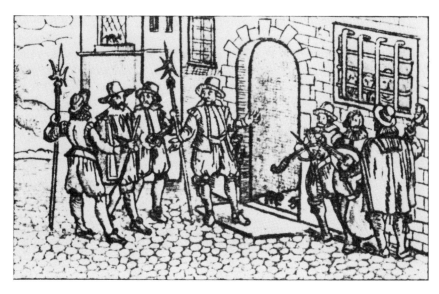

The Counter in Wood Street (*c.* 1550–1666), a debtors' prison in which many a 'scuffle' occurred and many a 'Kitty Careless' was imprisoned

and being nicknamed the 'Puffy Peer'. Many eminent ladies employed black men (ostensibly) as servants or sedan-chairmen but in fact as studs.

Captain and Harriott Lewis kept house in Little Stanhope Street, Piccadilly, from about 1768, their next-door neighbour being Mrs Dubery. Suddenly, the Captain died of smallpox, leaving Harriott in dire financial straits, and for a short while she was in the King's Bench debtors' prison, from which she was rescued by some potential 'protectors' because of her unusual charms and accomplishments. She went back to her house, and within a few months claimed a clientele of 'more than a score of peers and rich men ... none ever paying less than a soft-paper – a banknote for Twenty Pounds.' She was helped by Mrs Dubery and they became friends.

One of Harriott's regular visitors was the immensely rich and

powerful Earl of Sandwich, John Montague, a leading light in every lecherous exploit and a founder of the Hell-Fire Club, as well as a principal participant in the orgies at Medmenham Priory. He always gave her a douceur of twenty guineas and recommended her to his wide circle of equally lecherous and rich friends. In this way, Harriott accumulated within a short time more than a thousand pounds and a good store of jewellery, gold and silver plate, fine dresses and good furniture. She sought an opportunity to move into that fabled Mecca where even richer pickings were to be found.

In 1770 Elizabeth Allison (or Ellison), a well-known Jermyn Street bawd, had moved into a house in King's Place at one time occupied by Charlotte Hayes under the pseudonym of Flammingham. By 1772 she had taken over the next door house as well. But in 1774 she gave up the second house and 'Black Harriott' (as she was by now known) jumped at the chance and bought the contents as well. She was an immediate success and was all set for a brilliant future – when she fell in love with an officer in the Guards who was a visitor to her house.

She began to neglect her business and her clients began to fade away, while some of her nuns decamped without paying their dues as well as stealing some of her belongings. She ran out of money and from June to December 1776 she was 'gone away' according to the Rates Officer (most probably again in a debtors' prison), but she was in residence again in January 1777.

The crowning disaster came during the season of 1778, when Harriot and some of her nuns were at Brighthelmstone (Brighton), the Prince Regent's popular bathing-place. During her absence, her servants stole a great deal of her valuables and ran up large debts in her name with the fashionable Bond Street shops. By the time she returned, her creditors were on the doorstep – and at this juncture she fell ill. Her creditors forced her once more into the King's Bench prison, in which hellhole she wasted away, probably of tuberculosis, and died. The moral of this sad story is that bawds must not mix business with pleasure – and it is no business for amateurs.

Mrs Sarah Dubery

Sarah Dubery, unlike poor Harriott, was a professional to her fingertips, coming from a long line of professional whoremongers originating in Covent Garden, where one William Dubery had had a house in Charles Street in which he died in 1711. His son

Joseph moved upwards to St George's, Hanover Square; his sister
Sarah ran a small brothel in 1766 in St James, vacating these
premises in the autumn of 1770. Sarah was described in *Town and
Country Magazine* as: 'The Skillfull Matron of the Temple of Venus
in Stanhope Street, St James … much patronised by such as *Little
Infamy* Betty Davis.' This same Betty was eulogized in Harris's
List of 1764.

In January 1778 she was in St George's Court, St James, as *inter
alia* Mrs Dewberry and Dubery, paying a rent of £45 per annum.
(The alley had been known as King's Place from about 1744, but it
would seem that in the official records it was still an alley.)
However, it was no detriment that her name was so close to that
of Dubarry, or that she spoke both French and Italian: it was said
that 'her accommodations are most worthy of the Diplomatic
Body'. Her nuns earned 'very large sums of money', a great deal
of which they spent at 'Lazarus in Berwick Street' who would
upon occasion buy back his goods. He was *persona grata* with Mrs
Dubery, who most probably got a rake-off on his sales to her
nymphs.

Her house was also used as a rendezvous by all the most
famous courtesans of that period, including Isabella Wilkinson,
the famous equilibrist of Sadlers Wells. On one occasion this led
to a contretemps, involving her 'protector' Baron von Nollekens.
Mrs Dubery had promised the Baron the services of a brand-new
nun who turned out to be his Isabella, supposedly waiting at
home 'as chaste as Penelope!' Although diplomatic relations were
broken for a while, Mrs Dubery quickly found satisfactory
partners for both parties.

In 1792 there was a tremendous flurry of excitement and a great
increase in business when a Plenipotentiary from Sultan Selim III
came to London. King's Place's resources were stretched to their
utmost to accommodate the lustfulness of this visitation – the
subject of one of Gillray's lewdest caricatures.

By 1793 Mrs Dubery's house was being run by Becky Le Fevre
'who formerly plied her profession from Signora Chiappini's in
Gerrard Street'. Becky was clearly the manageress since Mrs
Dubery was in continuous occupation *vide* the Rate Books until
June 1814, when the house was taken over by Thomas Taylor;
Dubery's reign had lasted some thirty-six years.

Mrs Catherine Matthews

Catherine Matthews first appears on the King's Place scene on

Lady Day 1774, taking over Charlotte Hayes' residence. Although she became one of the top-class abbesses, little is known of her antecedents, but she was certainly very close to that ancient satyr the Duke of Queensberry, better known as 'Old Q', of whom it was written that he was ever on the hunt for a 'Tidbit'.

Her greatest catch for him was Kitty Fredericks 'the very Thais ... a delightful girl, an only child and her mother's pet.' She was well-spoken, well-educated, spoke French and was, above all, 'a very good little dancer'. She had been thrown into Charlotte Hayes' care at the age of fourteen, and was first 'placed' with the dissolute Lord Paget. Within a few weeks she had become the beloved mistress of Captain Richard Fitzpatrick, brother to the Earl of Orrery, until he was killed in action against the American Forces. Kitty then had to quit her home in Pall Mall and go back to her old 'home', now under the management of Mrs Matthews, who promptly introduced her to Old Q. From him she got 'a settlement of £100 the year for Life, a genteel House, Ten Guineas a week for Maintenance and the upkeep of a Carriage'. The old man paid Mrs Matthews 'a large sum' for this introduction. This love affair went on for four years, with such intensity that Kitty was known as 'the Duchess of Queensberry elect'. However the romance ended, as did the settlement, in 1779.

Another of her successful 'placements' was the tall elegant beauty 'of shallow understanding and much given to boasting' Elizabeth Hesketh, daughter of Sir Robert Hesketh, Bt. Her marriage to the Revd. Mr Bone foundered, when he discovered that she was having an affair with Colonel Egerton, son of the Earl of Bridgewater. He publicly repudiated her, with advertisements warning tradesmen not to give her any credit. Mrs Bone, as she now was, took to frequenting Mrs Matthews' salon, although the other inmates disliked her because of her airs and graces. Luckily Colonel Egerton came up trumps and bought her 'a genteel house at No. 11 Suffolk Street', where she received regular visits from Philip Stanhope, Earl of Chesterfield and others. (No. 11 Suffolk Street had been the dwelling of Charles II's early favourite, Moll Davis. It was to be known as a place for assignations until the end of the century, under various managements.)

Then there was the actress-*cum*-whore Margaret Cuyler, taken up by the brave Colonel Cuyler when she was but fifteen (although another version says that he was her father). He settled £300 a year on her, but she led him a merry dance until he threw her out. She then took up with Captain Thomas Metcalfe of the Bengal Lancers, pawning her jewels to buy his outfit when he was posted to the West Indies – an unlucky investment because

he was drowned on his way home when the *Isle de Paris* foundered and sank. At that stage she came to Mrs Matthews for succour: she also began a theatrical career with some success. Her amorous escapades were often mentioned in *The Rambler*; and even more explicitly in Charlotte Hazzlewood's *The Secret History of the Green Room* in 1790 which called her 'the Terror of the Green Room' because of her violent temper and outrageous behaviour. She moved in the same charmed circle as the Bird of Paradise and Tall Dally (Grace Dalrymple Elliott), and was well-known as one of the fiercest phaeton-drivers around the Prince Regent's hangers-on. Her last stage appearance was in 1800 at Drury Lane, after which not much is heard of her. She died in about 1813.

In the autumn of 1784 Mrs Matthews' house caught fire and was totally destroyed. This event received great coverage in *The Rambler*'s first issue in 1785, with a vivid picture entitled *The Bagnio in Flames* showing the girls jumping out of the windows. She was back again by the middle of 1785 when *The Rambler* mentions her part in the alleged *Petition by the King's Place abbesses* against the proposed tax on retail establishments. By June 1786, however, she had gone from King's Place, the house now being in Mrs Dubery's name; but Mrs Matthews' name appears once more in King's Place in 1792. Where she had been in the intervening six years is not recorded. The date of her death is likewise not known.

Mrs Catherine Windsor

Mrs Windsor's life prior to her appearance in King's Place in 1775 is unknown, other than that she was a Welsh woman and much appreciated by Welsh gentlemen in exile in London at the Court of St James. (She must not be confused with the lady of the same name and occupation in the much less elegant establishment in Wardour Street, Soho.) There is no doubt that her clientele was predominantly Welsh and that she recruited Welsh girls, although she complained that the difficulty was to keep these girls because they were always being tempted away by Welsh gentlemen.

She was particularly aggrieved when Betsy King, 'a very select Piece … a fine sparkling girl recently seduced at Black Harriott's' was cozened by Sir Watkin Williams Wynne – known as Sir W.W.W. – which caused a considerable coolness between them, although up till that time he had been a good and regular customer. So great was the leakage that she was compelled to

meet the coaches and wagons coming in from Wales and the West
Country 'to replenish her stock'. In this way she discovered the
remarkable Charlotte Williams, who became her principal
assistant until she too was whisked away by Richard Barry (later
to be Earl Barrymore), never to be seen in London again. Even

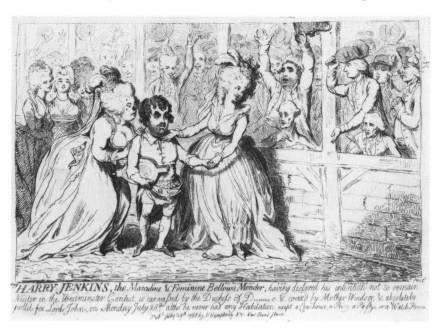

Harry Jenkins, a dwarf put up as a Parliamentary candidate in the 1789
election. He is introduced to voters by Mother Windsor and the
beauteous Duchess of Devonshire. 'He had never any habitation but a
cow-house, a Privy and a Pig-stye.'

before that, she complained that her 'star boarder, Gwyneth
Meredith … had been lured away by Sir Richard Atkyns, Bt.' a
member of the Hell-fire Club.

One lass who did not leave her was the pragmatic Mary
Newham, whose fine principle was that she would accept anyone
who came her way 'whether it be a *Soubise* [a man of colour] or
little Isaac from St Mary Axe … his Guineas must prevail because I
cannot see any more Sin in yielding to a Blackamoor, or a Jew
than to a Christian – be he even a Methodist.' These were also
impeccable egalitarian sentiments in King's Place, where by now
there were very many representatives of North African states as
well as many rich Creoles from the West Indies. There were also a
large number of wealthy third and fourth generation of English

Jews, now sowing wild oats in emulation of their Gentile friends. Indeed there is a caricature by Carrington Bowles, dated 1772 entitled *Beau Mordecai Inspir'd*, showing a fashionably dressed elderly Jewish fop being welcomed into a high-class whorehouse.

From 1783 to 1786 Mrs Windsor and her flock were regularly publicized in *The Rambler* magazine. Mrs Windsor took her fillies to the Opera House when the Prince Regent was present, and he often cast an appreciative eye. She and her girls attended all the fashionable watering-places – in August she would go with Mrs Weston's train to Brighthelmstone and then on to Margate, where the girls were 'on duty at the Hoy', which was a favourite rendezvous of the fashionable bucks.

In the summer of 1784 it was reported that:

> Mother Windsor has during the past Season engrossed almost entirely the right hand corner of the Crown Gallery at the Opera House; here she marshals her light and heavy troops ... [catering for] the smallest Newmarket Jockey to the Captain of Horse Guards.

In 1785 Mrs Windsor led the abbesses in a deputation to complain about the late hours kept by the House of Commons which 'prevented the Gentlemen from keeping their appointments.' In June of that year, it was reported that Mrs Windsor and Mrs Johnson 'were the most conspicuous ... in parading their troops in St James Park and other public places ... and Mother Weston's *Fencibles* were also ready for action'. In July it was reported that 'the Abbess Windsor with specially chosen girls were going on a Pilgrimage' to a number of watering-places, but they were back in St James shortly afterwards. *The Rambler* suggested that to cover all their journeyings they should get 'Hawkers and Pedlars' Licences'.

In 1784 Rowlandson gave her immortality in his print 'Best Friends', depicting Mrs Windsor with two pretty girls, the Prince of Wales, Perdita Robinson (the Prince's inamorata) and Charles James Fox, inferring that Perdita and the Prince were often to be found at Mrs Windsor's place. Fox was, of course, a famous wencher, and it would occasion little comment to know that he went there.

But most remarkable of all was Mrs Windsor's support of the young Dorothea Phillips, granddaughter of a Welsh divine, later to become famous as Dorothy Jordan the actress and, even more famously, as the consort of Prince William, Duke of Clarence, later King William IV. The family had arrived in London in the winter of 1785 in desperate poverty, and this 'beautiful,

warm-hearted but indolent imprudent and refractory girl' went to Mrs Windsor to earn some money to keep the whole family going. There she met Sir Richard Ford, became his mistress and gave him four children being known as Mrs Ford. Then Fate took a hand; in 1790, when she was only twenty-eight, Prince William fell in love with her, took her as his mistress, fathered ten children upon her and proved an affectionate lover and father.

By this time, of course, Dorothy had long severed her connection with Mrs Windsor, who in 1790 utilized Harris's List to promote one of her nuns, a young girl of seventeen, Sally Beckett, the daughter of a respectable Chelsea tradesman. In the same list she gave a plug for another of her elegant young ladies, the expensive Mrs Eley, the 'Fair Meretrice' who comforted Lord George Gordon in Newgate, where he was imprisoned after the 'Gordon Riots' in 1780.

Nocturnal Revels, in 1779, said that she was still busy attending to the demands of Old Q, and indeed her relationship with him must have been very close. In 1797 James Gillray's caricature *Push-Pin* shows her playing this game with the old lecher, while one of her girls looks on; the inference being that they were gambling over the price of her services.

At Christmas 1790 Mrs Windsor moved into No. 4 King's Place, where she stayed until June 1809. Then she moved to No. 1 and there remained until 1821, when the new tenant was a Mr Lloyd. The Welsh connection seems to have persisted throughout her life. She outlasted all her contemporaries and set a record of 'forty-six years continuous trading' in King's Place. It is all the more curious therefore that there is no record of the date of her death. The activities of King's Place did not cease with her departure; it was still a den of iniquity in 1844.

21 The Nasty Nurseries of Naughtiness

The junketings in the fashionable area of St James could not altogether hide the widespread nature of brothelry serving the needs of the mass of citizenry on a much more modest scale. Covent Garden and the ancient purlieus around the city's walls were still thriving and Drury Lane was by mid-eighteenth century designated 'the Nasty Nursery of Naughtiness', although there were several 'Whores' Nests' – such as Gress Street off Tottenham Court Road, and Blackman Street, Southwark, in which every house was a cheap whore-house.

When David Garrick asked Dr Samuel Johnson which were the two most important things in life, the reply was 'Sir! Fucking and Drinking!' Although he was a highly sexed man, he never patronized prostitutes nor brothels, contenting himself in need with masturbation. But since he had experienced poverty and hardship from birth he would not condemn the women. In 1751, in his magazine *The Rambler*, Johnson wrote that it could not be doubted that 'a great number of prostitutes follow that life with shame horror and regret ... but where can they hope for Refuge? The World is not their Friend, nor the World's Law.' He also had no time for whoremongers; neither 'the Bawds who dealt with Whores like a Dealer in any other Commodity ... [nor] the Beaus and Rakes who bought the Goods from these Dealers ... as a Man would buy Ironmongery from an Ironmonger.'

The nascent Industrial Revolution brought many thousands of men and women flocking into London and other urban areas for employment, which did not yet exist. They were forced to live in slums under the most horrible conditions. For the women, prostitution was often the only way out of the abyss of poverty. In 1793 the Bow Street magistrate blamed gross overcrowding and rack-renting for forcing the most respectable girls and women on to the streets, although he attributed it also to the demoralization caused by the French Revolution, which had created great unrest amongst the working population and the poor, as well as

stimulating the desire for more freedom.

Most at risk were young girls. In August 1777, Mrs Wood of Eagle Court in the Strand was charged with 'harbouring young girls in her house from eleven to sixteen years of age … sending them out nightly to parade the streets … [and] keeping them hard at work keeping the house clean all day … some half-naked and drunk and then sent them out at night'. The matter had been ventilated only because the Watch had picked up a girl of twelve 'with others of Mrs Wood's servants … [with] a man parading with them to prevent them running away with their Cloathes'. She 'made her escape' before the Bow Street officers came to arrest her. On the same day another bawd, Ann Morrow, was reported dangerously ill in the Clerkenwell Bridewell 'from the ill-treatment she had received from the Mob (when in the pillory … and her death is now expected hourly, she having lost the sight of both eyes.' The Bow Street magistrate opined that there were about 50,000 prostitutes then in London.

Prostitution has never been a crime in England; the crime is importuning or soliciting. In fact, a great number of prosecutions for prostitution at this time were linked with theft, or counterfeiting, or pickpocketing – all of which were hanging offences until in 1786 George III made transportation to Australia an optional punishment – when the American revolutionaries had refused to receive any more convicts after 1783 – but conditions at Botany Bay were so dreadful that often offenders preferred hanging. A legendary case recorded at the Old Bailey concerns a young girl who adamantly refused to be transported and the Duchess of Cumberland (the King's sister-in-law) and Mrs Fitzherbert (the morganatic wife of the Prince of Wales) pleaded with the girl to change her mind. When she eventually did so the whole Court, including the Judge, were moved to tears of relief.

There were now many brothels specializing in flagellation, the best known being Mary Wilson's, who had started in business about 1770 and in 1777 had moved to New Road, St Pancras, and later to even more commodious premises in Tonbridge Place nearby. From there she published *The Exhibition of Female Flagellants*, praising the great benefit of being whipped by women. Later she moved to fashionable Bond Street and then to Hall Place, St John's Wood, before emigrating to even lusher pastures in Paris in 1800. She sold the 'goodwill' of her business to Theresa Berkeley, who was to become the most famous flagellation madam in the land.

Theresa set up business in about 1770 in Hallam Street (near the present BBC). In 1787 she took over the famous house of

assignation known as the White House in Soho Square. It was a sumptuous mansion, long famous for its decor, which included Gold, Silver and Bronze Rooms (because of their individual colour schemes), and all were fitted with huge mirrors so that male and female clients could watch their own lewd antics. There was also the Painted Chamber, the Grotto and the Coal-hole, but the *pièce de résistance* was the Skeleton Room with a cupboard from which a skeleton issued – a subtle reminder of mortality to the older clients.

Her renowned collection of instruments included 'a dozen tapering whip-thongs, a dozen cat-o-nine tails studded with needle points, various other Supple Switches, thin leather straps, Curry combs, Oxhide Straps studded with Nails and green Nettles'. There was also a special chair-like contrivance which could be manipulated in all directions. In the first eight years she amassed a fortune of more than £10,000 which had been vastly increased by the time she died in 1836. This fortune went to her missionary brother-in-law, who repudiated it 'because he abhorred the means by which the money had been made'.

Another such establishment was run in Covent Garden by Mrs Collett, known to have been visited by the Prince Regent, 'but it is not known whether the Royal Wrist wielded the whip, or the Royal Buttocks submitted to it.' His patronage and support enabled Mrs Collett to move to the more salubrious district of Bloomsbury, and, after her death, her niece, Mrs Mitchell, entertained the noblesse until well into the nineteenth century.

There were also a number of specialist brothels such as that run by Eleanor and Anne Redshawe, who started off in Tavistock Street, Covent Garden in 1743, moving in 1750 to Bolton Street, Piccadilly. They catered for Ladies: '… an extremely secretive … discreet House of Intrigue … [for] the Highest *Bon Ton* … catering for Ladies in the highest Keeping … [and wealthy married ladies] who come in Disguise to Amuse themselves.' She had an arrangement with Mrs Matthews to supply extra 'ladies of refinement to accommodate the Highest Nobility' in case of need. Amongst her clientele was the Hon. Charlotte Spencer now 'very choice in admission of Lovers', and Lady Penelope Ligonier (who had been divorced by General Ligonier, 'because of her Wantonness and Profligacy').

A similar establishment was kept by Mother Courage, who kept a 'female coterie' in Suffolk Street, sheltering many a famous opera singer or actress. A welcome visitor was the lovely Martha Rae, Lord Sandwich's long-time mistress, while his Lordship dallied with the opulent delights of Signora Francusi at the opera.

Martha was to be murdered by a jealous lover on the steps of the Drury Lane Theatre in April 1779. The Russian ambassador was very welcome for his stallion-like prowess – he was reputed to have copulated seventeen times in one night with three young ladies at Mother Courage's – and also because he 'handed out gold five-guinea pieces like confetti'. Of this it was said (as also of Charlotte Hayes) that 'Here any number of Golden Guineas could be liquified into Champaign and Burgundy and Arrack far quicker than at any Gold-Refiners.' Here too could be found the

Rowlandson's engraving of Bow Street police court in the time of Sir John Fielding, 1808. A uniformed Bow Street Runner stands on the steps on the right

enchantingly beautiful Swiss Jewess, Therese Augsburger, famous as 'La Charpillion', whom Casanova found 'frigid', but who was later to find comfort with Old Q and with John Wilkes.

From 1784 the Harris List makes reference to Jewish courtesans: and elsewhere there are many references to Jews frequenting the Drury Lane brothels. This was a source of anxiety amongst the elders of the community, whose original code of conduct, the *Ascamoth* of the Sephardi Synagogue in St Mary Axe, had laid down that any Jew who was intimate with a non-Jewess should be expelled from the community; but by 1784 such was the laxity prevailing that a new and stronger version had to be promulgated.

The first Jewish courtesan noted by Harris is Charlotte Lorraine, living in 1780 in Good Street. She was known as the 'Agreeable Jewess' … a very desirable Companion who drank little and swore less'. She was also mistress to the second Earl of Upper Ossory. Later she married one Mr Hazzlewood, 'who had an income of three hundred a year and kept two Maids and a Footboy … but had no Carriage'. This latter deprivation proved insupportable, and she left him for a Guards officer. She had a theatrical career, and after 1790 published *The Secret History of the Green Room*, a very bright *chronique scandaleuse* about actors, actresses and their *amours*, though reticent about her own affairs.

From the Harris Lists, it became clear that almost every house in Berwick Street, Poland Street and Wardour Street was a brothel: a most notorious procuress Mrs Walpole lived at No. 1 Poland Street and advertised regularly some particular titbit. Mother Kelly was operating in Duke Street, St James, boosted by frequent mentions in *The Rambler*: in 1784 she conducted 'an Auction of several Orphan Virgins.' That same Mrs Wood who was being sought after in 1777 by Sir John Fielding's Bow Street Runners was now comfortably installed in Lisle Street, Leicester Square. Mrs Gray's establishment 'near the Opera House in Covent Garden' welcomed visitors with a glass of *Usquebaugh* on the house.

In 1780 appeared *The Characters of the Present Most Celebrated Courtesans*, Elizabeth Armistead, Sophia Baddeley, Gertrude Mahon (the Bird of Paradise), Betsy Coxe, Kitty Fredericks, Mrs Benwell, Mrs Bone, Mrs Hatton (daughter of Mr Ambrose) and Eleanor Ambrose, Miss Elizabeth Farren and her sister Mrs Gray, Mrs Mackay *née* Sutton, and Lady Henrietta Grosvenor. A later list in 1783 found Betsy Coxe and Kitty Fredericks 'in decline' and only six of the older list still in the running, but now included were Lady Penelope Ligonier, Margaret Cuyler the actress, and 'the beautiful and rich Mendez da Costa woman … then keeping Mr Macklin'. Elizabeth Mendez da Costa was a daughter of the great financier of the same name, an orthodox Jew whose anger knew no bounds at this betrayal. She was later to marry an MP, Mr Gooch and her equally beautiful daughter later became Countess of Galway. The Bird of Paradise was 'flying higher … with a new Chariot and new furniture'.

While these favourites were being toasted, poor ones were being roasted – burned at the stake for husband-murder or coining. Public anger ultimately mounted so high that George III had to enact that from 5 June 1790 'women were to be hanged instead'; not until 1829 were death sentences generally abolished

except for treason and murder. One of the foremost women leading the 'feminist' revolt was Lady Seymour Dorothy Fleming who secured a divorce – then a rarity – against her husband. He was granted one shilling damages. She had many amours, including one with the Chevalier de St George, son of the Old Pretender. A highly literate and articulate lady, she composed immediately after the divorce, using the pseudonym 'A Lady of Quality', a poem entitled *The Whore*. The introduction commends the readers 'to the amorous activities of liberated and sincere Worshippers of the Cyprian Goddess', listing Ladies Penelope Ligonier, Henrietta Grosvenor and Worseley. The last verses make a fitting conclusion to this book:

> Of all the Crimes condemn'd in Woman-kind
> WHORE, in the Catalogue first you'll find.
> This vulgar word is in the mouths of all
> An Epithet on ev'ry Female's fall.
>
> The Pulpit-thumpers rail against a WHORE
> And damn the Prostitute: What can they more?
> Justice pursues her to the very Cart
> Where, for her folly she is doomed to smart.
> Whips, Gaols, Diseases – all the WHORE assail
> And yet, I fancy, WHORES will never fail …
>
> Yet everyone of Feeling must deplore
> That MAN, vile MAN first made the Wretch a Whore!

Bibliography

BL British Library
BM British Museum
CSP(D) Calendar of State Papers (Domestic)
GH Guildhall
Mdx Middlesex Sessions Records

Anon., *The Two-Penny Whore*, or *A Relation of a Two Penny bargain* (London, 1670)

Anon., [?Daniell Mallet] *Gallantry a la Mode, a Satyrickall Poem* (London, 1674)

Anon., *Advice to a Cunt-Monger* (Yale: MS Osborne; London, 1675)

Anon., *An Essay on Scandal* (BM: Harley MS 7319, *c.* 1675)

Anon., *The Last Night's Ramble* (BM: Harley MS 7316, *c.* 1678)

Anon., *The Bridevvell Whores Resolution* or *The Confession of the 24 Backsliders* (London, *c.* 1680)

Anon., *A Pasquil or Pasquinade: The Last Will and Testament of the Charters of London* (London, 1683), see also Scott

Anon., *A Satyre upon the Players* (BM: Harley MS 7319, *c.* 1684)

Anon., *An Ill Song to a Good Old Tune* (London, ante 1686)

Anon., *A Catalogue of Jilts Cracks & Prostitutes* (London, 1691)

Anon., *A Genuine History of Sally Salisbury alias Mrs S. Prydden* (London, 1723)

Anon., *Don Francisco's Descent to the Infernal Regions: An Interlude, greeted by the Ghost of Mother Needham* (London, 1732)

Bloch, Iwan, *Sexual Life in England* (London, 1958)

Burford, E.J., *Queen of the Bawds: Madam Brittannica Hollandia and her House of Obsenitie* (London, 1973)

—— *The Orrible Synne: London Lechery from Roman to Cromwell's times* (London, 1973)

Chamberlain, John, *Letters* (*c.* 1617; ed. N E McClure, (Philadelphia, 1939)

Charles, Chevalier Phileas de, *Le 16eme Siecle en Angleterre: La Vie et des Actes de Maman Creswell* (Paris, 1846)

Cranley, Thomas, *Amanda, or the Reform'd Whore* (London, 1635)

Crossley, John, ed., *The Works of John Taylor, the Water Poet* (Manchester, 1870)

Delaporte, Louis J., *La Mesopotamie: Les Civilisations Babylonienne et Assyrienne* (Paris, 1925)

Dryden, John, *Satyre on the King and Duke* (BM: Harley MS 7319, London, c. 1675)

Dufour, Paul, *Memoires Curieux sur l'Histoire des Moeurs et de la Prostitution* (Paris, 1854)

Dunton, John, *The Whipping-Post: A Satyre on Everybody, with the Whoring-Plaquet or News of the Stallions & Kept Misses* (London, 1706)

Ebsworth, J.B., ed., *The Bagford Ballads* (Hertford, 1876)

Ebsworth, J.B., and Hindley, Charles, *The Roxburghe Ballads* (Hertford, 1877)

Evans, Chilperic, *The Code of Laws of the Great King Hammurabi* (London, 1904)

Evelyn, John, *Diary* (ed. William Bray, London, 1951)

Fletcher, John, *The Humorous Lieutenant* (London, c. 1625)

Garfield, John, *The Wand'ring Whore* (London, 1660-3)

—— *The Wand'ring Whore's Complaint for Want of TRADEING* (London, 1663)

—— *A Strange and True Conference etc.*, by 'Megg Spencer.' (London, 1660)

—— *Strange Newes from Bartholomew Fair or, The Wand'ring Whore DISCOVERED by 'Peter Aretino' translated by Theodorus Mirrorismus* (London, 1661)

—— *Strange and True Newes from Jack a Newberry's Six Windmills*, by 'Peter Aretine, Cardinall of Rome'. (London, 1660)

Gwillim, John, *The London Bawd, with her Character and Life, Discovering the Various Intrigues of Lewd Women* (London, 1711)

Harben, H.A., *A Dictionary of London* (London, 1918)

Head, Richard and Kirkman, Francis, *The English Rogue* (London, 1665)

INDEX of Inhabitants of the City of London (London: Guildhall MS, 1638)

Jastrow, M., *The Civilisation of Babylonia and Assyria* (Philadelphia, 1915)

Mackay, Charles, ed., *Songs of the London Prentices* (London, 1841)

McKerrow, E.B., ed., *The Works of Thomas Nashe* (London, 1910)

Mandeville, Bernard, *A Modest Defence of Publick Stews* (London, 1724)

Mercurius Philalethes, Select City Quaeries or the Discovery of Cheates, Abuses & Subtilities of the City Bawds & Trapanners (London, 1660)

Middlesex County Records from 3 Edward Iv-4 James II (ed. Jeaffreson., Middlesex Committee, 1888)

Middlesex Sessions Books 1689-1709 (ed. Harvey, Middlesex Committee, 1905)

Middlesex Sessions Books 1612-1618 (ed. Harvey, Middlesex Committee, 1935-41)

Nashe, Thomas, *Nashe his Dildo* (Oxford, Bodleian Library: Rawlinson MS(Poet)216, 1699)

Nicholas, Sir Nicholas, ed., *The Private Memoires of Sir Kenelm Digby. Bart., Gentleman of the Bedchamber to King Charles the First* (BM: Harley MS.6758)

O'Faolain, Julia and Martines, L., *Not in God's Image* (London, 1973)

Pearsall, Ronald, *Public Purity, Private Shame* (London, 1976)

Pepys, Samuel, *Diary* (1660-8; Latham & Mathews, USA, 1970-8)

Rae, James, *Deaths of the Kings of England* (Manchester, 1913)

Reynolds, Rowland, *The Character of a Town Miss* (London, 1680)

—— *The Ape-Gentlewoman or the Character of an Exchange Wench* (London, 1670)

Riley, H.T., ed., *Liber Albus* (London, 1861)

Rollins, H.E., ed., *Pepys Ballads* (Harvard, 1922)

Rosenbaum, Julius, *The Plague of Lust* (Paris, 1901)

Rye, William B., ed., *England as seen by Foreigners in the Days of Queen Elizabeth and King James the First* (London, 1865)

Scott, Sir Walter, ed., *A Collection of Scarce and Valuable Tracts of Lord Somers* (London, 1809)

Sellars, H., *Italian Books printed in England before 1640* (London, 1924)

Settle, Elkanah, *The Empress of Morocco – A Farce for Simon Neal at the signe of The Three Pidgeons in Bedford Street* (London, 1674)

Speed, Sam, *Fragmenta Carceris: the King's Bench Litany: The 'Legend of Duke Humphrey'.* (London, 1675)

State Papers(Domestic), The Calendar of (ed. J.W. Harvey, Records Commission, London 1856-95)

Stow, John, *Surveigh of London* (1598; ed. C.L. Kingsford, Oxford, 1908)

Stow, William, *Remarks on London* (London, 1722)

Strassmeier, J.M., ed., *Babylonische Texts (BC 555-538)* (Leipzig, 1887)

Tanner, Anodyne (pseud), *Life of the Late Celebrated Elizabeth Wiseburn Known as Mother Whybourn* (London, 1721)

Taylor, John, *A Common Whore* (London, 1622)

—— *Prayes & Vertue of Iayles & Iaylers* (London, 1623)

—— *A Vertuous Bawd, A Modest Bawd* (London, 1635)

Tempest, Pierce, *The Cryes of the City of London Being the Drawings Made by Marcellus Lauron 'Drawn after the Life'. (1653-1702)* (London, 1688)

Thompson, Maunde, ed., *The Letters of Henry Prideaux to John Ellis* (1675; London, 1875)

Thompson, Nathanael, *A Choice Collection of 180 Loyal Songs* (London, 1685)

Uffenbach, Count Zacharias von, *London in 1710* (trans. W.H. Quarrell and Margaret Moore, London, 1934)

Venette, Nicholas de, *The Mysteries of Conjugal Love Reveal'd* (Paris, 1906)

Vieth, David and Danielson, B., *The Gyldenstop MS – The 'Second Letter'. folio 116-117.* (Earl of Rochester – Cuffley) (Stockholm, n.d.)

Walker, Captain Chas., *The Authentick Memoirs of the Life Intrigues & Adventures of the Celebrated SALLY SALISBURY with the True Character of her most considerable Gallants – with a Key* (London, 1723)

Ward, Edward [Ned], *The London Spy – Including the 'History of the London Clubs'* (London, 1709)

Weldon, Sir Anthony, *The Court & Character of King James the First* (London 1817)

Wilmot, John, Earl of Rochester, *Satyre Against Mankind* (Oxford, Bodleian Library: MS Firth *c*.15., n.d.)

—— *Poems of the E of R* (London, 1722)

Wilson, J.H., ed., *Court Wits of the Restoration* (Princeton, 1948)

Wood, Anthony à, *Life and Times* (1664-81; Oxford, 1892)

Wright, Thomas, *Vocabulary of Anglo-Saxon English* (London, 1884)

Yearsley, P. McLeod, *Le Roy est Mort* (London, 1935)

Index